CAPTURING
THE LIGHT

Roger Watson and Helen Rappaport

CAPTURING THE LIGHT

The Birth of Photography, a True Story of Genius and Rivalry

St. Martin's Press ≋ New York

www.stmartins.com

Library of Congress Cataloging-in-Publication Data

Watson, Roger (Museum curator)
 Capturing the light : the birth of photography, a true story of genius and rivalry / Roger Watson and Helen Rappaport.
 p. cm.
 Includes bibliographical references and index.
 ISBN 978-1-250-00970-8 (hardcover)
 ISBN 978-1-250-03832-6 (e-book)
1. Daguerre, Louis Jacques Mandé, 1787–1851. 2. Talbot, William Henry Fox, 1800–1877. 3. Photographers—France—Biography. 4. Photographers—England— Biography. 5. Inventors—France—Biography. 6. Inventors—England—Biography. 7. Photography—France—History—19th century. 8. Photography—England— History—19th century. I. Rappaport, Helen. II. Title.
 TR140.D3W38 2013
 770.92'242—dc23
 [B]
 2013025241

St. Martin's Press books may be purchased for educational, business, or promotional use. For information on bulk purchases, please contact Macmillan Corporate and Premium Sales Department at 1-800-221-7945, extension 5442, or write specialmarkets@macmillan.com.

First published in Great Britain by Macmillan, an imprint of Pan Macmillan, a division of Macmillan Publishers Limited

First U.S. Edition: November 2013

10 9 8 7 6 5 4 3 2 1

J'ai capturé la lumière fugitive et l'ai emprisonnée! J'ai contraint le soleil à peindre des images pour moi!

[I have captured the light and arrested its flight! The sun itself shall draw my pictures!]

<div align="right">

Louis Daguerre,
letter to Charles Chevalier 1839[1]

</div>

I hope it will be borne in mind by those who take an interest in this subject, that in what I have hitherto done, I do not profess to have perfected an Art, but to have *commenced* one; the limits of which it is not possible at present exactly to ascertain.

I only claim to have based this new Art upon a secure foundation: it will be for more skilful hands than mine to rear the superstructure.

<div align="right">

Henry Fox Talbot,
letter to the editor of *The Literary Gazette*, 1839[2]

</div>

Contents

List of Illustrations

MY FIRST DAGUERREOTYPE.

There never was anything like it. True, a multitude of "types" and "graphs" have been brought out since then, and glass and paper and iron and leather and divers vehicles have been covered with impressions, and I have seen them, but nothing ever filled my eye so completely as that first daguerreotype.

For hours I have held it, carefully noting all the soft minutiae of light and shade: and still the little rough-edged silver tablet was a joy forever, discovering some merit of complete similitude hitherto unnoted; it seemed inexhaustible, yielding new pleasure as often as consulted.

A small and pleasant village in central Indiana was the locus of this primitive achievement; the time I think, the fall of 1842. Seth, my coadjutor and compeer in the enterprise, and myself were denizens of a cosy Law Office, in the second story of an unpretending building, where we tumbled the musty tomes of legal lore, hoping in good time to make lawyers of ourselves. Seth was an artist, that is, he had wielded a pencil in his day and produced some landscapes, and even portraits which were not without merit; at least, so said the knowing ones, who pronounced him a genius undeveloped, and bewailed his aberration in reading law. At one time he had tried his hand at farming, being beguiled by the smell of new-mown hay, or more probably by the per-diem to the harvest hands, (for Seth was poor.) But that was only a temporary expedient, and he did not take kindly to association with those "whose talk was of oxen." I may mention that he afterwards turned up at New

Orleans, where he verified the predictions of his quondam friends, by making a sensation in the way of landscapes and of portraits, and so the world lost a poor lawyer and gained a reputable artist.

Having an eye out for the new and curious, I had seen some time before intimations in the public prints of a wonderful French discovery in the art of portraiture, whereby it seemed quite probable there was a royal road to drawing and picture-making; and indeed, that the time was not distant, when one might look in a mirror, and leave his image sticking there. But as greater marvels have in like manner been announced and never heard of afterwards, I was disposed to regard this new wonder as belonging to the same class, until I saw another account of the mystery, and this time coupled with the more tangible statement, that the images of a camera obscura were made permanently visible, and giving a kind of outline of the method.

Seth and I talked over the new discovery for several days, determining, if possible, to verify our deductions by a practical test, and with a view to elicit all the paragraph contained, and to obtain a more complete clue to the *modus operandi*, we tried our hand on interpretation, and by dint of different emphasis and modulation, we thought we could more completely evolve the seeming mystery. The result of this unfledged exercise of legal acumen was, that silver plates properly exposed to the vapors of iodine, and thus coated with a thin film of a yellow or golden color, became sensitive to the action of light and received the image, which could be made visible by the fumes of mercury, and rendered permanent by a wash of salt and water ... The rest was easy of accomplishment, and with the judicious employment of pocket knives, tacks, paste, and the division of labor, a cigar box was soon transformed into a camera ...

"A regular built picture, by jingo!", said Seth, as we slipped it into the salt water and admitted the light. Sure enough, there it was. The iodine was slowly clearing off; and as more light was admitted we saw our miniature landscape—that old shed, with its water-stained shingles in the fore-ground, the barn yard and its carts and wagons, and even those horses —a little misty, to be sure—but that white horse was unmistakable. The building in the distance—the church and its steeple, and the leafless trees. There was a dim, hazy look about the horizon, and a sad want of what I have since learned to denominate "aerial perspective;" but Seth said that softening down of the harsh lines was decidedly artistical. To me, it seemed a realization of what I suppose everybody has thought of—the skilful combination of all the elements of that delicate frost work which we see on the windows of a cold morning into the perfect semblance of a real and familiar scene.

After repeated rinsings we dried it on the stove. I confess there was quite a crystalization of salt on the surface, and some streaks, but still there was a picture—to me an inexhaustible source of wonder and admiration. Afterwards I progressed somewhat in the art; adopted new improvements, and took likenesses of learned lawyers, with numberless imposing looking volumes piled on the table beside them; sentimental young ladies with guitars in their hands, and beautiful bouquets in the back ground; matronly ladies, with pocket handkerchiefs of table-cloth dimensions; children, with staring eyes and cork-screw faces, and love-sick swains who persisted in sitting with a huge hand placed over the region of the heart, and who brought back the picture after a few days because the heart was on the wrong side.

All these, of course, I admired exceedingly—but still, I repeat, there never was anything like that first daguerreotype![1]

Chapter One

THE LOCKED TREASURE ROOM

Man has always been fascinated by the sun, from the primeval days of his existence when he first stood erect on the great wide savannahs of Africa and gazed up at it through protecting fingers. To him the sun was not just a potent force, a god – the giver of life, food, warmth – the regulator of his very existence – it was also the giver of light. In the book of Genesis light was God's first creation and sunlight for ever after became the fount of an age-old puzzle which, from the moment man began marshalling his thoughts in written form, he longed to solve.

With the dawn of civilization and the creation of the very first written texts, be it on clay tablets, stone or parchment, the quest to capture the light and channel it – that inbuilt human desire to harness the natural elements and make them work for us – first entered the minds of thinkers and scholars around the world. In the fifth century BCE the Chinese philosopher Mozi was one of the first to talk of the power of light and spoke of a device for passing sunlight through a pinhole onto a 'collecting plate', its mysterious function being that of a 'locked treasure room' – a kind of lightproof box that would channel the power of the sun in such a way that man could safely observe it and the images of the recognized world outside that it projected.[1]

Over the centuries this idea was regularly revisited by a

succession of scholars from the Greek thinker Aristotle, who noted the patterns created by sunlight filtered through trees onto the ground below, to the first properly scientific description made in the eleventh century by an Arab scholar named Ibn al Haythaim. In a seven-volume treatise on optics – the study of the behaviour of light and its interaction with the human eye – written by him between 1011 and 1021, al Haythaim described the optical principle of a pinhole camera obscura with a single small aperture for letting in the rays of light and wrote up experiments he made during his years in Cairo that demonstrated how light travelled in a straight line. The *Book of Optics* was translated into Latin in manuscript form in the late twelfth century and finally printed in 1572. The use of the pinhole camera, in combination with glass lenses, in studying and understanding how light worked, was soon after discussed in the writings of the English Franciscan friar and scholar Roger Bacon, who may have read al Haythaim in translation, and also wrote on the other-worldly and more spiritual and magical qualities of light as the source of all creation. The key to harnessing it, as Bacon saw it, lay in the enlistment of optics, as he observed in his *Opus Majus* completed in 1267:

> It is possible that some other science may be more useful, but no other science has so much sweetness and beauty of utility. Therefore it is the flower of the whole of philosophy and through it, and not without it, can the other sciences be known.[2]

The first camera obscuras used in the study of light in this period were quite large, hence the name, which means 'dark chamber'. They were effectively small darkened rooms into which the light was projected through a small pinhole, producing an inverted image of the scene outside on an opposite wall. Such chambers were particularly popular for safely observing

solar eclipses and were used by Bacon for this purpose in the thirteenth century. From this original incarnation the pinhole camera was rapidly developed into a more practical camera obscura that could be adapted to different technical uses – most importantly, for directing natural light onto paper for use by artists and draftsmen in making accurate drawings from real life. By the sixteenth century the camera obscura had been dramatically reduced in size – down to that of a portable wooden box with a lens on one end and a ground glass to focus the image on at the other that could be set up on a table or stand anywhere. In this way a scene or object could be projected onto paper, and the camera obscura was increasingly used by artists to create a template for paintings executed later at their leisure back in the studio.

The greatest early exponent of the device was the artist Leonardo da Vinci, who during the Renaissance used the camera obscura to help him with the drawing of perspective; in his notebooks he described its use in his discourse on the function of the human eye. The painters Velazquez and Vermeer followed da Vinci as leading advocates of the camera obscura's use in the seventeenth century and the Italian master of waterscapes, Canaletto, made extensive use of it in order to create his vast, magical scenes of Venice in the century that followed. Scientific enquiry into the nature of light meanwhile reached its high point with Isaac Newton's seminal work on the subject during the 1670s which culminated in the publication in 1704 of his *Opticks*. In it, Newton unknowingly predicted the science of photochemistry when he remarked that 'The changing of Bodies into Light, and Light into Bodies, is very conformable to the course of Nature, which seems delighted with Transmutation.'[3]

Newton's ground-breaking work on optics, combined with his study of gravity and the orbit of the planets, marked a

watershed between the end of the dark age of alchemy – the art of 'transmutation' to which Newton alluded in his guise as the 'last of the magicians' – to the new age of practical science.[4] It came at the point at which scholars were making the dramatic leap from the metaphysical and philosophical discourse of how things might or could be done into serious empirical research and experimentation in the laboratory. This new age of scientific enquiry, based on experimental verification, was fostered by the work of the Royal Society in London, which took as its motto '*Nullius in verba*' – effectively meaning, 'Take nobody's word for it'.

Such is human inventiveness and curiosity that it was not long in the new eighteenth century before some of those who looked at the images in the camera obscura began wondering whether they could push the boundaries of its use. Might it ever be possible, they wondered, for the delicate images they saw projected through its pinhole or via lenses to be captured permanently onto paper or some other medium? Was it conceivable that a way could be found, through the enlistment of chemicals in fixing that image, to cause the image in the camera obscura to be frozen in time, in all its perfection? Would man ever be able to achieve the till then unthinkable, and make nature paint her own portrait?

By the end of the eighteenth century numerous practitioners – scientists, artists, astronomers, as well as businessmen and entrepreneurs – were beginning to broach this great puzzle, although investigation into light and how it worked was but one facet of the thrilling and tumultuous new period of scientific enquiry and invention across Europe that became known as the Age of Enlightenment. It brought with it the dawn of a new mechanical age that spurred inventors to design machines that could do what till then had only been done by the human hand.

Scientific experimentation at this time was largely the domain of gentlemen of leisure, of men – and with a very few exceptions, extraordinary women – grounded in the kind of classical education and private means enjoyed only by the moneyed classes. But there was also by the mid-eighteenth century a new generation of thinkers and inventors that had sprung up amid the thrusting new mercantile classes in the industrial heartland of England. No group more typified the extraordinary coming together of the exciting and disparate scientific talents of the age, and one that cut across religion and class, than the Lunar Men.

Chapter Two

SHADOWGRAMS

They called themselves the Lunar Men but the reason was prosaic rather than deliberately obscure or mysterious. The fourteen or so members of this small provincial society began meeting monthly in the late 1750s on the first Monday nearest to the full moon as a matter of practicality. At such times there would be more light in the sky to get home by when their meetings were over; although, as intellectuals, they were not unaware of the significance of the full moon as a time for conjuring the powers of darkness. And so, in a humorous nod to age-old superstition, they dubbed themselves the 'Lunarticks'. But they didn't meet in London in some grand institution or learned society; at first they simply discussed the latest scientific enquiry and invention over dinner in each other's home. Later they transferred their meetings to the Shakespeare Tavern in the freethinking, Nonconformist stronghold of Birmingham, a manufacturing city in the Midlands that by the mid-century was leading the way in industrial innovation.

The leading Lunar Men were an eclectic mix of talents who exemplified the age: Erasmus Darwin, a physician, philosopher and reformer, and grandfather of the much more renowned Charles, who even today still overshadows him; the abolitionist and porcelain manufacturer from nearby Stoke-on-Trent, Josiah Wedgwood; Matthew Boulton, another

highly successful manufacturer – of metal goods – who with his business partner and fellow Lunar Man James Watt pioneered the steam engine; and chemist Joseph Priestley a Nonconformist clergyman and outstanding scientist of the day who in 1774 would discover and describe the properties of oxygen. Together, these extraordinary individuals 'classified plants and isolated gases, they built clocks and telescopes, they flew in hot-air balloons and invented machines that could speak, performed tricks with magnets and dreamt up recipes for disappearing ink'.[1] It was men like this who blazed the scientific trail for the invention of photography in the century that followed. Erasmus Darwin, of all of them, foresaw what might one day be achieved; in his *Zoonomia*, published in the 1790s, he discussed visual perception, likening the camera obscura to the human eye, and in so doing reiterated man's age-old aspiration to make copies of the things he saw in the natural world around him.

> GENTLE READER! LO here a Camera Obscura is presented to thy view, in which are lights and shades dancing on a white canvas, and magnified into apparent life! – if thou art perfectly at leisure for such trivial amusement, walk in, and view the wonders of my ENCHANTED GARDEN.

The thought of entering that enchanted garden was a tantalizing one indeed, and even more so the possibility of finding a way of preserving an image of what it contained.

*

Tom Wedgwood, born in 1771, the fourth and youngest son of Josiah the potter, was very much the inheritor of Erasmus Darwin's enquiring mind and the atmosphere of scientific experimentation fostered by the Lunar Men. He should have

followed Josiah into the pottery trade, but he was, from childhood, plagued by ill health. But in the philanthropic tradition of the Lunar Men he had a keen social conscience and a sense of the responsibility that his family wealth brought him and channelled his failing energies into education and moral improvement. Tom was, wrote one friend, 'a strange and wonderful being. Full of goodness, benevolence, with a mind stored with ideas . . . A man of wonderful talents, a tact of taste, acute beyond description – with even good-nature and mild manners.'[2]

His father's involvement with the Lunar Society and the frequent visits to his home of its members, inevitably exposed Tom to the intellectual challenges and debate of the day and in particular Darwin's work, which he greatly admired. His chronic illness forced him to spend much of his life in private study and experimentation at home – when he wasn't travelling the world in a fruitless search for a cure. By his mid-teens Tom had proved himself to be a skilful draughtsman, having had lessons in perspective from the painter George Stubbs, but his great passion, from the start, was the study of gases, acids and metals and their chemical interaction with heat and light. He was encouraged in this by his father's chemical assistant, Alexander Chisholm, at the family home, Etruria Hall near Stoke-on-Trent. The firm of Wedgwood had already been using the camera obscura to draw country scenes from which transfers onto Wedgwood pottery products could be made and young Tom might have played a major role in the burgeoning family business, had his health not prevented him; but in 1793 he left the firm to concentrate on his scientific interests.

In the years that followed, Tom Wedgewood's slide into physical exhaustion was triggered by his obsessive bouts of experimentation, combined with headaches and depression. It led, in the end, to nervous breakdown and ultimate opium

addiction – a result of the large doses prescribed for him by Darwin. It blighted the tall, fine-looking Wedgwood's active and personal life, but it never dimmed his love of science and with it came the first tentative steps towards making photographic images on paper. Back in 1792, Joseph Priestley had spotted the twenty-two-year-old's potential when Tom had published a paper on his experiments with phosphorescence. Priestley wrote to him that year, telling him of the exciting path of scientific discovery out there, waiting for young men such as him. 'There is nothing more within the field of random speculation, and less within that of experiment, than the subject of *light* and *heat*,' wrote Priestley, adding prophetically, 'this I hope is a business reserved for you. It is ground unoccupied.'[3]

Tom Wedgwood had of course studied Newton's *Opticks* and was well versed in the latest scientific thinking on the subject of light. In his early experiments in the as yet unoccupied ground of photography some time in the 1790s he had worked with the dim old camera obscuras of the day. But he was frustrated to find that none of the exposure times he had used had been long enough to produce an image on his chemically treated material, because the light levels inside the camera were just too low. By the end of that decade, when his bouts of illness allowed, he once more attempted to find ways of creating images chemically, this time by contact exposure. What Wedgwood eventually achieved – though simple – were 'silver pictures', as Lunar Man James Watt described them, although they were later sometimes referred to as 'photograms' or 'shadowgrams'. He achieved them by applying a mixture of silver nitrate dissolved in water to pieces of paper and then exposing the paper to the light with small flat objects – such as leaves or insects' wings – laid on their surface. He also tried using pieces of white chamois leather as the medium, which proved more successful. The leather readily soaked up the

silver nitrate solution and it is possible that the ingredients used in tanning, such as galls and salts, that were already present in it reacted with the silver nitrate, giving a faster and more successful response.

But in all cases, the minute the images revealed themselves there in front of him, they began to darken dramatically if left out in the daylight. The same thing happened when Tom tried placing a semi-transparent silhouette of a picture painted on glass upon sensitized paper and exposed it to the light. All too briefly the image emerged only to begin once more to disappear if not immediately removed from the light. He was therefore able to show the images he had achieved to his friends only at night by candlelight, which would not be bright enough to change them. But shadowgrams such as this, which could only be viewed in the dark, were of little use; they did, nevertheless, survive, albeit in an ever-diminishing state, much longer than expected. Although they are now lost to us, these first tentative images were seen as late as 1885 by the chemist, Samuel Highly, who during his researches noted that he had been 'looking at specimens of some of Wedgwood's experiments with chloride of silver on bibulous paper' – probably held by a private collector.[4]

It is possible that during a brief period of remission in his illness after 1799 Tom Wedgwood went back to photographic experimentation in earnest. Some time between March and May 1802, when he was in London consulting with his doctor, he was able to recreate his experiments at the well-equipped basement laboratory of the Royal Institution, in collaboration with his friend and colleague Humphry Davy, who was a professor of chemistry there.[5] In his own experiments on heat and light in 1797, inspired by the work of the French nobleman and outstanding experimental chemist Antoine-Laurent de Lavoisier, Davy himself had concluded that light and not heat

was 'the important imponderable'. 'What we mean by nature is a series of *visible images*,' wrote Davy in his notebook, 'but these are constituted by light. Hence the worshipper of Nature is a worshipper of light.'[6]

To Wedgwood and Davy those fragile images produced in the laboratory at the Royal Institution in 1802 were miraculous little creations. But they were ephemeral: both men knew that in their current state they were doomed to be destroyed by the very thing that had created them – light. Davy had already tried and failed to preserve images of small objects projected by a solar microscope rather than the camera obscura. But like Wedgwood – and despite being a brilliant chemist – he had not been able to fix them. All that was wanting, in Davy's view, was a 'method of preventing the unshaded part of the delineations from being coloured by exposure to the day'. Once achieved, this would 'render the process as useful as it is elegant'.[7] But it was an intensely frustrating admission to have to make. There was just this one last piece of the puzzle remaining to be solved, but for decades no one would be able to crack it.

Although Tom Wedgwood's first tenuous experiments ended where they began, as they did for so many other precursors in the art of photography – in frustration and disappointment – yet in preparing his paper with the magical silver nitrate (known as lunar caustic by the ancient alchemists who believed that silver was associated with the moon), he had laid down the important germ of an idea.

This brief window of scientific discovery was the last enjoyed by Tom Wedgwood. His urgent need to write up his embryonic photographic 'speculations' was all too quickly curtailed by the inevitable slide back into illness, his senses dulled by the powerful opiates on which he had become dependent, and which he had shared with his close friend, the poet Samuel

Taylor Coleridge. It was Davy, therefore, who later that same year wrote up a rather dry and cursory 'Account of a method of copying paintings upon Glass and of making Profiles by the agency of Light upon Nitrate of Silver' – the first photographic experiments of their kind to be published.[8]

The final three years of Tom Wedgwood's tragically 'maimed life' were blighted by mounting hypochondria and a consuming fear of losing the powers of reason by which he had lived – the terror of dying insane or paralysed.[9] He died in 1805 at the age of twenty-seven. The loss of his talent was deeply mourned by Coleridge, who recorded that his friend had 'added a fine and ever-wakeful sense of beauty to the most patient accuracy in experimental philosophy' and had 'united all the play and spring of fancy with the subtlest discrimination and an inexorable judgment'.[10]

Despite that, in Wedgwood's legacy – the five pages of Davy's published account – lay many of the basic building blocks from which photography would eventually emerge. The first step – using light to initiate a chemical change – had been found by Wedgwood, but without the second step of halting that change at the right moment and freezing the image in time, photography would remain a dream.

*

Humphry Davy chose not to continue the experiments he had begun with Wedgwood. Discouraged by the problem of fixing the images, he lost interest and instead went back to his many and far more successful experiments in agricultural chemistry and electricity. Tom Wedgwood's little-known but pioneering work was quickly and totally forgotten.

Science, it would seem, had reached an insurmountable stumbling block – that of making the longed-for leap in harnessing the natural elements of light in conjunction with

chemicals to make images and fix them for ever. The possibility of capturing the light continued, however, to tantalize, promising the obvious laurels of precedence, wealth and fame to whoever got there first. But it would require a more physically vigorous personality in the uncertain but thrusting years of the new century, who in France would pave the way for a totally new approach to this challenge.

Chapter Three

THE BOX OF WONDERS

During Tom Wedgwood's childhood and the years of his first attempts at photographic experimentation in the 1790s, France had been going through the dramatic upheavals of revolution. Scientific enquiry had been flourishing there, although in general it had been restricted to the elite, educated classes rather than percolating down into industry and manufacturing, as it had done in England. In France, science remained predominantly theoretical rather than applied. All this, however, was summarily sidelined by political conflict and economic downturn, and many outstanding French men of science and letters fell victim to the inquisition that was the Jacobin Reign of Terror. The exploits of the Montgolfier brothers in pioneering manned flight with their hot-air balloons were dramatically curtailed, as too was the work of the chemist Lavoisier, whose experiments with hydrogen tapped directly into the balloonists' work with gases. In the late eighteenth century Lavoisier had played a pivotal role in turning the experimental tide away from the dark practices of alchemy towards the new science of chemistry, but he had perished on the guillotine in the Place de la Révolution in May 1794 on trumped-up charges, the new French republic declaring that it had no need of intellectuals such as he. But as his colleague the mathematician Joseph-Louis Lagrange – who had mercifully escaped the same

fate – had observed: 'It took them only a moment to cause that head to fall, and a hundred years, perhaps, will not suffice to produce another like it.'[1]

Revolutionary protest in France had initially been prompted by the indifference of the Bourbon monarchy to the economic crisis that was crippling the French countryside. Years of seclusion at their palace at Versailles had isolated King Louis XVI and his wife Marie Antoinette from the poverty endured by the common people, oppressed as they were by centuries of an outmoded taxation system that had bled them dry. Government coffers meanwhile had been drained by costly wars in Europe and financial support for the American Revolution. Three hundred years of an absolutist monarchy had, without compunction, favoured an acquisitive aristocracy and clergy – neither of whom paid taxes and who profited from the labour of the ruthlessly exploited Third Estate – the peasantry. The rural population was suffering hunger and deprivation as the old feudal system disintegrated; revolution now seemed inevitable. Nevertheless, King Louis XVI and his wife continued to indulge their sybaritic lifestyle indifferent to the widespread hardship in the French countryside, as drought and a succession of hard winters took their devastating toll on harvests and forced up bread prices. With the French national deficit reaching crippling levels (something approaching £800 million in today's values), the army of bureaucrats who supported the centralized, despotic rule of the Bourbons and who worked in the safe sinecures of government offices were daily feeling the rising anger of their fellow citizens.

Among those civil servants was Louis Jacques Daguerre, who held the lowly post of crier at the local bailiwick's court in Cormeilles-en-Parisis, a small town in the *département* of Seine-et-Oise, about ten miles north of Paris. Louis was a young husband when, on 18 November 1787, with France on the

brink of bankruptcy and martial law declared in Paris, his wife Anne Antoinette gave birth to their first child, a son, christened Louis Jacques Mandé Daguerre. Their baby was only eighteen months old when revolutionary forces stormed the Bastille in Paris in July 1789, unleashing a decade of fear and turmoil across France.

By the end of 1791, the local French courts where Louis Daguerre worked had been crushed by the revolutionaries, who had forced King Louis into an uneasy constitutional monarchy that within a year had collapsed. With the demise of the old legislative system, Daguerre senior found himself out of a job. His loyalty to the monarchy, however, had held him in good stead and he quickly found a post as a clerk at one of the wealthiest royal estates, near Orléans, eighty-one miles south-west of Paris. His privately held sentiments were confirmed by the name he gave to his new daughter, born in 1791, who was christened Marie Antoinette Daguerre. But in January 1793 Louis XVI, who had been arrested after trying to flee France, died on the guillotine; he was followed in October by his wife. As the legalized Reign of Terror took hold the worst of the violence and excesses of the French Revolution, and with it the systematic murder of the aristocracy, was confined mostly to Paris. Daguerre's employer, Louis Philippe II, Duc d'Orléans, although a cousin to King Louis, had long been a liberal and had come out as a Jacobin sympathizer, adopting the sobriquet Philippe Citoyen Égalité in support of the Revolution. For a few months the region where the Daguerre family lived seemed safe. But the revolution inevitably caught up with the duc. As a member of the hated House of Bourbon he was eventually arrested and was tried and summarily guillotined on 6 November 1793.

The news of the duc's execution inevitably cast a pall over

his estates at Orléans and those who worked there, but otherwise daily life carried on much as usual. For the young and inquisitive Louis Daguerre was now beginning to explore what a thriving regional centre such as Orléans had to offer. Paris may have had the finest theatres, a grand opera house and world-class musicians, but popular entertainment of a different order made regular appearances in French towns like Orléans, particularly on market days and during religious festivals such as the carnival in the weeks leading up to Lent. Public occasions such as this provided a far more immediate and visceral kind of street entertainment for ordinary people. Often of a crude or bawdy nature, it catered to the short attention span of its audience, as people moved from one market stall to the next. The knockabout, stylized violence of the enduringly popular puppet show 'Polichinelle et Joan' – the French version of Punch and Judy, a show that had originated in Italian *commedia dell'arte* in the fourteenth century – was complemented by the tomfoolery of colourfully costumed jugglers, the breathtaking antics of acrobats and a wealth of other street performers. All of them sought out ever more dramatic and eye-catching performances that would win a few sous, tossed from their pockets, as the crowds passed by.

These short excursions into fairytale and fantasy, even when clothed in tired and tawdry costumes and performed on improvised stage sets that had seen better days, were common sights in places like Orléans when Louis Daguerre was a child. Their magic appealed to his developing imagination, for from his youth he demonstrated an artist's sensibility and was an acute observer of the world around him. On festival days and market days, when itinerant performers would haggle for prime positions on street corners where they could set up their stalls and small marquees, boys like Louis with a coin or two in their

pocket to spend would have weighed up the relative merits of what was on offer before putting their money down and entering into the world of wonders offered up to them.

In his childhood, there was one popular entertainment above all others that must, from the first, have captured Louis's imagination: the magic lantern peep show. An age-old form of entertainment, lost to us now, but very common in Europe from the Renaissance, it fell somewhere between portable puppet theatres and the penny-arcade stereoscopic peep shows of the later nineteenth century. Chinese shadow-play – or *ombres chinoises* – using jointed paper puppets fastened to pegs, had been all the rage in Paris in the 1770s and at the royal court at Versailles after being brought back from the Far East by French missionaries. But this form of entertainment reached a far wider audience in its cruder form, as the itinerant peep show of the late eighteenth and early nineteenth centuries. The peep-show operator could travel the provinces and set himself up on any street corner, much like the jugglers and acrobats who haunted provincial markets and fairs, but with the differ-ence that his show was not open to view, but was contained inside a simple wooden box, usually the size of a tea chest with the largest being about three foot square fixed at the top of folding legs. The box was gaily painted, with a peep hole in the front, often with a magnifying glass in it, and was not too different in appearance from the already familiar camera obscura of old. Publication in 1558 of Giovanni Battista della Porta's *Magiæ Naturalis* had long since taken the camera obscura into the realms of popular entertainment, as the means of creating natural magic through the peep shows, although it continued to be used by artists and draughtsmen.

At travelling fairs in the late eighteenth and early nine-teenth centuries, the curious would step up and pay their money to peer inside – usually one at a time, though some of

the more sophisticated travelling peep shows had more than one peep hole. The operator would then begin telling his story for everyone gathered around him to hear, animating it by means of a few strings or pulleys that protruded from the side. But only those who had paid their money could see what was happening, mysteriously, inside that simple wooden box. What their eyes focused on through the peep hole was a miniature theatre with a proscenium arch and rich scenic decorations, far more intricate than anything that those living in the provinces had seen or would ever see in their lives and of the kind most people had only ever heard about in stories. The players in the peep-show story contained inside the box were, of course, nothing more than paper cut-outs and their action consisted of simply being moved back and forth across the stage in front of changing scenery. But if the operator who pulled the strings could spin a good story and if the interior of the box was well decorated and his show went smoothly, what in effect the viewer saw was a form of silent cinema in its earliest, crudest incarnation. The more sensational and scary the peep show was, the more popular, for it created in miniature a world of the supernatural and fantasy that had been thrilling post-Revolutionary Paris for several years.

The larger, theatre-based incarnation of the magic lantern show had premiered in Paris as the *fantasmagorie* – phantasmagoria – at the Pavillon de l'Échiquer in January 1798 to overnight success. It was the creation of the Belgian Étienne-Gaspard Robertson – a trained physicist and amateur painter. By a clever combination of optics and skilfully hand-painted slides, Robertson drew on the then popular genres of fantasy, horror and melodrama by conjuring up every kind of ghostly apparition, spectre and clanking skeleton, making them fly through the air and spring out at his unsuspecting audience from the smoky backdrop onto which they were projected. He

had cleverly chosen to stage his shows at 7 p.m. every evening in the appropriately Gothic setting of the Cour des Capucines, off the Place Vendôme. The location was a ruined convent which reeked of the must and chill of ages and where terror lurked in the shadows as dusk fell and his audience took their seats in an auditorium draped in black and as dark as the sepulchre. The terrifying effects of Robertson's apparitions – 'spirits, ghosts and every species of optical delusion'– were enhanced by the magic lantern projector being rolled backwards and forwards behind a large semi-transparent screen, thus zooming in and out of the images much like film camera techniques today.[2] By using several projectors at the same time Robertson could even make his array of ghosts, goblins and banshees appear to be passing through solid objects; his assistants added to the terror inspired in his paying customers by creating a live soundtrack of disembodied voices, weird musical sounds and shrieks and howls.

Robertson took great delight in the realistic effects of his newly patented 'Fantascope': 'I am only satisfied if my spectators, shivering and shuddering, raise their hands or cover their eyes out of fear of ghosts and devils dashing towards them; if even the most indiscreet among them run into the arms of a skeleton,' he declared.[3] The subjects he chose to present – such as the decapitated heads of French revolutionaries Danton and Robespierre – were often perilously close for comfort, reviving memories of the all too recent real-life tumbrels and guillotines of the city during the Jacobin Terror. Other stories ranged from recreations of Shakespeare's more macabre characters such as Macbeth, through biblical stories, to representations of figures from literature such as Voltaire and Rousseau. With the turn of the century and the rise of Napoleon, scenes of his triumphs in war would later become increasingly popular at phantasmagoria shows.

Travelling practitioners of the kind seen at the market place in Orléans by the young Daguerre were, by comparison, very limited in the effects they could create, relying in the main on the flair of the operator's lurid storytelling, with the help of sound effects created by an assistant, if he could afford to have one. But, primitive though they were, the peep show and the phantasmagoria had all the attraction for impressionable teenagers of today's cult vampire movies and the influence of the genre's artistry and showmanship, as well as its experimentation with optical illusion, is very clear in Daguerre's career, once he made the transition from rural France to the capital.

Young Louis Daguerre had been fortunate, despite the revolutionary times in which he lived, to grow up under the care and tutelage of loving parents. Although the riots and devastation seen in Paris did not reach Orléans, the impact of the Revolution was felt throughout France in the number of young men who were conscripted into the military by the various revolutionary governments that followed the execution of the king. By the 1800s, men were increasingly being called up to take part in military campaigns, first in Italy, and then, with the inexorable rise of Napoleon Bonaparte, throughout much of Western Europe. Particularly notable was the enforced conscription of large numbers of schoolteachers, leaving few behind to educate the young. Daguerre suffered as a result; he was sent to the *école publique* in Orléans, but, like most schools in France at the time, it is unlikely that it met regularly and his education would have been intermittent at best. The poor education he received may, in the long run, have done him a favour by saving him from becoming a clerk or some other small-town functionary similar to his father. It forced him to exploit the natural artistic gifts he was already displaying, for, from a very young age, he had attracted attention and praise for his ability to execute incredibly lifelike drawings, much to

the pride of his parents. Like any other draughtsman of his day, Daguerre was already more than familiar with the uses of the camera obscura, but in the years to come he would be inspired to use it in a new and dramatically different, theatrical way.

Chapter Four

AN INHERITANCE

If Louis Daguerre, a man of humble parentage, limited education and with an obscure early history was the child of the new and thrusting post-revolutionary France, William Henry Fox Talbot was his absolute antithesis. Born into the English landed gentry in 1800 he could trace his distinguished ancestry back to the time of Richard I and King John. Unlike the brash and adventurous young Daguerre, Talbot basked in the privilege of a first-class public-school and Cambridge education with no pressure to go out and earn his own living. In the rarefied, gentleman's world that he inhabited, the boundaries of knowledge and scientific innovation were advanced not by the cut and thrust of the commercial world, but by the dedicated elite of, in the main, privileged intellectuals, who like the Lunar Men before them looked upon their researches as sufficient for science's sake. But position and privilege also brought their own particular problems: unlike Louis Daguerre, Henry Talbot had never known his father and the landowning world he was born into was one that had saddled him, from the very first, with crippling debts.

Behind great men there is often a great woman, and in the case of Henry Talbot it is undoubtedly his clever and imposing mother who looms large and vociferously in his early life and whose drive and ambition to see her son make the best of

himself set the stamp on his early career. A daughter of the 2nd Earl of Ilchester, Elisabeth Theresa Fox Strangways had from a young age been noted for her intelligence, beauty and sparkling wit, as well as a headstrong disposition and a notorious fickleness that occasionally got her into trouble. 'My Dear little volatile friend,' a relative once wrote to her, 'How much I wish you were not like a pretty little feather floating in every wind, that with your excess of spirits there was a solidity in your affections that those who love you might never feel disappointed.'[1] Lady Elisabeth's erratic, mercurial personality and her indiscreet and often outrageous comments set tongues wagging wherever she went. They also drew an array of admirers; when she came of age her father's title and a respectable, though not generous, dowry of £3,500 had attracted a string of hopeful husbands. But she had rejected them all in favour of a handsome soldier whom she had met during a visit to her married sister Lady Mary Lucy Talbot at Penrice, near Swansea, in 1795.

William Davenport Talbot was a cousin of Mary's husband Thomas and owner of Lacock Abbey in Wiltshire; on the surface he seemed to have it all: property, good looks and a cultivated manner. He had inherited Lacock from his childless uncle John Talbot in 1778 but had never taken possession of it. The abbey was a place steeped in history dating back to the thirteenth century. Its founder, Ela, Countess of Salisbury's husband had gone on Crusade to the Holy Land and her son had died fighting there. In 1232 the widowed Ela took the veil with her two nieces and retreated to Lacock, where she founded an Augustinian nunnery; when she died she was buried beneath the altar and her body was later moved to the cloisters when the church was demolished. In 1574 Queen Elizabeth I had slept at the abbey on a visit to Wiltshire and in 1645, when it was a royalist stronghold, it had been captured by the Round-

heads. The buildings had been altered or added to during the Tudor period and later in eighteenth-century Gothick style. Lacock Abbey was, on the surface, a beautiful place to behold, but one shackled by long-standing mortgage debts, as well as bequests entailed on it by the wills of John Talbot and his father before him.

In 1783, after a year at Oxford, William had therefore opted to join the army; by 1795 he had risen to the rank of Captain, having served in Holland, Gibraltar and Canada. Sadly he was forced to resign his commission that year, due to chronic ill health. He went to Penrice to recuperate at his cousin's house, where he met the twenty-two-year-old Lady Elisabeth, who obligingly took on the role of nurse and amusing companion to the handsome young soldier. By the end of the year, entranced by Elisabeth's 'pretty little figure and her bewitching smile', William had proposed marriage and was pressing his suit with great ardour.[2] Elisabeth's family at first was decidedly opposed to the match, for her suitor was nine years older than she, had no title, and although he had inherited a property he had no fortune to speak of. Elisabeth was no stranger to romantic attachments, having enjoyed a string of admirers; she now set her sights on William Davenport Talbot and insisted on having her way. Although she had grown used to an extravagant lifestyle and would find it hard to adjust to any reduction in her living standards, the previous year had brought changes to her life that may well have influenced her desire to marry and leave home. Her widowed father had remarried, to a woman only two years older than Elisabeth herself, bringing a shift in her status in the family and the curtailment of her influence over a father who till then had indulged her every whim.

While Captain William Davenport Talbot might, on the surface, have seemed a romantic prospect to the capricious

young Elisabeth, there were in fact long shadows lurking in his pedigree. By rights Lacock Abbey should not have been his at all, but should have gone to one of his two older brothers, but they had both been disinherited, it is said due to some un-specified mental disability that they shared. William himself was already gaining a reputation for unstable, headstrong behaviour as well as a habit for profligacy with money. By 1790 he had added another £2,600 to the estate's already stagger-ing debts. The Fox Strangways remained unhappy about the match; Elisabeth's aunt Susan – who herself had made a reckless marriage after running off with an Irish actor – begged her niece to reconsider and to think of her future. Elisabeth was not to be swayed and on 17 April 1796 she and William were married in London. Their first few months together appear to have been happy but soon her husband's frequent bouts of illness – it is unclear whether they were mental as well as physical – began to put a strain on the marriage. Elisabeth was impatient with her husband, putting William's ill health down to hypochondria: 'he fancies that he has had so many violent illnesses that he may at any time succombé [sic] to a slight one,' she wrote rather callously to her sister Harriet in 1798.[3] In 1800 her growing exasperation was tempered, how-ever, by the consolation of a child – their son, William Henry Fox Talbot, having been born on 11 February at Melbury, his maternal grandfather's home. But the couple's joy was tragi-cally short lived; William Davenport Talbot suffered a relapse soon after in London and was once again confined to his sickbed. He died on 31 July, leaving the twenty-six-year-old Elisabeth a widow and his five-month-old son without a father. Worse, he died alone, for Elisabeth, typically, had not taken her husband's relapse as seriously as she should have done and had left London earlier in the month for Penrice, taking the infant Henry with her.

This perception of the shallow and heartless Elisabeth leaving her husband on his deathbed for a visit to Wales was one that coloured many people's later opinions of her. Her lack of regard for others, including William's family, extended even to his funeral; when the cortège left London for Lacock a week later Elisabeth remained behind in Wales, supposedly prostrate and indisposed, whether through illness, grief or shame is not known. The cause of death was never specified although rumour abounded. The spectre of mental illness was raised when the doctors who had attended William Davenport Talbot during his final illness 'proposed opening the head' in order to examine his brain, asserting that 'the family had been affected with epileptic fits'.[4] This, they added, 'ought to be done for the sake of the child he had left'. Lacking any proper understanding of the condition, early nineteenth-century society looked upon epilepsy as a form of inherited family madness. Such an admission would be a crushing social stigma for a family of the Talbots' standing; it would explain the disinheritance of William Davenport's two older brothers and the fears about his own erratic health.

Quite apart from the society gossip generated by William's death and Elisabeth's inexplicable response to it, she and her infant son Henry were left in a very difficult position by this sudden death. They had no home of their own, as Lacock Abbey had been let to try to ease some of the debt, and Elisabeth and Henry were forced to live on the charity of friends and relatives, moving from one house to another in Dorset and South Wales. In addition, the infant Henry had now inherited the Lacock estate along with all its massive debts. Desperate to reclaim something of her lost social position and undo the shame of her absence at her husband's funeral, Elisabeth returned to the social scene in London somewhat sooner than was deemed appropriate, or for that matter

respectable, for a widow, leaving Henry behind with her sister Mary and her brood at Penrice, often for lengthy periods of time. This exercise in damage limitation was probably with a view to protecting the future of her son, for slowly Elisabeth was able to redress the damage to her reputation and eventually would meet the man who would become her second husband. Meanwhile, young Henry remained in the care of a loving extended family full of children who treated him like a brother. The quiet country life at Penrice on Wales's beautiful Gower Peninsula was the beginning too of his lifelong love of botany, thanks to the passion for amateur 'botanizing' – then all the rage in England – of his aunt Mary.

In early April 1804 Henry and his mother were joined at Penrice by the new man in Elisabeth's life, another captain – Charles Feilding – only this time a naval one. Although Feilding had been in service during the period of the great sea battles of the Napoleonic Wars, such as Trafalgar in 1805, he had witnessed none of them as he had been attached to coastal duties and had spent time out in the West Indies. He and Lady Elisabeth were married on 22 April 1804 and promptly left for an extended honeymoon, leaving Henry behind again in Wales. Upon their return he joined his mother and stepfather, living with them in a succession of houses in London and on the south coast. Even though Charles Feilding remained on active duty until 1809 he managed, during periods of leave, to make a start on sorting out the chaos of the Lacock estate and putting its financial affairs in order for his stepson. He proved to be a man of exemplary character, attentive in the care of his wife and warm in the affection he showed young Henry. He oversaw the running of Lacock in tandem with the highly capable Lady Elisabeth, who had been appointed Henry's legal guardian. Nobody doubted her abilities as a mother to care for her son, but under the laws of inheritance and primogeniture,

she had to be appointed Henry's guardian during his minority in order to protect his future inheritance. Feilding had lost his own father at the age of three, the age Henry was when they had first met, and the bond that developed between them was one that not only enriched Feilding's life but also helped to form the kind and gentle man that Henry was to become. Before long, Charles had so totally supplanted the dead husband and father that William Davenport Talbot becomes a mere cipher in the story.

Now happy in a stable marriage, in the four years that followed Lady Elisabeth finally turned her full attention to her son, becoming his main tutor and endowing him with her own considerable intellectual and linguistic gifts. She introduced him to languages – Greek, Latin and French – sharing with him a passionate love of the Classics, and instructed him in basic arithmetic too. As Henry's skills with language improved so he and his mother created games for learning new verbs and vocabulary. Speaking French became so natural to them that throughout his life Henry often wrote letters to his mother in French and they frequently spoke it at home. By nature reclusive and bookish, he had a natural aptitude for learning and took to it with all the enthusiasm of the classic schoolboy swot. From the age of five Henry maintained a detailed diary, almost certainly at the encouragement of his mother, in which he recorded his ambitious range of study, such as this in October 1806:

> Wrote two tenses of the word *avoir* & six Latin & French words. Did a sum in compound subtraction & another in compound multiplication & *proved* them. Read 2 chapters of the Roman History. Looked up the map of Ancient Italy for Latium and Hetruria. Counted in French up to 100. Wrote four lines in the Writing Book. Translated part of the French Fable about le garçon & le Papillon.[5]

Henry Talbot's diary is a fascinating record of a restless, inquisitive mind, constantly on the lookout for the new and unexplored, and characterized at all times by his ingrained mathematical precision. The wider world interested him not one jot: he disliked Lacock Abbey when he first visited it, and Windsor Castle too, and thought little of an encounter he had there with King George III and his daughters. The world of study was the only one that interested him, and as Henry's erudition grew, so his mother's periods away from him decreased. The flighty Elisabeth who had once preferred fashionable society to her own family, was now becoming a settled *grande dame*, and a loving wife and mother. But as her son grew and his intelligence demanded ever-greater academic scope it was clear that he could not remain at home with his doting mother as his sole tutor. Young Henry Talbot must be sent away to school to complete his education.

Chapter Five

THE PANORAMA

In 1800, the year of Henry Talbot's birth, the thirteen-year-old Louis Daguerre was already contemplating employment. A highly accomplished portrait that he had drawn of his mother and father helped secure him an apprenticeship with a local architect in Orléans. Taking the long view, Daguerre's father probably thought it better to get his son into a good profession than attempt to prolong his already interrupted school education. Architecture would have seemed a safe occupation for his artistically talented son and so he committed him to three years' study of draughtsmanship to a very high standard. The daily task of creating measured drawings, to scale and in perspective, could have been a drudge to many young men, but for someone like Louis Daguerre – instinctively devoted to accuracy and detail in all things – the architectural discipline he learned only increased his desire to conjure up the world around him as accurately as possible. Hours of constant, scrupulous practice under the watchful eye of his master were something that had a direct impact on Daguerre's later artistic career, establishing a discipline of dogged craftsmanship and experimentation that would lead to his greatest achievement.

Indeed, Daguerre's dedication had already paid off by the age of sixteen; in 1804, after three years of demanding technical training, he was ready to spread his wings both artistically and

socially. The bigger, more attractive world of art beckoned. He was eager to leave the family home to study painting and stake his claim to fame and fortune in the artistic capital, not just of France, but also of the world – Paris. His parents, not surprisingly, were alarmed at the idea of their only son leaving home so young. They feared that he would fall into the legendary bad habits and lax morals of the bohemian artists who haunted the artistic colonies there. The life of an artist was notoriously uncertain and they worried that it would not provide a reliable source of income, particularly at a time when France was once more in the grip of political upheaval.

The year 1804 was certainly a dramatic one, for Paris in particular, as it was the year that Napoleon Bonaparte wrested the French throne back from the fractured Republican movement, re-establishing a hereditary monarchy with himself as emperor. Order was at last returning to the French capital under Napoleon's firm hand, although beyond that, his military ambitions were already sowing the seeds of conflict to come: Britain, Russia and their allies were even now embarking on a decade of military confrontation with Napoleonic France. Despite his parents' fears and the still fresh memory of the chaos of the preceding decade, Daguerre would not be dissuaded from going to the capital and his persistence paid off. Eventually a compromise was reached, with his father once more securing him an apprenticeship, this time to Ignace Eugène Marie Degotti, a celebrated Italian stage designer and scene painter who had just been appointed Chief Painter at the acclaimed Paris Opéra. This venerable Paris institution was founded in 1669 by Louis XIV and, having suffered during the dislocations of the Revolution, the Opéra was now enjoying a resurgence at the artistic heart of Paris under the new name given it by Napoleon of the Académie Impériale de Musique.

The Paris of the early 1800s that greeted the teenage Louis

Daguerre was considerably different from the Paris of today. The now familiar city of wide, tree-lined boulevards, beautiful parks, fine museums and grand architectural ensembles would not develop until Baron Haussmann's radical reconstruction of the capital in the 1860s during the reign of Napoleon III. Till then, Paris remained an overcrowded, huddled medieval city of dirty narrow streets – many of them unpaved – crammed with dilapidated wooden houses with overhanging gables that were a breeding ground for disease and where fire could spread rapidly. One of the provisions of this three-year apprenticeship, insisted on by his parents, was that Daguerre should live in the home of his master. They hoped that such familial surroundings would offer him stability and security and keep him out of trouble. But although Daguerre avoided revolutionary politics he did not remain resistant to the bohemian habits of his fellow artists. He became a familiar face in the popular garden cafés of bohemian Montmartre where singing and dancing were part of the everyday cultural life of the city enjoyed by artists. He was extremely fond of dancing and even danced as an extra in some of the productions at the Paris Opéra, enjoying the diversion from his work and possibly developing a taste for the applause as well. The young Daguerre was light-hearted and a natural exhibitionist who cut quite a figure. Lithe and athletic, he was known for entering parties walking on his hands; he could walk a tightrope nearly as well as most professional acrobats of the time, something he possibly picked up in his youth in Orléans by watching and then imitating the itinerant acrobats he saw as street entertainers. None of this exhibitionism of course was guaranteed to earn him a living but it did bring a degree of social success if not notoriety. Daguerre's rising popularity, confirmed by the acclaim of his friends and acquaintances, laid the foundations for the confident master showman who would later run his own business. Louis

Daguerre was made for Paris and Paris for him; his voracious appetite for artistic innovation and novel forms of entertainment at last had found the outlet it had been waiting for.

By now Etienne-Gaspard Robertson's phantasmagoria had ended its successful run in the city (although other sensationalist shows supplanted it), with the enterprising Robertson taking his show on tour abroad before moving into his second great passion – ballooning. He had in any case effectively borrowed the idea from the German magician Paul de Philipsthal, whose own Phantasmagoria show, dubbed the 'Grand Cabinet of Optical and Magnetic Effects', was now all the rage at the Lyceum on the Strand in London.[1] The success of the phantasmagoria as a form of popular entertainment was in no small part due to the clever use of optics and very soon others were cashing in on the popularity of this genre, devising even more ambitious ways of entertaining audiences with audio-visual illusions of reality. Louis Daguerre was one of them: in 1806 he turned his attention to the grand-scale successor to the phantasmagoria. He may have still been young and inexperienced, but he was highly ambitious; at the age of only nineteen he decided the time had come to move on in his career. Leaving Degotti's studio, he took a job as assistant to Pierre Prévost, a painter renowned for his panoramas – the newest must-see form of entertainment in Paris. The invention, however, was not French but English, the word having been coined by the painter Robert Barker, when he had first exhibited a panorama of Edinburgh painted on a cylindrical surface at a venue in Leicester Square, London in 1793.

Panoramas were enormous paintings, each taking hundreds of hours to paint – the largest then known being 360 feet in length and 52 feet high – and were mounted on the wall of a circular room with a raised viewing platform in the middle. The objective was to present a new – and, years ahead of its

time, 'cinematic' – experience of art and landscape; indeed one might call the panorama shows the nineteenth-century precursors of the wide-screen epic of today's IMAX cinemas. Light was allowed in from skylights above, and directed onto the paintings, creating an illusion of reality that astounded nineteenth-century Parisians. Effectively, what was being offered was a form of theatre in the round, but with the audience instead of the actors in the middle. The sheer scale of these paintings, with their depictions of great cities such as Rome or Jerusalem, was breathtaking; those of later historic battles during the Napoleonic Wars capitalized on rising nationalistic sentiment in Paris. The panorama offered visitors the chance to see parts of the world they could never hope to visit, as one travel writer observed in 1816:

> In less than an hour, by means of a score of pictures which pass before your eyes, you traverse the four quarters of the globe in the most economical and least fatiguing way; and almost with as much advantage as three fourths and a half of the travellers who take the trouble of visiting these places themselves.[2]

In all, Prévost and his assistants completed at least eleven large-scale panoramas: six were city views, four were battle scenes and one was a view of Paris from the Tuileries. Their detailed realism was of supreme importance and visitors often lost all sense of being indoors, so fully were they taken in by the illusion. During a visit to one of Prévost's panoramas, the famous painter Jacques-Louis David was overheard to remark to his students 'Really, one has to come here to study nature!'[3]

The panorama's new form of visual display was a far more liberating experience of art than a visit to a staid, conventional art gallery; and such was the enormous success of the first panorama that others rapidly sprang up all over Paris, with

those painted by Prévost and his assistants considered by most to be among the best. With his move into panorama painting, as with architectural drawing before it, it was as though fate was taking a hand, directing Daguerre's natural talent towards the replication of reality – and the ultimate goal of photography – for his work had been praised time and again during his years with Degotti. Settling into his first professional post after six years of apprenticeships must have been a challenge for him, but he was by instinct a hard worker constantly looking to capitalize on opportunities and improve his talents. And he now had even more reason to do so: just a week before his twenty-third birthday in 1810 he married Louise Georgina Arrowsmith, a twenty-year-old woman born in France of English parentage.* The couple were married in the Protestant Reformed Church of Paris, something the Catholic Daguerre must have acceded to at the request of his new in-laws. Daguerre's marriage to Louise was a love match; though sadly they were never able to have a child of their own, they did unofficially adopt Marguérite-Félicité, the illegitimate daughter of Louise's brother Charles (who, two decades later, worked as an assistant to Daguerre at the Diorama) and brought her up as their own, in the end making her heir to their fortune.

With the responsibility of a wife, Daguerre settled down under Prévost for nine years, working hard and learning the

* There is some confusion as to the maiden name of Daguerre's wife; sometimes she and her family are referred to as Smith and at other times Arrowsmith, as appears on Louise's gravestone. Explanations for this change of name have been attributed to the inability of the French to embrace complicated foreign names, or to Louise's brother John, who lived in London, adopting the name after inheriting a business from his uncle who used the name Arrowsmith. Neither is a fully believable explanation for this but we do know that her brothers, John in London and Charles in Paris, both used Arrowsmith later in life after beginning as plain Smith.

craft of creating paintings on a massive scale that drew the observer into a clever illusion of reality. He became a noted master at exploiting the awe and admiration that the magic of this type of painted realism created in an audience and turned out more than twenty major panorama paintings during that time.

Towards the end of his time with Prévost, dramatic political change had once more engulfed France, which since 1803 had been engaged in the Napoleonic Wars. In 1814 the Russians, Prussians and Austrians laid siege to Paris and after the French capitulated, Napoleon was forced to abdicate and moved to the island of Elba. The following year he left Elba and raised an army but a little more than a hundred days later he was once more defeated and sent into exile on St Helena. With the restoration of the Bourbon monarchy in France under Louis XVIII, the political situation in Paris calmed and Daguerre once more decided to strike out on his own as an artist. Recognition of his skills as a painter mattered greatly to him; he had for several years been exhibiting some of his canvases annually at the Paris Salon, and in 1814, King Louis had purchased his *Interior of a Chapel at the Church of the Feuillants, Paris*. But for now it was his panorama work that earned him a living.

The valuable skills Daguerre had learned during his years with Degotti and Prévost enabled him, in August 1816, to take a position as chief painter at the Théâtre de l'Ambigu-Comique on the Boulevard du Temple in the 3rd *arrondissement*. Founded as a marionette theatre in 1769, the Ambigu was one of Paris's popular second-string theatres, specializing in the cheaper, more downmarket attractions of melodrama, vaudeville and pantomime. In order to pull in the public, the repertoire relied as much on spectacular scenery and stage effects as it did on the acting. Before Daguerre's arrival much of what had passed

for atmosphere on stage had been literally painted onto a conventional backdrop; any lighting effects used were crude and far from convincing. If an actor proclaimed that night was falling, the stagehands simply extinguished the lights all in one go. But Daguerre changed all that. In addition to the subtle and beautifully detailed backdrops that he painted, he was the first to introduce a style of imaginative lighting effects that had never before been seen on the stage. Now, when a character talked of night falling, Daguerre ensured that there would be a gradual and subtle diminishing of the light. His moonlight scenes in *Le Songe* (a ballet based on Shakespeare's *Midsummer Night's Dream*) and in Charles Nodier's supernatural melodrama *Le Vampire* were breathtaking in their realism. But perhaps Daguerre's most talked-about master stroke was his design for the eruption of Mount Etna in *Le Belvédère*, based on another of Nodier's plays and one by Schiller – which became one of the theatre's biggest commercial successes. This and his other flamboyant stage effects caused problems, however, for Daguerre: his fellow professionals resented the fact that his spectacular effects garnered the lion's share of press attention. A review of *Le Songe* waxed lyrical about one moonlight scene: 'One could not leave off applauding it . . . The success obtained is due solely to M. Daguerre, the designer, and it is he alone who should have been credited [for the success of the play].'[4] In popular melodramas, where the quality of the writing counted for little, the atmosphere created through backdrop, lighting and other stage effects was of paramount importance in pulling in the punters and Daguerre excelled at this, so much so that during the remaining two of the six years he worked at the Ambigu, he also began creating designs for the Paris Opéra.

Capitalizing on his considerable success at theatrical decoration and his developing reputation not just as a gifted painter

of stage 'effects' and a master of theatrical mechanics, Daguerre was inexorably moving in the direction of science and invention. By the beginning of the 1820s, having pushed his skills with the panorama as far as he could, he was ready for new challenges in the ways in which he worked with light and colour. Perfectionist that he was, Daguerre was now intent on furthering a long-standing personal search – for a way of capturing an image that was even more naturalistic than the panorama.

Chapter Six

AN INNATE LOVE OF KNOWLEDGE

In 1808, when he was eight years old, a place was found for Henry Talbot at Rottingdean, a boarding school near Brighton. Lady Elisabeth worried that Henry might be homesick, although she suffered by his absence as much as if not more than he. Henry certainly missed his mother deeply at first, complaining that 'I have all the Comforts I can possibly have but nothing can reconcile me to your loss . . . when I come home for the holidays instead of seeing me fat & rosy . . . you will most likely see me thin & pale worn out with sorrow.'[1] His homesickness was, however, short lived and he soon became totally engrossed in his studies.

Rottingdean was influential for a small school. It was run by the local vicar, the Reverend Thomas Hooker, and had among its pupils a nephew of the Duke of Wellington and a son of Jerome Bonaparte (brother of Napoleon). It offered a typical Classical education as well as the basics of mathematics and literature, with its daily curriculum based around the traditional disciplines of learning Latin and Greek declensions by rote and translating poetry and prose into and out of these languages. Geometry rapidly became for young Henry a thing of beauty, its study eagerly anticipated. 'Got up early to be ready for Mr Waulthier,' he told his mother in one letter.[2] 'He taught me to define circles & triangles & Parallel lines & angles

& tangents and radii, besides hypotenuses, sectors and scants.'* At an age when most boys relished being out on the rugby or cricket pitch, and despite making the occasional, indifferent foray there, Henry took far greater pleasure in cerebral work with pencils and graph paper. His aunt Mary had already schooled him in the Latin tags of botany on his visits to Wales and his gifted mother had encouraged his study of Classics so that young Henry had no difficulties with such a disciplined approach to learning. Indeed, so scrupulous and systematic was he in all things that at the age of only eight he wrote to his stepfather 'tell Mamma & every body I write to to keep my letters & not burn them'.[3] It was a precocious request but one that ensured that historians today have a peerless archive of more than 10,000 letters written by and to Henry Talbot, along with more than 300 notebooks and other papers covering seventy years from which to draw on. The contrast with perhaps no more than 100 surviving letters written by Louis Daguerre scattered amongst many archives, and no known notebooks, is a stark one. Whereas the story of Daguerre's life and his experiments with photography is full of apocryphal stories and sparsely populated with verifiable facts, Talbot's life reads like a scrupulous daybook, cataloguing every step he took along the way.

At the age of twelve, having completed his studies at Rottingdean, Henry was enrolled at Harrow, one of England's oldest and most prestigious public schools, founded by royal charter in 1572. A parting gift from the Rev. Hooker at Rottingdean was a glowing testimonial, thanking Henry for being a model student and offering a fulsome assessment of his future prospects:

* 'Scants' meaning secants: a geometry term referring to a straight line that cuts a curve in two or more parts.

You seem to me to set out in the World under the very fairest auspices. Most excellent & (what is not always the case) most clever Parents, brilliant & solid Talents, & a degree of improvement, if these do not hereafter, work out something different from the common run of men, I shall be most grievously deceived, & disappointed.[4]

The years at Harrow that followed were the stuff of every ambitious parent's dreams. Henry excelled at all things academic, particularly Classics, and from the outset enjoyed the added advantage of being placed in the House of the headmaster, Dr George Butler, a scholar of some distinction, who was highly respected by the parents and well liked by the boys in his care. Henry's interest in science continued to expand, and it is here that he had his first youthful encounter with chemical experimentation. He spent his pocket money on chemicals and a few crude pieces of apparatus and began carrying out some very basic experiments. Once, when he was tinkering with nitre, sulphur and potash, things went alarmingly awry, his mixture exploding 'with the noise of a pistol and attack[ing] the olfactory nerves of the whole Household', as his mother later humorously explained to her sister.[5] She feared her son was making 'dangerous' experiments.[6] Worse still was the fire hazard they created, with Dr Butler informing Lady Elisabeth that because of her son's taste for chemistry 'the Sun Fire Office would not ensure his house for a single day'.[7] Henry was therefore advised to stick to the theoretical and banned from conducting any more experiments at school. But this did not deter his scientific curiosity; the enterprising Henry soon managed to find an obliging blacksmith in town 'who lets him explode as much as he pleases' in his smithy, as the quietly proud Lady Elisabeth was pleased to note, and without the least flicker of alarm.

During this period, Henry also began to take a much more serious interest in botany, moving beyond the purely amateur pursuit that he had enjoyed with his aunt Mary and cousins at Penrice. With the help of a fellow boarder at Harrow, Walter Calverley Trevelyan (himself to become a noted Victorian naturalist and geologist), he began the systematic cataloguing of the flora he had collected in and around the Harrow area. The end result, 'Plants indigenous to Harrow: Flora Haroviensis, compiled by Fox Talbot and Walter Calverley Trevelyan', was written during 1814–15, but remained unpublished. The sole copy, a systematic and searching enquiry into the subject accompanied by descriptions of their findings, can still be found in the library at Harrow School and is the first concrete evidence of his then embryonic approach to science. How typical of the scrupulous Henry Talbot, and how unlike the mercurial Louis Daguerre, who made few if any notes during his own long years of experimentation and appeared never to have taken much care of those that he did keep.

During his years at Rottingdean and Harrow, Henry continued to spend most of the school holidays at Penrice, which had retained a special place in his heart. Leaving it at the end of the holidays to return to Harrow, he once observed, was like 'leaving the Garden of Eden'.[8] By the age of fifteen his academic achievements were already considerable and he returned home from Harrow after spending more than a year in the sixth form, during which he had won numerous academic awards and was at the top of his class. There was a tradition at Harrow that any boy achieving such high levels of academic excellence in the sixth form should be made head boy, but it is said that the Rev. Butler resisted the imposition of this protocol in Henry's case, thinking the duties would place too heavy a burden on a boy of only fifteen. Instead, he recommended that he be taken out of school at the end of that term.

After a long summer holiday spent mostly at Penrice, Henry spent a few months with a tutor in Yorkshire, but found the instruction lacking after his time at Harrow and didn't enjoy the company of the boys there. Soon after, his stepfather decided the time had come to introduce Henry to the artistic and intellectual rite of passage enjoyed by few but the privileged – a visit to the Continent. Although the English gentry had never lost their love of travel and the Grand Tour – popularized from the mid-seventeenth century – was still a desirable goal for all young men of title of a certain age, the French Revolution closely followed by the Napoleonic Wars had curtailed European travel for all but the most intrepid Englishmen during the first years of the century. Napoleon's final capitulation and imprisonment meant that by 1816 the Continent was once more open to the English travelling gentleman.

This first tour Henry made with Captain Feilding wasn't extensive, focusing as it did mostly on Paris, but it would be one of many journeys that he would make in the coming years. From the Continent, he regaled his mother with stories of all the many fascinating things he saw, the most celebrated spectacle of all being that in Paris, when, in a crowd of 8,000 people, he saw the world's first lady parachutist, Mademoiselle Garnerin, make a balloon ascent from the Champs de Mars and then jump from the basket at a height of 2,500 feet and float back down to earth using a parachute. Paris, which had led the way in aeronautics in the previous century, was once more at the centre of the fashionable craze for ballooning.

A special excursion in which Talbot took particular pleasure was a visit to Waterloo, less than a year after the great battle. In the detailed journal he kept of his trip, as he would on so many others, Henry's scrupulous eye and his wry descriptions of people, places and events are memorably por-

trayed, such as this observation on the trade in war memorabilia: 'The musket balls which were lodged in the trees in the greatest abundance have been all carefully cut out for sale . . . valuable relics of the fray are now become scarce. Fresh arrivals of bullets and buttons from London [are] to be sold on the field, warranted genuine.'[9] War tourism in Europe was clearly big business.

Back home in England Henry now had the joy of siblings: his half-sisters Caroline and Horatia – born in 1808 and 1810 – were of an age where they could write him letters and made his visits home even more enjoyable, as they loved to dote on their older brother and he in turn enjoyed spending time with them. But studies once more beckoned and Henry soon went off to Rutland to continue his education with the Reverend Thomas Kaye Bonney. He became very fond of Bonney and enjoyed their shared interest in mathematics and astronomy, staying with him until September of that year, when the question of his further education was to be decided.

Although both his father and his stepfather had been military men, it had been clear from that start that, because of his intellectual gifts, Henry would pursue a very different line and go up to university. Throughout his school years, his mother had attempted to read up on the scientific subjects her son was most interested in, but her heart remained with the Classics and modern languages which she was now working through with her daughters and which she hoped would be Henry's choice at university. But Henry's mind was now focused on the challenges of mathematics, one of the great subjects of the day and the basis of most of the science that he loved. Lady Elisabeth wittily chided her son at the inconvenience of his choice, in words nevertheless full of love: 'You seem so mathematically inclined that I ought *en bonne mère* [like a good mother] to send you to Oxford to counteract it that

you may not grow into a Rhomboidal shape, walk elliptically, or go off in a tangent, all which evils are imminent if you go to Cambridge.'[10]

Loving and caring though his mother was, Henry knew where he wanted his future studies to take him and it was off to Trinity College, Cambridge that he went, thanks to the excellent grounding he had received at Rottingdean and Harrow. He thrived at Cambridge and loved the studies to which he had devoted himself, though he maintained his interest in the Classics so dear to his mother's heart, in 1820 winning the coveted Porson Prize for translating a section of Shakespeare's *Macbeth* into Greek verse. Lady Elisabeth and his stepfather responded with pride and continued to push him to do his very best and hopefully win some of the prizes that students worked so hard for. The title of Senior Wrangler was one that all undergraduates in mathematics aspired to, awarded to the student who did the best at his mathematics examinations in his final year over a range of papers from Euclidian geometry, through algebra and trigonometry to optics and astronomy. Optics in particular would play an important role in much of Henry's later work. He had been taking a quiet but secondary interest in it during much of his scientific work since childhood, when he had first begun working with magnifying glasses and rudimentary microscopes.

When Henry failed to win the coveted title of Senior Wrangler, coming twelfth, his parents' disappointment was considerable, particularly that of his mother, who in many ways indulged her own academic interests vicariously through her son at a time when the world of study was closed to women. Henry had, nevertheless, achieved a first-class degree, only without the status and prestige the title would have brought. He was deflated but phlegmatic, and quickly moved on. Henry had found solace, he told his parents, in astronomy;

besides, there was something to be said for maintaining an interest in several things at once. He was already a gifted polymath, as one observer at Cambridge had already noted: 'He has an innate love of knowledge, and rushes towards it as an otter does to a pond.'[11] Henry Talbot, he predicted, 'bids fair to be a distinguished man'.

Chapter Seven

MORE BEAUTIFUL THAN NATURE[1]

In April 1821, while still working at the Ambigu and the Opéra, but ambitious to push the boundaries in his artistic work, Louis Daguerre had entered into an exciting new business venture with an old colleague, Charles Marie Bouton. Bouton was another of the panorama painters at Pierre Prévost's studio with a skill for perspective and the use of light, and the two men decided to pool their talents in the creation of a new and highly commercial visual spectacle. Their own experience of painting on the grand scale for the panorama was now combined with Daguerre's experience with innovative lighting effects for the theatre. At the end of that month they found a site for their new venture in the rue de Samson (now the rue de la Douane), and took out a lease on the land. Having created their own limited stock company, they secured funding from a group of investors, who snapped up 200 shares at 1,000 francs each. On 11 July the two men pulled off a new theatrical sensation when they opened the first Paris Diorama.

The critic of the *Paris Monthly Review* was one of the earliest to describe the remarkable veracity of the two canvases on display; in his view there was no comparison with the panorama. The difference was 'immense':

> Anyone who views the interior of Canterbury Cathedral
> from the gallery of the Diorama, can with difficulty

persuade himself that he is not looking up its almost interminable aisle, from the actual organ loft. And again, when the scene is changed, and we gaze upon the valley of Sarnen, we are electrified by a representation so miraculous in execution – we mark so plainly before us the mountains, lake, and buildings, which some of us have seen before, while leaning from our rustic balconies, – that the mind loses itself in a vision of wonder and delight.[2]

The area in which the Diorama was located might have been a little shabby and downmarket but the two partners had big ambitions; it was their intention to offer spectators 'the complete means of illusion through animating the pictures by the diverse movements of nature, such as the agitations of water, the passage of clouds and stars, the effects of the sun, moon, rain, snow, etc.', in so doing 'to expand the bounds of painting by procuring for France the merit of an invention as agreeable as it is useful to the progress of the arts'.[3] Such was the spectacular success of the venture – recouping its investment inside twelve months – that the two men quickly set up a second Diorama – across the Channel in a specially built, spacious triangular auditorium at the end of Portland Place in London, near the entrance to Regent's Park. They had no difficulty in finding British investors to cover the then substantial building costs of £12,000 (around £500,000 today) of the London venture; the £40 shares sold like hot cakes and were soon being offered for resale at £100 each.

On Monday 29 September 1823 the London Diorama opened, acclaimed by the *Morning Post* as 'the very *beau idéal* of pictorial illusion', and offering visitors the same two views premiered in Paris: an interior of Trinity Chapel at Canterbury Cathedral painted by Bouton and a landscape of the 'Valley of Sarnen' in Switzerland by Daguerre.[4] But it wasn't

cheap – a box cost three shillings and even to sit in the main amphitheatre was two shillings. The audience gasped at the illusion created by both paintings, in particular the fountain at Sarnen, 'from which a copious flow of water runs bubbling . . . giving all the appearance of a living stream'.[5] Soon all the English papers were telling their readers that the Diorama was a must-see: and it wasn't just hoi polloi who beat a path to its door: British royalty, high society and 'other persons of distinction' were soon flocking there too.[6] The Dean of Canterbury came specially to view the Diorama of his cathedral and 'could scarcely believe, at the sight of the Cathedral, that he was not in his own Chapel'.[7]

In the ten years that followed, dioramas, like the panoramas before them, were established in a number of cities across Europe and the United States, notably the one opened near City Hall in New York, but it was the London and Paris venues that exclusively showcased the work of their inventors Bouton and Daguerre, bringing them not just public acclaim but national honours too. In France Louis XVIII made both Daguerre and Bouton Knights of the *Légion d'Honneur*. The Paris Diorama they created, along with those of their imitators, are long since gone, with the exception of the one in London which is now the headquarters of the Prince's Trust and still proclaims its original purpose in bold black lettering – 'Diorama', in the stone pediment on the roof.

The Diorama was a vast improvement on the panoramas that Daguerre and Bouton had worked on with Pierre Prévost. Instead of a single enormous painting mounted in a rotunda and lit with unchanging lights, the resplendent new Diorama contained similarly large paintings, 72 x 46 feet in size, executed on thin translucent fabric that was painted on both sides. But instead of creating a circular painting with the audience of up to 350 people taking their place in the middle, these paintings

were executed on a flat base that was presented to the seated audience through a proscenium arch, much more like a theatrical event, or so some described it, as though the audience were looking through a magical window onto the world. The lighting was the key to the effect created, in scenes ranging from fishing vessels in the harbour at Brest, to Holyrood Chapel in Edinburgh, to the snowy peaks of Mont St Godard. Designed by Daguerre, instead of being static like the panoramas, the Diorama came alive. Light was directed onto it from various windows and skylights above that could be opened or shuttered mechanically to varying degrees. These shutters were slowly operated during the performance so that at first the light fell on the front surface of the painting revealing a daylight scene, but as the light slowly shifted to the rear of the painting, it would appear that day had become evening. The illusion was so extraordinary, so captivating that many people refused to believe that what they were seeing was a two-dimensional surface rather than some magically conjured-up three-dimensional space. Describing some of the important inventions of the day, the English physicist and inventor Frederick Bakewell confirmed the 'perfect illusion of the Diorama' in his 1859 book *Great Facts*, in which he recalled that 'a lady who on one occasion accompanied the author to the exhibition was so fully convinced that the church represented was real, that she asked to be conducted down the steps to walk in the building'.[8]

Unlike the old panorama exhibit, which was a single painting replaced infrequently, the Diorama show comprised more than one scene. After the audience had absorbed the first scene for about fifteen minutes, the seating area began to rotate, with the first view disappearing off to one side while a second scene came into view. Sometimes sound effects – waterfalls, thunder and lightning, church bells – were added to

the scenes to create an even greater sense of realism. The enormous success accorded to Daguerre in the press and to a lesser extent his partner Bouton was yet another impetus in Daguerre's continuing quest for capturing a more perfect realism in his work. The public adored his Diorama; they found it so real, so enthralling, and were beguiled by the cleverness of Daguerre's optical illusion, and, like a magician's audience, they revelled in their own desire to be fooled.

It proved to be the perfect coming together of his varied talents, utilizing as it did his skill at architectural drawing and realistic painting of panoramas with his more imaginative, illusionistic scene-painting with light and sound in the theatre. He never ceased to push the boundaries of what was possible on stage; in some of his later Diorama paintings Daguerre went beyond the illusionary, introducing real three-dimensional items, such as chalets imported from Switzerland and a live goat in one alpine scene.

Perhaps by this point Louis Daguerre realized that he had reached the limits of what he could achieve with paint and brush, for he still craved something more – he still wanted to find the golden road to even greater realism. Like all artists working at that time, particularly those whose paintings focused on architectural scenes and depended on accurate delineations of scale and perspective, he was long familiar with the camera obscura. But for Daguerre and other panorama painters work-ing in the 1820s and 1830s, the act of creating gigantic paintings from such small camera obscura drawings, expanding them from a few inches into 52-foot-high canvases, must have blurred their definition, leaving much to be desired. The artist creating the diorama was obliged to add in a great deal of detail later, either from memory or from his own imagination. It would have been a huge frustration to a perfectionist such as Daguerre, who longed to reproduce all the fine details pro-

duced by the small table-top camera obscura, but on an epic scale. Once more he was defeated by the limitations of the human eye.

If Daguerre was to continue in his quest for the ultimate in the realistic presentation of nature to his audience then he had to reach out beyond the limits of his own human skills and follow a radically new path: he had to enlist the help of chemistry far beyond the basics known to painters. It was a huge leap for a man the wellspring of whose creativity had been the intuition and flair of the artist rather than the cerebral, rational world of the scientist. At this point, Daguerre must have rued his lack of a formal education, perhaps for the first time. He was an artist, not a scientist; what did he know of chemicals and their reactions beyond the mixing of oils and pigments to make paints? But in an age when scientific enquiry was racing ahead, Daguerre was sure that sooner or later a way could be found to capture the image of the camera obscura in all its detail, if not in full colour – at least in the shades of grey familiar to artists from engravings and drawings. And so, undaunted by his frustrating lack of practical knowledge, he began to read up on chemistry and gather information for a series of experiments. What he lacked in scientific training he made up for with the self-confidence and determination garnered from his many successful years in the theatre and Diorama and from a lifetime of working long hours. He had every reason to believe he could achieve his goal for had he not already conceived new ways of capturing reality, thrilling theatre audiences with his innovative pictorial, lighting and sound effects? He certainly had the brashness and confidence to pull it off; but the simple fact was that in the early 1820s Daguerre had not the least idea of how he would reach his goal. Had he known more of the complexities of chemistry he might have been daunted; instead, it was precisely his

scientific naivety that allowed him to tackle the challenges that lay ahead, unaware of the minefield of potential failure that lay before him.

<div align="center">*</div>

Daguerre never set down his precise thoughts at the time, but in around 1824, after the success of the Diorama had been secured, he equipped a laboratory-cum-studio that he had created for the purpose in a poorly lit basement room of the Diorama building with chemical apparatus and materials. Here he set to work, by candlelight and in a state of at times demented frenzy that astonished and alarmed his friends. 'For about two years he lived almost continually in the midst of books, retorts and crucibles,' recalled the oculist, Charles Chevalier.[9] But Daguerre carried out his experiments behind closed doors. No one, not even his wife, was allowed across the threshold into his mysterious laboratory to observe what went on there. From the outset Daguerre seized control of his own legend-in-the-making and with it the subsequent retelling of how he created his own unique photographic process.

'How many times have I seen him', recalled another friend, Paul Carpentier, 'shut up in his studio for two or three days without leaving it, eating without taking any notice of the food which Madam Daguerre, alarmed, had brought him, not sleeping, obsessed with his idea.'[10] The obsession was relentless, all-consuming, but Daguerre was determined that he would be the one to find a way of capturing that most fugitive and ephemeral thing in the natural world – light – by bringing it to play in tandem with the camera obscura, creating images of perfect realism beyond anything he had yet accomplished in the panorama or the Diorama.

As a totally untrained amateur with no prior interest in science, Daguerre was of course unaware that others had

already been trying for decades to find this Holy Grail and one by one had failed. Scientists of considerable professional standing had already carried out photographic experiments only to capitulate, in the end, to what seemed to them the impossible. The quest to capture light was like the alchemist's search for the philosopher's stone that would turn base metal to gold. Daguerre had no idea whether it was possible or how many years of experimentation it would take to reach his goal. Frustratingly for posterity, he never described the technical path that he took in his experiments. Much of what we know about the process he eventually created comes to us therefore at second hand, from accounts published after his death. And like any posthumously published tales of ground-breaking achievement, they contain a mixture of truth and mythology and must be read with a degree of scepticism.

One such – and it is the tale most often told – relates to those first early years of photographic experimentation. Published soon after Daguerre's death in 1851, the story went that at the time of his most obsessive and protracted experimentation, his wife Louise became deeply concerned that her husband might go mad in the process. 'One day in 1827,' so the story went, after giving a lecture at the Sorbonne in Paris, the eminent chemist Jean Baptiste André Dumas was approached by a woman 'who seemed to be in a very worried state of mind'.

> 'Monsieur Dumas,' she said, 'I have to ask you a question of vital importance to myself. I am the wife of Daguerre, the painter. He has for some time been possessed by the idea that he can fix the images of the camera. He is always at the thought, he cannot sleep at night for it. I am afraid he is out of his mind. Do you, as a man of science, think it can be done, or is he mad?'
>
> 'In the present state of our knowledge,' replied Dumas,

'it cannot be done; but I cannot say it will always remain
impossible, nor set the man down as mad who seeks to do
it.'[11]

Although we only have Dumas's word for it, this story con-
veys the very real intensity of Daguerre's scientific quest and the
extent to which it had by now taken over his every waking
thought. But has it not always been the case that much of
scientific innovation and greatness springs from an element of
madness or obsession somewhere along the line? Fortunately
for Daguerre, he wasn't alone in his new-found interest in
chemistry. The atmosphere of enquiry of the eighteenth-century
Enlightenment had by now given rise in Paris to a number of
public lecturers on scientific subjects who also gave practical
demonstrations – men such as the inventor and mathematician
Professor Jacques Charles. In one of his lectures Professor
Charles would create a silhouette of a member of the audience,
though, unlike the cut-out silhouettes of the time, his weren't
cut from paper by hand, but produced by projecting a person's
shadow onto paper that had a light-sensitive chemical coating
on it. No camera was involved – it was simply a matter of the
shadow of the subject's head registering on the paper and then
letting science do the rest. Professor Charles's shadows, of
course, weren't permanent, but continued to darken until the
subject's silhouette was swallowed up. Whether Daguerre ever
attended one of these demonstrations or not, he surely would
have been aware of them and may well have got his first inspi-
ration from such demonstrations.

There was also a flurry of books being published at the
time on scientific themes, many of them aimed at amateurs
and describing chemical tricks that even the inexperienced
could perform to the amazement of their friends. William
Hooper's *Rational Recreations*, a collection of 'Electrical and

Magnetical Experiments' published in the late eighteenth century, contained an entire chapter on how to use silver salts on paper for creating shadow images and invisible writing. The combination of science and magic evident in all these books and lectures could not have failed to attract the attention of Daguerre but despite all the wealth of scientific enquiry at his disposal and his own best efforts his early attempts at capturing the light were fruitless. Without a real working knowledge of the chemistry needed or any training in scientific methodology, it was unlikely that they ever would have succeeded. Making the leap from pseudo-scientific parlour tricks to capturing an image permanently by means of the camera obscura was a much larger one than Daguerre was capable of. But he kept on trying. Like many others who searched for a way to make light do the work of the artist, he began with an obvious chemical already in use: a solution of silver chloride coated onto paper – a reasonable and relatively simple preparation and almost certainly the chemical that Professor Charles had used. Like his unknown competitors, Daguerre must have quickly found in these early experiments that silver chloride paper was not terribly sensitive to light. While it might capture a shadow directly on the paper in strong sunlight, rarely was it sensitive enough to register even the brightest image of the camera obscura, and worse, even if a faint image were formed on the paper, within hours it would have vanished, with the entire piece of paper turning black if left exposed to the light.

But it wasn't just the right chemistry that Daguerre needed; he also had to have the best and brightest camera obscura that he could find. The finest scientific instrument-makers and practitioners of the science of optics in Paris were his friend Charles Chevalier, who with his father Vincent had premises on the Quai de l'Horloge in the Ile de la Cité in the heart of old, medieval Paris. The Chevaliers not only provided Daguerre on

a regular basis with the lenses he needed, but also offered him considerable encouragement and advice. Charles Chevalier and Daguerre had become friends and would often sit in Daguerre's studio discussing optics, with Charles initiating him into the latest and best of optical achievement and speculating with him on whether capturing an image would ever be possible. But the frustration persisted; Daguerre's experiments, while continuing with the same intense dedication, still had as little success as ever. A chance encounter was soon to change all that.

Chapter Eight

LACOCK ABBEY

In the spring of 1821, after completing his four years at Cambridge and now reaching his majority, Henry finally received – at least symbolically – the keys to the Lacock estate. In reality it was still being let to John Rock Grossett, the local Member of Parliament, and would remain so for another six years. The occasion was, nevertheless, marked, on his twenty-first birthday, by a frank and exhortatory letter from his ambitious mother:

My Dearest Henry

Upon *giving you up* into your own hands, I have forced myself to say many things to you unpleasant in their own nature & peculiarly so *to me* who not only abhor the details of business, but to whom all allusion to *former times* & to past melancholy transactions must be extremely painful. It was however *right* to do so, & I have now only to wish you to *understand* your own affairs, & to give me the satisfaction of knowing you think they have been as well managed as, from the circumstances, they could be. To myself I take no credit for this; it is due to the person who (with fortunately a head for business complicated even as yours *then* was) from the first moment he ever saw you, took an affectionate interest in all your affairs only to be equalled by a parent, & who has made up to you in Care & zeal,

for the loss of one – if anything can. He will always be
ready to explain or advise should you want either, but
otherwise will not henceforth interfere.[1]

Although it was clear that Lady Elisabeth was now preparing
to relinquish some of her control, she added that she intended
to maintain her motherly interest and 'preserve the right *which
Nature gives me*, of suggesting any thing which from your youth
& inexperience may not occur to you'.[2] She had every reason
to hope her son would not disappoint her and that he would
look after the best interests of the family. 'If you are as great a
blessing to my old age as you were a Joy to Mes jeunes années,
I have nothing more to wish. Heaven preserve you to me! & to
your Sisters, whose protector I trust you will be, when We are
gone.'

*

In an extraordinary turn-around of its fortunes, and despite the
economic hardships of the times, when Henry took possession
of his inheritance, Lacock was back on its feet. This was thanks
– as Lady Elisabeth had so forcefully pointed out – to the
unstinting efforts of his stepfather, Captain Feilding, working
in tandem with an excellent estate manager who ran things
during the Feildings' frequent absences abroad. With all debts
paid off, the buildings in good repair, the tenant farmers'
cottages well maintained and efficient collection of their rents
in place, Henry found himself with an annual income of about
£1,800 per year (*c.* £76,000 in today's values) and no need to
pursue any occupation other than that of gentleman. As Lacock
Abbey had been leased out, Henry's mother, stepfather and
half-sisters Caroline and Horatia were living, for the most part,
on the Continent in a series of rented houses and villas. With
nothing to keep him in England and no need yet to assume the

role of country squire, Henry joined the family on their elegant tourist progress across Europe.

Between 1821 and 1827 he travelled, sometimes with his family and sometimes alone, along the route of the old Grand Tour. The family seemed to have a preference for Paris and various cities in Italy, but Henry ventured further, travelling to Vienna, Berlin, Geneva and spending a month on the island of Corfu, then under British protection. While his family often remained in one place for several months at a time, he seemed unable to settle anywhere for very long. In less than six years he made at least a dozen trips back and forth across the Channel and still found time while in England to visit Penrice and various of his relatives' homes. His travels across Europe were not what one might call Byronic or in the romantic spirit of the times. There was no trail of broken hearts, or hints of scandal or sexual dalliance of any kind. Instead, Henry Talbot's letters – both to his family and his contemporaries – were preoccupied largely with science and his intellectual pursuits, describing much-sought-after meetings with leading botanists and other scientists. They also included the obligatory visits to grand houses or churches, and, under the direction of his uncle William Fox Strangways, (later the 4th Earl of Ilchester), the occasional search for good Italian paintings, or, more often, newly made copies of them. Uncle William, who was only five years Talbot's senior, tried to cultivate in his nephew a con- noisseur's eye for great Renaissance art, but it was an interest that never really grasped Talbot, who in any event did not have the funds to indulge it.

August 1827 brought a temporary respite from all of this travelling when John Rock Grossett chose to give up his lease of Lacock Abbey. Talbot decided against looking for another tenant; it was time that he had his own home and a permanent

base from which to embark on any further travels. Over the previous six years he had been conducting a correspondence with a number of fellow intellectuals in Britain, as well as making contact, when on the Continent, with some of the leading European scientists of the day. In 1822 he had become a member of the Royal Astronomical Society and spent a month in 1825 working at the Paris Observatory with the leading French astronomer François Arago, the man who fourteen years later would become Louis Daguerre's greatest champion.

Having chosen finally to settle down at Lacock to manage his own estate after years of continental travel interspersed with time spent in London, Talbot was ill-prepared for the slower pace of the rural scene. By the beginning of the 1820s, however, the political climate was beginning to heat up. In many parts of England, the end of the old enclosure system was forcing local villagers to find paid employment to sustain themselves and their families. This change, combined with the rise of mechanization and the decline in village industries such as weaving – which had moved to larger towns and factory mills – now propelled many families from subsistence farming into a state of abject poverty. By 1830 southern England and East Anglia were the scene of a period of violent protest, known as the Swing Riots, during which poor farm workers rose up, wrecking threshing machines and burning hayricks in protest at the wave of industrialization that was destroying their traditional way of life. The riots were eventually put down by government troops and the ringleaders were hanged or transported. But it was a wake-up call for the gentry, who had by now realized that the current system was unsustainable. In another major change that year, and one that was symptomatic of the unstable times, the Whigs – the liberal reform party – were returned to power after decades of Tory dominance.

Lacock was one of the few estates to escape the rampage of destruction of the Swing Riots, thanks to the goodwill built up there by Talbot, his stepfather and their steward Henry Awdry. The family had always dealt fairly with villagers and contributed without complaint to the support of the local poor. And so, with the backing of his community, in 1831 Talbot decided to take a public stand; he announced his affiliation with the Whigs and his intention to run for a seat in Parliament. It is a decision that remains difficult to explain. Preternaturally shy, Talbot was never a public man; he detested making speeches for their own sake and didn't have his mother's gifts for carrying on polite social conversation. But something had clearly stirred his sense of public duty and *noblesse oblige*.

The local town of Chippenham, whose constituency included the village of Lacock, had a population of around 4,000 of which only 129 males were at that time entitled to vote and return two Members of Parliament under control of their patron, a local landholder named Joseph Neeld. In the event, at the election in 1831 nepotism ruled and the second seat went to Neeld's brother-in-law. Undaunted, Talbot immediately began campaigning for the next election, which followed just a year later, though once again everything in his personality ran counter to the demands for vigorous canvassing of the electors and the common practice then of throwing parties in order to curry their favour – both of which Talbot hated doing. His sensibilities and creative imagination were not suited to the cut and thrust of politics but were firmly rooted elsewhere – in the rarefied world of mathematics, classical literature and European intellectual reserve and detachment. Nevertheless, on election day 10 December 1832 Talbot came second in a close race, winning the other seat alongside Neeld. But by the time he took his seat in Parliament his mind was most decidedly on other things. For he had, at last, fallen in love.

Just five years earlier, Talbot had appeared to be heading for the life of a typical carefree, well-educated young gentleman of his class, under no pressure to earn a living, and with nothing to do but drift from one foreign capital to another, dabbling in scientific experiments and writing an occasional pamphlet or article on subjects ranging from mathematics to folklore. But he had never been a dabbler, or a dilettante, and in spite of having been constantly on the move he had kept abreast of developments in his fields of interest through wide correspondence with his scientific peers. Now aged thirty-one, he was an established member of the landed gentry, the master of an extensive country estate, a recently appointed Fellow of the Royal Society, a newly elected Member of Parliament. And soon he was to become a husband as well. His choice of bride was Constance Mundy, whom he had met on a visit to relatives at Markeaton Hall in Derbyshire that autumn. But it was his stepfather and his half-sister Horatia who were the first to receive the news, Talbot's excuse for not telling his mother being that as his other half-sister, Caroline, was about to deliver her first child he didn't want to distract Lady Elisabeth at such a time. Perhaps the more honest explanation was that he feared his domineering mother might object. One thing was clear, in a letter written to his stepfather on 7 November 1832, the forthcoming wedding was a love match. His family's response to his decision 'must rest upon your opinion of my good judgement', he told him. 'I suppose if I were to tell you what a charming person she is you would not believe half of what I should say, therefore I prefer to be silent on the subject, for I could not tell you my own opinion of her without using language which might appear to partake of exaggeration.'[3]

Constance would not in fact have been a complete stranger to the family – her elder brother had married one of Lady Elisabeth's nieces, Harriet Frampton, and Talbot's sister Horatia

remembered Constance as 'very pretty' from a visit she had once made to Lacock.[4] Talbot need not have worried about his mother's response, for she was glad that her son had found someone who shared his enthusiasms and could make him happy and she promptly sent her reassurances: 'you may depend on my Expressing myself in the most flattering manner of her in the world and saying all that you could wish when it comes to be known'.[5] The wedding took place at the society church of All Souls in Langham Place, London, which was just down the street from the Mundy family's London home in Queen Anne Street and a short walk from Talbot's London base in Sackville Street. As Parliament was soon to return from its Christmas break, however, the honeymoon would have to be postponed. Instead the couple spent a week at his uncle's villa by the River Thames in Richmond, Surrey.

From the first, Talbot took his duties as an MP very seriously and during 1833 he and Constance had to spend much of the first six months of their marriage apart, with Talbot tending to his official duties for the most part in London and Constance left to settle in as the lady of the house at Lacock Abbey. For all his good intentions, however, Talbot's was to be an undistinguished parliamentary career: he left little mark aside from using his influence as an MP to enable a man from Wiltshire who had been sentenced to transportation to serve his term in an English prison instead, and helping secure a clerkship in the Customs Office for a young man from Chippenham who showed potential. With her husband away, it could not have been easy for the twenty-one-year-old Constance. At Henry's request, Captain Feilding, Lady Elisabeth and Horatia had lived with her at Lacock in order to assist her in taking over the reins of lady of the house that had been held by her mother-in-law.

On the 21 June 1833 Henry Talbot and his wife Constance

finally set off across the English Channel to France on a six-month honeymoon. But it would be science not love that would preoccupy him during these crucial months, setting Talbot firmly on the quest for a new art form that was soon to consume him and transform his life.

Little did Talbot know that as he breathed the salt sea air crossing the Channel to France, a determined young Frenchman was already vigorously pursing the same path, only by means of radically different methods. And as yet the two men knew nothing of each other's existence.

Chapter Nine

SEEKING THE IMPOSSIBLE

If Louis Daguerre had carried on as he had been, he may well, through trial and error, have eventually come up with a viable method for making photographic images and fixing them. But by 1826 his work had stalled, as it had for so many others who had gone down the same road over the preceding twenty-five years. It was luck that changed the whole course of his future research – thanks to his friendship with Charles Chevalier.

Early in 1826, a military officer from Sennecey-le-Grand in the Burgundy region of south-east France, who had been passing through Paris, called in at Chevalier's premises. Colonel David Niépce was on an errand for his cousin, a French aristocrat, landowner and amateur scientist, Joseph Nicéphore Niépce. Niépce, who lived in a quiet rural town named Chalon-sur-Saône, had spent many years working on a series of inventions with his brother Claude, their most ambitious being the development of their 'Pyréolophore' – a combustion engine for boats – which they hoped would bring improvement to their family's fading fortunes. In 1813 the brothers had turned their attention to perfecting techniques in the exciting new and lucrative French art of lithography – the mechanical reproduction of images in publishing.

The classically educated Nicéphore Niépce was reasonably well grounded in the science of his times, having enlisted it in

his first attempts to capture outdoor scenes through the use of the camera obscura using paper sensitized by silver chloride. But, as with Tom Wedgwood before him (of whose work Niépce knew nothing), the chemicals he used did not prevent the images created from fading and then disappearing altogether. In 1822 Niépce did, however, achieve a degree of success with a different process employing bitumen. Within two years he had succeeded in copying images of engravings and drawings on copper, glass and stone, but was constantly frustrated by pressing financial problems and his desire to continue with his experiments was thwarted at every turn. Nevertheless, by 1826 Niépce had succeeded in creating a few images, including his first reasonably successful and certainly ground-breaking camera image, made from the second-floor window of his studio at his home Le Gras – an impressionistic image made with bitumen on pewter that had taken an eight-hour exposure to achieve. But the image was so faint as to be barely visible, with only the basic light and dark tones discernible. It was nevertheless the first major step forward since Wedgwood's experiments.

It was at this point that Nicéphore had asked his cousin to buy a camera obscura for him from the Chevaliers in Paris for the latest experiments that he was conducting on fixing images. Charles Chevalier must have been shocked to discover that his friend Daguerre was not alone in his quest and that he had serious competition. He said nothing to the officer about his friend's experiments but managed to get Nicéphore Niépce's address from him before the Colonel left with his purchase. During a visit Daguerre made to Chevalier's shop soon after, Charles told him of the visit by Colonel Niépce. Thinking more of his friend than client confidentiality, Charles gave Daguerre Niépce's address and urged him to get in touch to see if their work was progressing along similar lines.

Until now, Louis Daguerre had been used to working alone,

and seemingly wasn't deterred to discover others were conduct-
ing similar experiments. After all, he lived in an age when
scientific enquiry was flourishing and competition was inevi-
table. But his strong business sense would surely have come
into play. As a showman with his eye on the main chance, he
was only too well aware that whoever first solved the problem
of capturing light permanently – on whatever kind of medium
– would not only garner all the accolades but would stand to
make a handsome profit from the sale of any such process.
As soon as he got back to his studio that January of 1826,
Daguerre composed a letter to Niépce (sadly now lost*), in
which he told him, 'For a long time I, too, have been seeking
the impossible,' initiating a tentative discussion on their separ-
ate experiments. He revealed nothing specific about what he
was doing but intimated, somewhat grandiosely, that he had
been experimenting, with some success, for some time. This
was certainly an exaggeration but Daguerre was desperate to
find out how far Niépce had got in his own work; the last thing
he was going to admit to was a string of failures.

Not surprisingly Niépce was extremely wary when he
received Daguerre's letter, as he made clear to his son Isidore.
He had never heard of him and, more worryingly, had no idea
how Daguerre had come to know about his work. He was not
inclined to reply; Isidore later recalled that his father had been
rather offended by Daguerre's brash, unorthodox approach
which, to his mind, had breached the protocols of formal
introduction. And so he responded in a reserved and somewhat

* The first few letters between Daguerre and Niépce have long been lost. It is
thanks to the Russian academician Joseph Christianovich Hamel (1788–1862)
that the remainder of the letters, in addition to Niépce's valuable research
notes, were obtained by him from Isidore Niépce after his father's death and
deposited in the Russian Academy of Sciences, which, under the Soviets,
published the correspondence in 1949, edited by T. P. Kravets.

chilly tone, giving little or nothing away about his own work and merely indicating that his experiments had indeed been continuing for some time.

Having opened up a dialogue with Niépce, Daguerre puzzlingly then failed to seize the initiative. He had probably been forced to turn his attention back to the Diorama, which despite being an initial success and patronized by the great and good was a costly and time-consuming operation to run. He was under constant pressure from his shareholders to produce newer and better paintings – on average three or four a year. His investors might not have been pleased to discover that Daguerre meanwhile was sowing all of his best seeds in a very different garden – photography. In any event, France now was entering a period of economic downturn that had begun to affect the Paris Diorama's takings and Daguerre was forced to sell off his shares in the London operation in order to fend off personal bankruptcy. It was almost a year before he replied to Niépce's letter – in January 1827. In a further socially indiscreet *faux pas*, Daguerre this time had the temerity to ask Niépce to send him a sample of his images, still without revealing anything of his own work in exchange. Niépce was no fool and before responding very rightly tried to find out more about Daguerre, seeking the opinion of Augustine Lemaître, a Parisian engraver with whom he was acquainted:

> Do you know M. Daguerre, one of the inventors of the Diorama? This gentleman having been informed, I know not how, of the object of my researches, wrote to me . . . to inform me that for a very long time he had been occupied with the same object, and to ask me if I had been luckier than he in my results . . . If one is to believe him, he had already obtained some very astonishing results; yet in spite of that, he asked me to tell him first of all, whether I believed the thing possible.[1]

The cautious Niépce had been surprised at Daguerre's excitable tone and a certain inconsistency in his claims – what he labelled as 'incoherence of thought'; he was equally sceptical about his proclaimed quest for 'perfection' in making prints.[2] 'I am going to leave him in the path of *perfection*,' he tartly told Lemaître; he would say nothing more to him until Lemaître had given him his view.

Lemaître's response was encouraging but measured. He knew about Daguerre, as did most of Paris and the art world, but he had only met him once and then just briefly and could not say more as to his character. He did, however, admit that Daguerre 'has great talent for imitation' and 'an unusual gift for everything concerning mechanics and effects of light'.[3] Niépce still was not inclined to take things further. The results of his own work, using pewter as the medium, he told Daguerre in reply, had not been to his satisfaction; the two men were clearly working on entirely different methods and he worried that Daguerre's might be superior to his own. He kept his letter short and wished him success. But Daguerre would not give up and finally capitulated by sending Niépce a specimen of his work in response.

Although Niépce remained highly sceptical, he had by now reached a point of major discouragement in his own work and was perhaps more open to Daguerre's approach. All his and Claude's many years of work on a succession of inventions had failed to bring the money they urgently needed to prop up the family's dwindling fortunes. Working alone at his estate near Chalon-sur-Saône in the heart of the Burgundy countryside 185 miles from Paris, Niépce was also constrained by not having ready access to the kind of materials and scientific information that Daguerre probably enjoyed in Paris. He could not be certain of Daguerre's motives or the extent to which they were truly in competition with each other, but nor could

he risk being pre-empted by a competitor. By now collaboration may have seemed the best option open to him. And so, after much hesitation, in June 1827 Niépce sent Daguerre one of his own images – of the Holy Family – without giving him any information on the process he had used to achieve it. He had clearly been taken in by Daguerre's persistent braggadocio and, appearing discouraged that his own process was probably inferior to his, Niépce opened the door to further discussion:

> I think, sir, that you have probably followed up your first attempts; you are on too beautiful a path to remain there! Occupying ourselves with the same object, it should be of mutual interest to reciprocate our efforts to attain the goal ... I would be as desirous of knowing your results as I would be delighted to be able to offer you those of my own researches on the same lines.[4]

The businessman Daguerre did not have the social skills to treat Niépce with equal grace in response; he replied with a remarkably frank critique of the sample plate, emphasizing its drawbacks and weaknesses much more than praising any potential he saw in it. Niépce, always self-deprecating about his own work, had warned Daguerre in his accompanying letter that the sample was very imperfect but would give some idea of what was possible. He clearly got over whatever hurt feelings Daguerre's brusque reply induced, for less than two months later he met him in Paris. (In later years Niépce's son Isidore would claim that his father had been deeply offended and had resolved not to 'compromise his secret', but this came at a time when Isidore had already begun to criticize what he saw as Daguerre's usurpation of the credit due his father.[5])

For the time being the exchange of letters between the two men stalled, for in August 1827 Niépce's brother Claude was taken ill in London. He had moved there a decade earlier in

an attempt to find a buyer for their internal combustion engine for powering boats, but since then had succeeded only in squandering precious time and money. Niépce decided he must go to his brother. Forced to spend a few days in Paris while awaiting the issue of his passport for England, he took the opportunity of meeting Daguerre in person to discuss their mutual interests. At first the two men were on their guard, anxious not to reveal too much. Each seemed to think that the other was more advanced in his experiments, with Niépce writing to Isidore that Daguerre had not only managed to capture permanent images but was in the process, apparently, of fixing the colours of nature as well.

It is possible that Niépce had seen some of Daguerre's experiments with different-coloured phosphorus, possibly intended for special effects at the Diorama, and had thought that this was part of his photographic experimentation. Phosphorus is a material unlike any other, which at the time might have seemed to contain properties for creating the much-sought-after direct positive image. When exposed to light phosphorus glows, effectively giving off its own light. After the light is removed, phosphorus appears to have created a positive image, with the light areas brighter than the material surrounding it. Intuitively this would seem to make some sense, but in reality, and unlike silver salts – which were already in use for creating shadow images as popular entertainment – phosphorus doesn't change its structure when exposed to light but simply reacts to it; when the light is removed the image becomes dormant again. Silver salts, in contrast, go through an actual chemical change, from one substance to another, the light causing them to break down, depositing metallic silver permanently in the paper, which creates the dark part of the image. Using phosphorus, there was no way of making the image glow indefinitely or for it to remain stable when viewed in the light.

Nevertheless, Niépce had been taken in by Daguerre's brash salesmanship and thought he knew what he was doing. Colour images were certainly something the ambitious Daguerre would have wanted to achieve, but in reality neither he nor anybody else had produced anything in their experiments so far that made this seem remotely possible.

During Niépce's stay in Paris, Daguerre was a wonderful host, taking great pleasure in showing him round his brainchild the Diorama – 'I have seen nothing here that has struck me more or given me more pleasure,' Niépce told his son – and in conversation no doubt convincing Niépce that he knew exactly what he was doing.[6] The truth was somewhat different: in his three years of intense and obsessive experimentation Daguerre had made virtually no progress. Niépce could not know that in fact Daguerre's latest photochemical experiments had been entirely abortive. He had begun by using paper coated with silver salts, but these had turned dark when exposed to light, creating an image that was reversed in tone – what would later be known as a 'negative', but like some of the other early experimenters he was looking for a method where light would produce whites, creating a direct positive image. Failing to spot the enormous possibilities of the negative, Daguerre had rejected silver salts. But without notebooks or published reports by him, it's not clear where he next took his experiments. It would appear that from the time he learned of Niépce's experiments until the two men became business partners, he made little headway at all.

After a few days Niépce continued his journey to Kew, a village near the River Thames in England, to see Claude, whose illness was worse than he had anticipated. At Kew, Nicéphore met Franz Bauer, a botanist and artist at the Royal Botanic Gardens nearby. He was a sympathetic friend to the brothers and spent many hours discussing scientific ideas with

Nicéphore. More importantly, Bauer was a Fellow of the Royal Society, which was known worldwide as the arbiter of scientific innovation. Although Nicéphore had been quite excited by the artistic potential of the process he had discussed with Daguerre in Paris, he knew that an impartial, scientific opinion could prove useful as well. He was now under considerable pressure; money was so short that he decided to confide his photographic process to Bauer, whom he felt would understand not just the artistic aspects of the process but the scientific ones as well. He showed him samples of the images he had brought with him and to his immense relief Bauer thought them a scientific marvel and worthy of sharing with the Royal Society.

In 1827 Kew Gardens was at a low point; it had depended heavily on King George III – widely known by the sobriquet 'Farmer George' – for support and patronage and he had never let it down, but his son George IV had shown little interest in Kew or in anything that his father had admired. As a result the gardens at Kew, and Bauer himself, had lost much of their status and influence in the scientific community. The Royal Society was rudderless too; its president, Sir Humphry Davy (who had been knighted for his scientific work in 1812), had been suffering from a heart ailment and had been forced to resign through ill health in July 1827. It was a tragic piece of bad timing, for if Niépce's work had been drawn to Davy's attention a year or so earlier, he might have had a decidedly different reception, in light of Davy's work with Tom Wedgwood back in 1802. In its current state, however, the Royal Society fell back on established rules and procedures that would have required Niépce to reveal his process publicly in order for it to be considered by its membership. With his financial future at stake, he could not risk revealing his process without restriction and, most importantly, without any financial compensation. It was a terrible disappointment and a dispirited

Niépce returned to France, but not before leaving examples of his work in safe keeping with Bauer, including his first photograph taken with the camera obscura, as well as a description of the process. Sadly Claude died in January 1828, just two weeks after his brother had returned to France. Niépce was bereft at losing not just a brother, but a business partner, confidant and source of constant encouragement when experiments proved slow to produce results. Suddenly he no longer had the confidence or the finances to carry on alone.

Chapter Ten

THE HELIOGRAPH

When he returned to France early in 1828 a disconsolate Niépce once more resumed his correspondence with Daguerre, who was still anxious to continue his experiments and hoped he could flatter Niépce into revealing the chemistry behind his process. He had yet to see any real examples of his work, and so Daguerre turned on the courtly charm and began wooing his future partner: 'It would be a real pleasure to me, if agreeable to you,' he told him, 'to indicate to you how to derive profit from it. I cannot hide from you that I have a burning desire to see your attempts from nature, for while my own discovery has as basis a more incomprehensible principle, it is certain that you are much more advanced in results, which must surely encourage you.'[1]

Niépce, however, remained reticent about sharing any more of his work. Another year went by, with more long-distance technical discussions by letter, during which Daguerre raced from one idea to the next whilst the quiet and methodical Niépce at last, and without fanfare, continued making progress with his own photographic process. He described the results to an ever eager Daguerre, who by now was itching to get to the nub of his rival's work, and promptly wrote back:

It is impossible to be more excited than I was when I heard that you have continued your experiments, and

especially at the thought that you have obtained new results; I will receive with great pleasure examples of your successes.[2]

When Niépce informed Daguerre soon after that he was preparing a paper on his process for publication it must have set alarm bells ringing in Daguerre's head. He had to move fast or possibly be pre-empted entirely. The only solution was collaboration, which he immediately suggested, once more emphasizing the financial rewards: 'there should be some way of getting a large profit out of it before publication, apart from the honour this invention will do you,' he urged.[3] Money was always Daguerre's first concern; honours were important but necessity placed them second.

Such was the sixty-four-year-old Niépce's state of extreme financial difficulty by this time that at the end of October 1829 he finally realized that a partnership was the only solution. It was better to work with Daguerre than be in competition with him, and only recently Lemaître had told him that Daguerre was now working with a much-improved camera obscura. And so Niépce suggested they go into partnership. As his process – which he had given the name 'heliography' – was more advanced and he was the elder of the two partners, Daguerre, in deference, travelled to Chalon-sur-Saône to sign the ten-year partnership contract on 14 December and finally learn the secrets of the heliograph process. This in itself could be seen as an admission by Daguerre that his experiments at the time were actually going nowhere; Niépce might have the upper hand as the creator of this new process, but if there was money to be made in it, Daguerre as a man of business had the skills needed to exploit the heliograph commercially.

He spent a further two weeks with Niépce the following May and June 1830, being initiated by his partner into the

mysteries of heliography. As Niépce told his cousin: 'we worked constantly from morning to night; but even though we obtained important improvements to my processes, we have not yet any result on speed that would allow us to make better use of the camera that M. Daguerre brought me.'[4] Nevertheless, Daguerre obtained complete written instructions on Niépce's method, sufficient to allow him to return to Paris and begin his own experiments in hopes of creating a marketable product.

*

During the period of their collaboration, one might imagine that Daguerre and Niépce had little else to do but spend time experimenting in their laboratories and comparing notes, but Daguerre, for one, was still running a highly demanding business. Everything in his life had to be done at double speed; in between his work on new canvases for the Diorama, photographic experimentation consumed what precious little spare time remained. Daguerre worked at an intensely frenetic pace, as his chaotic letters to Niépce demonstrate. When he had begun his photographic experiments in 1824, the Diorama was only two years old and was still the money-spinning wonder of Paris and London. Eight years later it had run into financial trouble. Having given up his stake in the Diorama in England Daguerre was now increasingly on the brink of personal bankruptcy in Paris and faced with having to close his operation down; financial pressures now also threatened his continuing photographic experiments, which took much time and a good deal of money. The persona of the self-confident showman-entrepreneur was rapidly becoming just a brittle façade.

Now, of all times, Daguerre needed to pull something out of the bag. But in 1830 revolutionary upheaval once more visited Paris, leading to mob violence in July, which totally

disrupted the already failing Diorama business and caused further substantial financial losses. Charles X was deposed and replaced by a new king, Louis-Philippe. Crisis after crisis hit Daguerre: his partner Bouton resigned due to ill health that same year, leaving him to create all the new Diorama paintings alone; at the end of March he had had to drop everything to go to London to mount a new Diorama painting. Worse still, he and Niépce had been forced to suspend their scientific correspondence – in which they used a code for the chemicals they were using, to protect their secret – because they feared their letters would be intercepted by the police and they would be accused of being agents of the revolution. Daguerre's sense of urgency and frustration was escalating. Unable to find the time for further experimentation, or to raise money to prop up his ailing business, he tried a different route – royal preferment. In a desperate attempt to salvage things, he petitioned the queen for a promotion to officer of the *Légion d'Honneur*, explaining that

> The favour that I dare ask for is at this moment priceless for the good it would provide my establishment, which is already so honoured by the consent of your august family, by attracting the public attention that I desperately need because of the enormous sacrifices I was forced to make in order to sustain my Diorama after the difficult times we have gone through.[5]

Now having to field complaints from Niépce about his failure to respond for several months to his latest letters, Daguerre was frantically trying to focus his energies on finding a way to work with Niépce's method if he was to save himself from financial ruin. But the heliograph process was quite different to his own and that of other earlier photographic experimenters, all of whom had begun – and in most cases ended – their

experiments working with silver salts on paper. Niépce, having
tried paper as early as 1814 and rejected it, had instead settled
on working with metal plates – first pewter and then silver-
plated sheets of copper – normally used by engravers for
printing. His use of the camera obscura to create a plate that
would allow for mass reproduction of the image in a similar
manner to engravings was an unusual sideways step away from
Daguerre's experiments, which had always been aimed at
making one-of-a-kind images in-camera similar to the unique-
ness of a painting. Niépce at times appears ambivalent about
his heliographic plates: he knew they were not only useful for
printing but could have a pleasing aesthetic of their own. He
seemed torn between their utility and their natural beauty, so
much so that the work he took with him to London in 1827
had consisted of plates framed like paintings, as though they
themselves were works of art rather than simply the template
from which the photographic image would emerge in printer's
ink.

The difference between making a one-of-a-kind image
versus a mass-produced print may seem a purely academic one,
but in the art world, the difference was immense. In the nine-
teenth century, Art, in the classical sense, was still traditionally
divided into two categories: the major arts were painting and
sculpture; everything else was considered a minor art, including
the graphic arts of drawing, engraving, etching and the recently
introduced technique of lithography. Drawing was considered
to be merely preparatory work for paintings and sculptures and
therefore not 'finished' art in itself. The printing processes of
etching, engraving and lithography were seen as reproductive
arts – used to make copies of paintings and sculptures for the
masses and therefore not original art in the usual sense. The
purist art establishment in France was hostage to snobbery and
had always turned its nose up at attempts to raise the minor

arts to the level of the major ones. Despite knowing that they risked inflaming hostility to their work, Daguerre and Niépce never strayed from the idea that they were on the brink of coming up with a radical new art form. Inventing a new scientific process was challenge enough, but in order to perfect it, it was perfectly reasonable that they should conform to artistic formats already in existence. While Daguerre the painter still hoped to achieve one-off images in the camera that reproduced the range of colour of a traditional painting, Niépce's approach – of creating metal printing plates from which multiple images on paper could be made – was based on already existing examples in the graphic arts and in many ways appeared the more practical.

For the time being, Daguerre had to contain his impatience and content himself with working with Niépce's very different method as he had little to offer in the way of a new process himself. He remained loyal to their contract, continuing to work with the heliograph and trying to make it a viable process. But in the end it became increasingly clear that it was not going to be possible to improve it to a marketable level. In itself the heliograph was a giant step forward in the history of photography, and one that would remain a scientific marvel of its time, but it was not the ultimate object of popular desire. At first glance, Niépce's camera image of the view at Gras just looked like a pewter plate that had been polished. In order for the image to be seen, it had to be viewed at exactly the right angle and in optimal conditions. It was far too faint and Daguerre knew that this would not be sufficient for it to be exploited as a viable commercial product with the sensation-seeking public. As a printing plate it appeared crude and any prints that came from it would be cruder still. A much more sensitive substance was needed to fix the image and create a more robust end-product with full shadows and highlights –

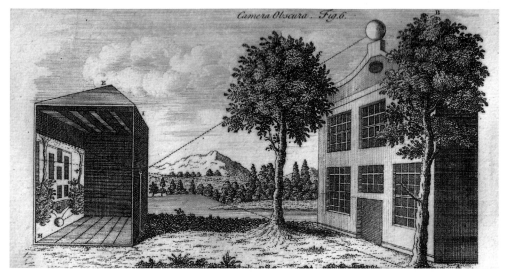

1. Camera Obscura, illustrating the inversion of the image.

2. Camera Lucida in use. The artist is viewing both the scene in front of him and the image projected on to the drawing paper simultaneously.

Now pray lend your Attention to the Enchanting
prospect before you. This is the prospect of Peace.
only Observe what a busy Scene presents itself.
The Ports are filled with Shipping. the Quays loaded
with Merchandize. Riches are flowing in from
every Quarter this prospect alone is worth all the
Money you have got about you.

Licensed by Authority
Billy Ham's Grand
Exhibition of Moving
Mecanism or Deception
the 5 Senses.

Mayhap it may. Master Shewn but I canna
zee any thing like what you mention
I zees nothing but a wide plain with some
Mountains and Molehills upon't as sure as a
Gun it must be all behind one of those?

Billy's Raree-Show — or John Bull en-lighten'd

3. *Billy's Raree Show – or John Bull Enlightened*, a cartoon showing a peep show.

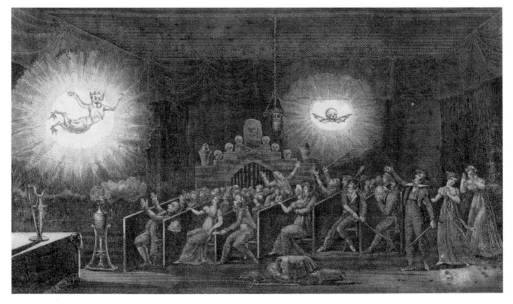

4. The Phantasmagoria of Etienne-Gaspard Robertson, in the ruins of the Capuchin monastery, Paris. Frontispiece from *Mémoires: récréatifs, scientifiques et anecdotiques / du physicien-aéronaute.*

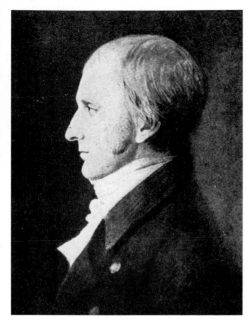

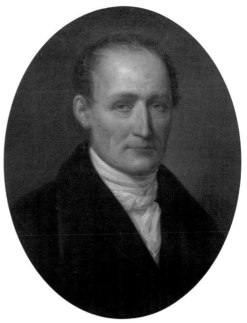

5. Thomas Wedgwood. 6. Joseph Nicéphore Niépce.

7. View from the window at Le Gras. Heliograph by Nicéphore Niépce, 1826.

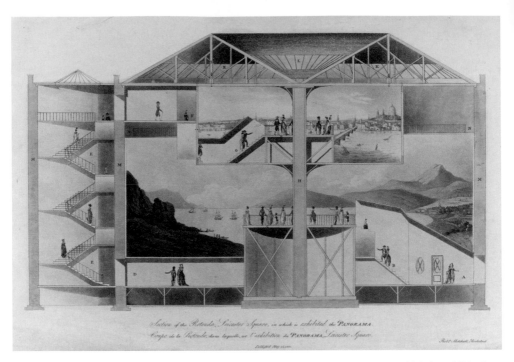

8. Barker's Panorama. *Section of the Rotunda, Leicester Square, in which is exhibited the Panorama*, etching by Robert Mitchell, 1801.

9. Daguerre's only surviving Diorama painting, 1842.
In the church of St Gervais – St Protais, Bry-sur-Marne.

10. William Henry Fox Talbot.
A daguerreotype by
Richard Beard using the Wolcott
Johnson camera,
c. 1842.

11. Louis Jacques Mandé
Daguerre. Daguerreotype by
Jean-Baptiste Sabatier Blot,
Paris 1844.

12. Notre Dame Cathedral, Paris, by Louis Daguerre, *c.* 1838.

13. *Coquillage*, daguerreotype by Louis Daguerre, *c.* 1838.

14. Lacock Abbey. Salt print from a calotype negative by Roger Watson, 2010.

15. *The Latticed Window,* August 1835. The earliest extant negative of the oriel window at Lacock Abbey. Taken by William Henry Fox Talbot.

16. A portait of his indomitable mother, Lady Elisabeth Feilding, by William Henry Fox Talbot, *c*. 1844.

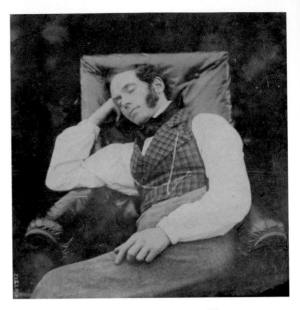

17. Talbot's assistant, Nicolaas Henneman, asleep in photographer Claudet's chair. Attributed to William Henry Fox Talbot, *c*. 1845. Salt print from a calotype negative.

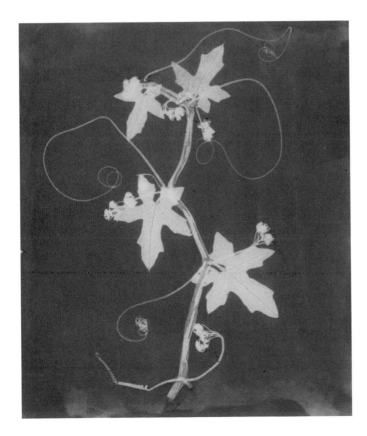

18. Photogenic drawing of the fern *Bryonia dioica*, by William Henry Fox Talbot.

something that went one better than what engraving and drawing had already long been achieving. It was a very tall order.

Nevertheless, with financial pressure mounting for both men, they struggled on. They continued to correspond, in their code for the substances used, with Daguerre for example suggesting in May 1831: 'I think after many new tests that we ought to concentrate our researches on 20 this substance is highly light-sensitive when it is in contact with 18' (the references being to iodine and silver plate respectively).[6] For the next two years the partners carried out a number of experiments to improve the heliograph process – individually in their own studios, and through the exchange of detailed research notes in a flurry of letters. They then worked together during further visits made by Daguerre to Niépce's home in June and November of 1832. Earlier that year Daguerre had finally failed to obtain compensation from the government over his losses during the 1830 disturbances that might have bailed him out at the Diorama. He was now seriously contemplating moving his operation to London and in January informed Niépce of this in no uncertain terms. 'Before making this decisive move, it is absolutely necessary for us to agree and make a final effort to find out what we might actually gain from our research.'[7] At the end of March and faced with debts of 60,000 francs, Daguerre finally capitulated and declared bankruptcy. The pressure really was on.

In the months that followed he and Niépce combined their knowledge, using a new material brought from Paris by Daguerre, which enabled them to invent an entirely different process, rarely mentioned in most histories, called the 'physautotype'. Similar to Niépce's heliograph, this was based, not on the light-sensitivity of silver salts, but on the hardening of a resin when exposed to light. Whereas Niépce had used the

tar-like bitumen of Judea as his resin, Daguerre now introduced his own version – distilled lavender oil, a more refined substance with which he coated the metal plate prior to exposure.

In the end, neither process was entirely satisfactory. Niépce's heliograph was not particularly pretty to look at: the hardened black bitumen allowed for the plate to be etched but the unevenness of the lines left an image which resembled a very faint and crudely etched plate. It was, by any measure, a scientific success but an artistic and practical failure. If a new art form was their ultimate goal, then Daguerre and Niépce had to create images that were beautiful if they were ever going to charm, amuse and truly impress the public and encourage them to part with their money. Their physautotype, for all its limitations, was nevertheless a step in the right direction. Still an awkwardly slow process, the image it created was more robust, less crude and, in some ways, truly beautiful. When exposed and developed, it left a white residue on the silver plate where the light had struck, and when the plate was angled towards something black the white image appeared to stand out as a positive image surrounded by the reflection of the black. Though more elegant than the heliograph, this new process was not one that could be achieved quickly and as a means of creating images made in the camera obscura it offered no real advantage. But as a new concept, it was a major shift away from the heliograph and that was what counted. Daguerre and Niépce were no longer trying to create a printing plate: they were now focused on creating a revolutionary new end-product – a direct positive image – which in concept can be seen as the precursor to the daguerreotype. Sadly, however, although the physautotype process was fully documented by the two partners and has since been recreated in modern times, no physautotype is known to have survived from Daguerre and Niépce's experiments.

Failing to find this new process fully satisfactory, the two inventors went back to the drawing board yet again and revisited their earlier experiments. A chance discovery by Daguerre led him to abandon the processes involving the hardening of a resin and return to the idea of using silver salts. The method he now took up was to make the silver on the metal plates they had been using receptive to the light by sensitizing it with fumes produced by iodine. This method came about in his laboratory, after Daguerre had by chance left a spoon on an iodized plate which happened to have light falling on it. When he later picked up the spoon he noticed that it had left a perfect shadow picture of itself on the plate. It was this observation, so it is said, that led him to begin his experiments with sensitized silver plates. Daguerre's later, much-retold story of the invention of photography, which he never wrote down and which may well have varied with the telling, grew from such apocryphal stories, all seemingly possible and utterly simple in their detail. They are the stuff on which the mythology of the birth of photography in France is based.

True story or not, Daguerre's move to combine silver and iodine in the photographic process is absolutely crucial, for it would be instrumental in who would get the ultimate credit for the invention of photography in France. Niépce had in fact used iodine first, although in a different way, before he had entered into partnership with Daguerre. When silver is exposed to iodine fumes it turns a dark bluish purple. Having noted this, Niépce had used this discoloration, not as a sensitizer, but to highlight the images of the heliographs that he made with bitumen. But it was Daguerre who noticed the crucial factor – the light-sensitivity of the iodized plate. He reported his startling findings to Niépce who then attempted some experiments of his own with iodine-sensitized silver plates, but he had no

success with them and, forever afflicted by disappointment, went back to working with resins. For now, Daguerre's planned move to London was put on hold. The temptation to speculate on the possibilities that such a move might have opened up to him had he done so is considerable. Suffice it to say that in London Daguerre would have had access to a wide range of scientific enquiry, including the weekly lectures held at the Royal Institution. These might have led him to a new partner with whom he might have solved the photographic problem sooner. One thing at least seems certain: if Daguerre had moved to London, he and Henry Talbot sooner rather than later would have heard about each other. But any speculation is moot because at this point tragedy struck.

Just as Daguerre was writing yet another letter apologizing for delays in his responses to the latest experiments, the sixty-eight-year-old Niépce died suddenly of a stroke. 'My dear friend Isidore,' Daguerre wrote movingly to Niépce's son on 12 July:

> I loved the good Monsieur Niépce as much as if he had been my father; this blow is absolutely terrible for me too; and so it is with eyes wet with tears that I write. I do not need to describe to you the grief I am feeling . . . It deprives me of all courage at the moment. But we must nevertheless redouble our efforts in thinking how we shall immortalize his name with the publication of his discovery.[8]

There is no doubt that Niépce's death could not have come at a worse time for Daguerre; Niépce was not only the senior partner but had many more years of methodical and diligent research behind him. His death threw Daguerre's photographic experiments once more into total uncertainty. But Daguerre was not one to capitulate in the face of adversity. Undaunted,

and galvanized by his desperate financial situation, he went back to his laboratory with renewed determination and refused to abandon his search. For Niépce's family, however, the suddenness of his death brought further tragedy. It had come before he and Daguerre had been able to finesse and capitalize on their process. The long-standing debts run up by Nicéphore and Claude in their years of scientific experimentation had left their family destitute. Niépce was buried in a pauper's grave and the estate at Chalon-sur-Saône was sold soon afterwards. His name could so easily have slipped into obscurity thereafter but instead Daguerre did the honourable thing and maintained the contract with Niépce's son Isidore, albeit with some modifications.

It remains impossible to talk of Daguerre's final success without acknowledging his enormous debt to the work of his partner Niépce in leading him in the right direction. As with so many things in the history of invention, where people have marvelled at the dedicated lone inventor, creating in his laboratory something that dramatically changes our perception of the world around us, in most cases such achievements are ultimately the result of a long, slow cumulative process of enquiry by a succession of individuals, each in turn standing on the shoulders of their predecessors.

Nicéphore Niépce's reputation still endures, thanks to that extraordinary, faint but ground-breaking image he made back in 1826. He had left it in England with Franz Bauer in 1827, and after last being exhibited in 1898 the image remained hidden away in a trunk for more than fifty years, until rediscovered in 1952, thanks to the amateur sleuthing of photographic historian Helmut Gernsheim. Four of Niépce's heliographs survive today, ensuring that his contribution to photographic history endures. But their importance should not be overstated; what Niépce achieved was just the beginning.

Chapter Eleven

THE MELANCHOLY ARTIST

Nicéphore Niépce died just at the point when Henry Talbot – still oblivious to the existence of his two rivals in France – was departing for the Continent on a six-month honeymoon with his bride Constance. It was a luxury for them both to have that much time together but it was not quite the romantic twosome one might expect newly marrieds to enjoy, for they did not travel alone. Typical of their time and their social status, Constance had her lady's maid – a Mrs Jones – with her and Henry had a manservant called Dominico. Neither servant, however, proved satisfactory during the trip; Dominico was quickly replaced in Paris by a servant named Francesco and Mrs Jones was left behind in Berne.

In fact, the Talbot entourage increased even more, for the couple picked up a third member of the party in Paris and then added three more relatives in Italy, so that what began as a honeymoon soon progressed into a family tour. Six months away on the Continent on honeymoon might seem a long time by modern standards but in terms of a Grand Tour it was quite short, with many people often taking tours lasting two or three years. The couple travelled along the traditional route, first taking in Paris and then journeying on through Switzerland to Italy. The convention for visiting particular countries at particular times was generally tied to the vagaries of the

weather and the established social season in each venue. Paris then – and even now – was not a place to spend the month of August, nor did the Grand Tourist visit Italy in that month either, as it was far too hot there. Switzerland with its cool mountain breezes and lakes was the place to linger in midsummer, before the traveller moved on to Italy in late September or early October in order to avoid the onset of winter in the Alps. Progress on such tours was intentionally slow and leisurely, the rationale being not just to see the sights, but also to absorb each different culture through an exploration of its theatre, art, cuisine and the idiosyncrasies of daily life there.

By the time Henry and Constance left Dover in June 1833 it was possible to cross the English Channel by steam packet in four or five hours, a considerable improvement on the old journey by sail, which took eight hours or more, weather permitting. But in the days before a European rail network had been established, land travel by coach was still as arduous as it had ever been and it took the couple three days to reach Paris from Calais. Because travel by water could be decidedly faster than by land many travellers, particularly in Switzerland, used boats to tour the towns and cities located around the shores of lakes. Nineteenth-century travellers thought nothing of walking often substantial distances, which of course was encouraged as a good form of exercise. At one point in their travels through Switzerland, when Talbot was impatient that the boat they were sailing on was not carrying them along fast enough, he had the boatmen put him and the ladies ashore, from where they walked the last seven miles to their hotel – no mean distance for women encumbered by corsets and long dresses.

In Paris English visitors would head for the opera and the theatre, go shopping for the latest fashions, eat in fashionable restaurants and visit other English families living in the capital.

Many would make a point of calling on the surviving members of the French aristocracy. Much reduced in both their social status within France and their financial situation, the French upper classes found the company of their English visitors refreshing for it allowed them still to behave like aristocrats in their company, without fear of anti-royalist reaction. While they were in Paris, Talbot met up with an old family friend, Amélina Petit de Billier, who had lived with the Talbot family as governess and companion to his half-sisters Caroline and Horatia while he was a student at Cambridge. As the product of a French upper-class family fallen on hard times after the Revolution, Amélina – with neither a fortune nor a husband to sustain her – had had little option but to work as a governess. For now, however, she joined the Talbots as a travelling companion, spending the months of July and August with them in Switzerland, for much of the time in Berne. In later years she returned again to Lacock, this time as governess to Talbot's own children, and remained with the family, as a permanent guest of the abbey, until her death more than forty years later. The love the family had for her is evident by her inclusion in the family burial plot.

Switzerland did not have the social or intellectual cachet of France or the classical appeal of Italy but it provided a picturesque respite from the city, where long walks through alpine woods and even a bit of amateur mountaineering could be enjoyed. In September the Talbots and Amélina set off again, travelling down from the Alps into Italy, the primary objective for most Grand Tourists. Italy allowed the educated Englishman a chance to see the places he only knew about from reading Latin texts in school, to absorb the ambience of Classical antiquity and the bustling cities and educate himself by visiting palazzos and villas and soaking up the improving nature of Renaissance art. If you were a connoisseur with a

long purse you might buy a few choice pieces to send back to England, or more commonly hire one of the many artists available to paint a decent copy of one of the old masters to hang in your country house back home.

In late September the Talbots had reached the mid-point in their journey when they arrived at Varese in northern Italy. Here Henry's half-sister Caroline and her family joined them. From the early days of the Grand Tour and surviving even past the birth of photography, one of the favourite pastimes, particularly when the traveller found himself or herself at a picturesque location, was to record the experience by making sketches and watercolours to show family and friends when back home. In the account he later wrote of his photographic method, published as *The Pencil of Nature* in 1844, Talbot recalled a particular day at Lake Como that autumn of 1833 when he had been attempting to make a few sketches using a drawing aid called a camera lucida, but had found the results frustratingly inadequate. Unlike the more instinctive Daguerre with his natural artistic flair and his solid grounding in draughtsmanship, it was typical of the dogged and logically minded Talbot to opt for something more pragmatic, and make use of a scientific instrument to help enhance what his limited skills could achieve.

The camera lucida – which is not to be confused with the camera obscura – was invented in 1807 by the English chemist and physicist William Hyde Wollaston and was comprised of a brass rod with a small prism on the top end, attached vertically to a portable drawing table. When the artist looked down through the prism his vision was split between the view in front of him and the drawing paper below. An optical illusion, caused by the prism, made it appear that the scene was being projected onto the paper on the drawing table, which the artist could then use in order to make his drawing by effectively

tracing that image onto the paper. Talbot had discovered, as had others before him, that the device could be very useful in correcting perspective and scale, but only for those artists who had already mastered the art of sketching. In unskilled hands, such as his own, it offered very little help indeed. As he later recalled of the two age-old devices:

the *Camera Obscura* and the *Camera Lucida* [are] certainly very ingenious and beautiful instruments, and in many circumstances eminently useful, especially the latter . . . They assist the artist in his work: they do not *work for him.* They do not dispense with his time; nor with his skill; nor his attention. All they can do is to guide his eye and correct his judgment; but the actual performance of the drawing must be his own.[1]

After attempting a few sketches he was therefore utterly dismayed. 'When the eye was removed from the prism – in which all looked beautiful – I found that the faithless pencil had only left traces on the paper.' The results, he concluded gloomily, were 'melancholy to behold'.[2]

This was not false modesty speaking, but a real sense of personal disappointment. Talbot's surviving drawings from that 1833 trip are melancholy indeed – mere crude outlines of the scene in front of him without any of the shading or artistic technique that might distinguish the hand of the trained artist from that of the unskilled amateur. To make matters worse, if not humiliating for a man of his academic excellence, while Talbot lacked the necessary skills himself, he was surrounded by women whose talent greatly eclipsed his own. His half-sister Caroline, like most genteel young women of her class, had been given drawing lessons as a child and would continue to draw throughout her life. As too did Constance, who had a good eye and a facility with a pencil that Talbot could only

envy. Frustrated by his inability to make simple sketches, he began to ponder the huge gulf between the beauty of what he saw and the reality of what he was able to draw. There was no comparison; the fault lay in his own untutored hand. Talbot's rationale in response to this problem was typical of that of many men of learning in this period: there had to be a technical solution to the problem. But in his case, could one be found in the arena in which Talbot was both most comfortable and most competent? He was reminded of a trip he had taken to Genoa in 1824 when he had used a camera obscura instead of the camera lucida:

> this led me to reflect on the inimitable beauty of the pictures . . . which the glass lens of the Camera throws upon the paper in its focus – fairy pictures, creations of a moment, and destined as rapidly to fade away. It was during these thoughts that the idea occurred to me . . . how charming it would be if it were possible to cause these natural images to imprint themselves durably, and remain fixed upon the paper![3]

In the few weeks spent at Lake Como, Talbot, Constance and Caroline wrote many letters home describing their day-to-day excursions but nowhere did Talbot mention his philosophical or practical musings on creating such 'fairy pictures'. He did, however, make a note of the idea at the time, along with a few suggestions of how best to pursue it. When he got back to Lacock he transcribed that jotting into one of his scientific notebooks:

> Nitrate of Silver
>
> Wash a sheet of paper with it. Place a leaf of fennel or other of complicated form upon it. Press it down with a pane of glass – when blackened with the sunshine place it

in something that will alter its property of blackening –
qu. Prussiate of potash? Sulp. Acid. Mur Soda. Carb.
Soda.

Instead of the leaf try several bits of coloured glass – thus
a silhouette might be taken, especially in a dark room.[4]

The original note, scribbled down that day at Lake Como, has
long since been lost but because Talbot with his usual precision
dated the entry when he copied it into his notebook a few
months later at Lacock, we in fact know the exact day when
the idea of photography first dawned on him. It was some time
during the afternoon of Saturday 5 October 1833 at the Villa
Melzi on the shores of Lake Como. That short, simple note-
book entry of only seventy-seven words contains the germ of
an idea that would be the basis of numerous experiments taken
up by Talbot throughout 1834 which led him to the develop-
ment of his own distinctive process of photogenic drawing.

The notebook in question, which Talbot designated 'Note-
book L', and dated on the flyleaf 8 January 1834 soon after his
return from the Continent, contains more than one hundred
pages of entries relating to experiments that he undertook,
most of them dealing with spectrometry and mathematics, but
his chemical experiments were also noted along with a few
photographic ones that he had begun some time that spring. A
close reading of the notebook reveals that by the end of 1834
Talbot had all but formulated the method for his photogenic
drawing process.

Unlike Daguerre, Talbot, the diligent and highly methodi-
cal scholar, had long since made a habit of recording the
details of his experiments, his mathematical investigations and
even his observations on linguistics so that he could refer to
them later. He organized his notebooks by date and main topic
and assigned a letter or letters to identify each topic's place in

the running order. His photographic experiments fall between just four notebooks that he labelled L, M, P and Q, the first dating from 1834, the last ending in around 1840. Two other notebooks interrupt this series – notebooks N and O – but they contain no photographic experiments, testament perhaps to Talbot's constantly wandering, inquisitive mind and the fact that he had simply moved on to other topics by then.

Talbot's Notebook L containing his 1833 jottings from Lake Como was rediscovered at Lacock Abbey in 2009 after having gone missing for at least eighty years. Along with the other three photographic notebooks it offers a great deal of insight both into his working habits and into the quicksilver mind of a typical Victorian polymath. His astonishing ability to leap coherently from one unrelated topic to another and then to return to the first topic later in the same notebook – or sometimes several notebooks later – is astonishing. As these were only kept for his own reference – as a kind of improvised *aide-mémoire* – Talbot did not feel compelled to organize them into separate notebooks for each specific area of interest. Open any volume, therefore, and it might begin on page one with notes on the Hebrew derivation of a word in English, to be quickly followed on the next couple of pages by a mathematical formula defining a section from a curve, only to be followed by several pages of notes on a chemical experiment. To peruse one of these notebooks is to travel, unfettered, through the mind of a brilliant man.

Bearing in mind the organized and logical way in which Talbot worked, the story of the invention of his own quite different photographic process does not come across in the same haphazard way as that of his French rival. Daguerre's story is full of apocryphal tales of accidents and chance encounters, but Talbot did not rely on the serendipity of misplaced spoons. He understood chemistry and was able to work in a

methodical manner, with each experiment based on results gleaned from previous experiments. And unlike Daguerre's wife, who supposedly worried publicly that her husband might lose his sanity in pursuit of his idea, Constance Talbot was confident in the importance of her husband's scientific work and totally supportive of it.

It all hinged, in the end, on the personalities of two very different men. They were both brilliant in their own way, but their styles were as different as their processes. Daguerre had the verve of the Gallic artist, full of energy and intensity, locking himself in his laboratory for days on end – if one believes that part of the myth – collar loose, sleeves rolled up, chemical stains everywhere. Talbot, on the other hand, would sit quietly in his study, patiently working through the problem in his head first, planning the experiments that would prove or disprove a theory. He would then carry them out in a measured way, carefully weighing the ingredients, knowing their probable chemical effect, watching the experiment progress and then dispassionately recording the results in his notebook. Talbot's brilliance was assured and attested to by his fellowship of the Royal Society and the reception of his scholarly papers.

It was a classic example of the Hedgehog and the Fox: the dogged and determined Talbot, with a regular income unrelated to his work, slowly persisting in his one big idea and in no rush to announce it to the world; while his rival, the mercurial quick-footed fox Daguerre, leapt from one enterprise to another; his living depending on his coming up with a new sensation to replace the diminishing commercial idea that had preceded it.

Chapter Twelve

FIXING THE IMAGE

During the years of Daguerre's collaboration with Niépce, Henry Talbot's investigative energies had been equally abundant over in England, but they had been spread across a wide range of interests. Indeed, he accomplished more in the 1830s than most men could hope to in a lifetime. In addition to his parliamentary commitments, raising a family and taking up the reins of a great estate, his writing and publishing of scientific papers in particular blossomed, with four papers appearing in 1833 and five in 1834. These were well received by his peers and his family was rightly proud of his scholarship. But in 1830 his first foray into publishing, with a vanity publication entitled *Legendary Tales in Verse and Prose* – a collection of fairy tales and other stories – had been a flop. It had failed to win the approval of the highly critical Lady Elisabeth, who had thought her son's book lightweight for someone of his undoubted academic talents and mental powers. She did not mince her words: 'knowing as I do *your sterling* abilities I do not like these tales & poems to be taken in the world for the Standard of *what you can do*.'[1] Enough said; the dutiful Talbot bowed to his mother's greater wisdom and did not repeat the mistake of straying from serious scholarship again.

After returning from honeymoon early in 1834, Talbot had been eager to lock himself away in his laboratory and resume

his nascent photographic experiments, but as a Member of Parliament and a family man he faced the constant distractions of the social scene of receptions, balls and official dinner parties, all of which the far more sociable women in his family enjoyed, but which Talbot would do anything to avoid. Such was his busy schedule therefore, that opportunities for experimentation came spasmodically. During the few visits he managed to make to Lacock from London that spring it was a case of Talbot muttering a satisfied 'hmm' before putting his work away and carrying on with other business. Most of his time was still taken up with parliamentary duties that kept him away from Constance. For, after their return from honeymoon and a happy family Christmas spent at Lacock, Talbot had been called away for the next sitting of Parliament from early February 1834. In the meantime, Constance carried on as best she could in maintaining the family home at Lacock, which from midsummer on was very quiet.

It was in mid-August, when Parliament rose for what ended up being an unexpectedly long recess, that he finally got back to his experiments. For in October the old Houses of Parliament in Westminster where members had met since the thirteenth century, burned to the ground in an accidental fire caused by workmen and the House of Commons did not meet again that year. By now, the change in Talbot's personal circumstances since he had first stood for Parliament in 1832 had made him re-evaluate his future. In their first two years of marriage, and with the exception of their honeymoon, he and Constance had spent little time together and they both had suffered from these protracted absences, their affection evident in the frequent letters sent between London and Lacock. Talbot's personality was maturing and his tastes changing, and although he found the fellowship of other scientists pleasing, his parliamentary duties in London often placed him in the

company of men whose conversations he found tedious and often incomprehensible. He longed to reclaim his life with his beloved wife and return to the quiet but stimulating contemplation of mathematics and science and the company of his family, who, even if they didn't share all of his enthusiasms, looked upon him as a great man still bound for even greater glory.

There were, in addition, other more everyday demands on his time as the owner of a country estate and the village that surrounded it. He had his trustworthy estate manager, William Awdry,* who collected the rents, paid the taxes and generally managed the day-to-day business, and until mid-1834, his mother and stepfather were usually on hand as well, but it was still an unsatisfactory way to run his affairs. Up to this point Henry had conducted most of his business by post or by proxy, not through his wife – who was still too young and inexperienced to make any major decisions – but through a surprisingly acquiescent Lady Elisabeth, who, whilst continuing to offer her maternal opinions freely on whatever she felt needed to be done, nevertheless solicited her son's approval for any major changes. But his stepfather and Horatia were both now unwell and it worried Talbot greatly. Captain Feilding was only in his mid-fifties, but his health had begun to deteriorate with gout and other arthritic complaints often keeping him laid up in bed for days at a time and Horatia, who had suffered greatly with her chest (consumption, the great killer of this period, was never even hinted at), had succumbed to something sounding like rheumatic fever. At the recommendation of their doctor they both spent time taking the waters at Bath before their eventual departure with Lady Elisabeth for the Continent, where they would remain for most of the next three years.

* A relation of Henry's steward, Henry Awdry. Three generations of the Awdry family served the Talbots.

In April the following year – 1835 – Talbot's first child Ela Theresa was born, named for Countess Ela who had founded Lacock Abbey six hundred years before.

<p style="text-align:center">*</p>

With so many family preoccupations consuming his time, it is not certain exactly when in early 1834 Talbot found time to undertake what would prove to be his first ground-breaking photographic work, but it is clear that he was able to get some done, because he sent samples of some of his experimental pieces to his sister-in-law Laura Mundy for her amusement sometime that summer. They had, however, proved a disappointment; they had continued to darken into nothingness and by the end of the year Talbot was sending Laura replacements of what she referred to as his 'shadows'.

In order to progress his photographic work, Talbot had to enlist the help of chemistry, which was still a relatively new scientific discipline in its concrete, experimental form. When he had attended university it was grouped along with the other sciences under 'Natural Philosophy', but he had always read avidly on the subject and, when the opportunity arose, carried out his experiments.

The origins of chemistry in fact went back centuries, to the murky medieval traditions of the original quasi-chemists, the alchemists. Often denigrated if not demonized in literature as little more than witches or magicians – half priest, half sorcerer – alchemists had traditionally been linked to the mythical quest for finding a way of turning base metals into gold. Later pioneers had endeavoured through serious and dedicated observation to understand the nature of the world around them and find ways of explaining it in scientific terms that were compatible with long-held religious belief, but throughout they were handicapped by a lack of empirical research. Working

almost entirely with texts that had come down from the ancient Greeks, mixed up with elements of popular superstition and mythology, the observations, collected over time by alchemists and then filtered through the minds of the great thinkers of the Enlightenment, nevertheless became the basis of chemistry in its early years.

One of the first to tackle unknowingly what today might be called proto-photochemistry, was a woman. Elizabeth Fulhame, a Scottish amateur chemist and wife of a physician in Edinburgh, had been in contact with some of the noted scientists of her day. These included the proto-chemist Joseph Priestley, one of the leading Lunar Men. Inspired by his work, Fulhame conducted her own chemical experiments in the 1790s on dyeing fabrics with the salts of precious metals such as gold and silver. In the process of reducing them down to coloured metallic deposits on the cloth, she noted the chemical power of sunlight and its interaction with them, in effect becoming one of the first scientists to describe photochemical imaging and the silver chemistry that would dominate photographic techniques for the next century or more. Some of Elizabeth Fulhame's hair-raising experiments with dangerous gases and volatile liquids in her improvised laboratory at home could have caused her serious injury, but she was a forceful and courageous character, well ahead of her time, who spoke her mind and defended her right as a woman to embrace scientific experimentation. She published details of her method as *An Essay on Combustion with a view to a New Art of Dying* [*sic*] *and Painting* in 1794, mindful of protecting her work from the

> furacious attempts of the prowling plagiary and the insidious pretender to chymistry, from arrogating to themselves, and assuming my invention, in plundering silence: for there are those, who, if they can not by chymical, never

fail by stratagem, and mechanical means, to deprive industry of the fruits, and fame, of her labours.[2]

In her later robust resistance to hostile criticism of her son's work and the pirating of it, Lady Elisabeth Feilding would prove to be an uncanny, and equally vociferous, kindred spirit.

When he began his photographic experiments in the mid-1830s, the scientific discipline of chemistry, as Henry Talbot would then have perceived it, was only about fifty years old. Its generally acknowledged 'father' was Antoine Lavoisier, of whose work both Talbot and Daguerre would have been well aware. Lavoisier had been executed six months before the publication of Elizabeth Fulhame's pamphlet, but his influence had nevertheless persisted on both sides of the Channel. More important to Talbot as an Englishman – and certainly a person with whose work he would have been familiar – was Joseph Priestley. At the end of the eighteenth century Priestley had carried out ground-breaking experiments on the chemical nature of gases in a laboratory less than five miles from Lacock at Bowood House, the home of Talbot's great-uncle the 1st Marquess of Lansdowne. Priestley had been hired by the marquess as a librarian and tutor but was encouraged to continue his scientific and theological studies by him. Fortunately, both Lavoisier and Priestley were highly disciplined and methodical and their chemical experiments were written up and published in books and journals which Talbot could have read. His own notebooks throughout the 1830s contain details of numerous simple experiments that he conducted that were typical of this infant science, such as combining two chemicals and then observing and noting changes occurring in colour, precipitants and reaction. Such experimentation would appear elementary to a student chemist today, but in the 1830s it provided the essential building blocks of a whole new science.

One of the essentials to be mastered in the creation of a viable positive–negative photographic process was the creation of light-sensitive paper. Scientists had been aware of light-sensitive materials for centuries but until now no one had found a way of making use of them in this respect. For example, a mineral known as 'horn silver' or *luna cornea* was a naturally occurring combination of silver and chlorine. It had long been noted that after a few minutes of being exposed to the light its whitish colour would turn dark, almost black. But the general assumption was that it was exposure to air, not light, that caused this change. Johann Schulze, professor of anatomy at the University of Altdorf near Nuremburg, was the first scientist to investigate this colour change in silver compounds in 1725, when an experiment he was conducting to create phosphorus went wrong. Having poured nitric acid into a bottle of chalk, he awaited a reaction; the nitric acid had been contaminated with silver, as he soon realized, and he was surprised to see that the side of the bottle facing the window began to darken. Schulze deduced that silver was the contaminant and repeated the experiment, this time putting a higher concentration of silver in the solution. This time the mixture turned dark even more rapidly and so Schulze followed up with what today would still be considered a good analytical experiment. He mixed up two bottles of the chalky solution containing silver nitrate, corked both to preclude the possibility of the contents being changed by exposure to air, and placed one bottle on a windowsill and one near a fire. This would determine if the change was due to sunlight or heat. The bottle on the windowsill darkened rapidly on the side facing the window while the one near the fire remained unchanged, providing the first conclusive evidence that light alone could effect a change on a chemical substance. This one, simple experiment was the first step in creating the chemistry of

photography. Schulze's article on his findings, entitled *Scoto-phorus pro phosphorus inventus* (a joke in Latin meaning 'In seeking the "bringer of light" I found the "bringer of darkness"') was published in 1727 in the *Transactions* of the Imperial Academy at Nuremburg and was later translated and quoted in numerous scientific journals and books. It also appeared in an elementary form in a number of books of recreational science where basic scientific experiments were described so that the layman could recreate them as amusing parlour tricks. By the time Talbot was conducting his own experiments more than a century later it was an accepted fact of science that silver nitrate was light-sensitive and yet, surprisingly, nobody, save the few experimenters already mentioned, had, till then, succeeded in putting this crucial knowledge to anything more than novelty use.

Chapter Thirteen

THE LATTICED WINDOW, AUGUST 1835

The 'brilliant summer of 1835' would long be remembered by Henry Talbot.[1] August that year was a month of searing heat across England. Root crops shrivelled in the fields for lack of water and dairy cows foraged disconsolately in parched meadows where the grass lay dry and scorched. Farm workers had been out reaping the cornfields early that year and a bumper harvest was promised. But the fine weather was no pleasure for those trapped in towns and cities; anyone who was able to do so had fled the stink of the city and confined spaces. For Talbot, currently serving a term as local juror at the Wiltshire assizes, there had, however, been no escape that broiling month, locked up as he was in the courtroom at Devizes, seven miles from Lacock.

He was relieved to have completed his term as MP for Chippenham, having found political life at Westminster an enormous waste of time. Politics was, to his mind, a 'troublesome game' and he did not seek re-election, gratefully exchanging the 'mob' at the House of Commons for the rural tranquillity of Lacock.[2] But Talbot was a man who took his social duties seriously; they were expected of a gentleman of the moneyed classes and of his standing in the community and so, soon after leaving Parliament, he had been called upon once more to do his civic duty and sit as a juror at the local county court. It was

a chore to have to attend at such a time of year, but work for the local judiciary had promised to be a good deal more tolerable than the tedious, wearisome debates at Westminster that had kept him away from his family and in close and unpleasant proximity to London's fetid River Thames.

As a man of private means, he could also once more indulge his scientific interests and enjoy the detailed exchange of letters with various fellow scientists on a range of disciplines – physics, chemistry, botany, astronomy and archaeology. Like many men in his position, he was consumed by interests for which he had no preconceived outlet other than an occasional learned paper here and there in scientific journals. But the demands of running the Lacock estate and fulfilling his professional posts were a constant distraction from his primary interest – the study of light and optics. Only that summer, prompted by his friendship with the English scientist and astronomer Sir John Herschel, Talbot had been plotting an observational calendar for the eagerly awaited return of Halley's Comet, due over England that autumn. It only came into view every seventy-five years and this was a once-in-a-lifetime opportunity for the keen amateur astronomer.

It was not just the heat that had made August an unusually stressful month for him. Talbot had taken Constance and his infant daughter Ela to stay with relatives for a seaside holiday in the more salubrious environment of the Isle of Wight, but with a heatwave raging in Europe, and with it the spread of disease, he was desperately worried about the well-being of his mother and his half-sisters. They were trapped in San Bartolomeo in northern Italy by a cholera epidemic that was now rampaging through southern France and threatening the coast of Italy. Talbot's half-sister Caroline had just lost a baby born prematurely due to the heat and stress of their being forced to remain in Italy.

Talbot had been desperate to see his sisters and mother safely back home to England but was powerless to do anything to help. For a good part of that month he had been sequestered on a Special Jury in the stuffy courtroom at Devizes, debating the most tedious of petty parochial business – latterly, the issue of liability for repairs to a local parish road at Fittleton. He complained in a letter to Constance of the oppressive heat and the long hours involved, with nothing to eat and drink; it left him feeling drained and exhausted. After three days of legal wrangling by the barristers – something only too painfully familiar to Talbot from his days in Parliament – the jury, of which he was foreman, remained divided and could not reach a verdict.

Yet, somehow, in the midst of all these competing preoccupations Talbot had found time for experimentation on his one continuing passion – capturing the images of nature permanently on paper. He was in fact picking up on the idea that had been brewing since his honeymoon at Lake Como, when he had become frustrated by his own inability to draw accurately. He recalled, from earlier trips, the perfection with which the camera obscura was able to project an image onto ground glass that could then be traced in pencil and had since often pondered whether it might be possible to find a way of capturing these images permanently on the paper. Now, in late August 1835, and with the blazing sun outside providing the perfect intensity of light needed, he finally found time to set up an experiment at Lacock that would attempt to do just that.

The cool stone interior of the abbey provided what today seems the archetypal romantic backdrop to an attempt to produce a fixed, stable photographic image. With his long background in scientific enquiry and chemical experimentation Talbot created first a solution of sodium chloride (ordinary table salt), which he painted onto a piece of ordinary writing

paper. When it was dry he took a solution of silver nitrate and painted that onto the same sheet of paper. The mixing of the two solutions on the surface of the paper created silver chloride, a silver compound much more light-sensitive than silver nitrate alone and much more receptive to the image at which it was directed. To heighten the sensitivity further, he repeated the coatings several times on the sheet of paper, depositing a stronger layer of silver chloride. He positioned this piece of paper – not much bigger than a postage stamp – in the back of a small wooden box that he had had constructed for him by the local carpenter at Lacock – an object so crude and inconsequential-looking that Constance had teasingly called it his 'mousetrap' – and placed a microscope eyepiece on the front of it to focus the image.[3]

Whether Talbot's choice of subject was arbitrary or one he had long since chosen, we don't know, but in a letter to his aunt Lady Mary Cole four years later he recommended for her first camera experiments that 'The object to begin with is a window & its bars placing the instrument in the interior of a room.'[4] For in this, his first experiment, he had set up his device on a shelf facing the central latticed window in the south gallery of the abbey. During renovations to Lacock that he had initiated in 1828–30 Talbot had replaced the original windows of this long room above the original abbey cloister with three oriel windows, which looked out onto the garden and beyond them the River Avon, which wound languidly through the abbey grounds.

After a short period of time (the exact length is not recorded, but has been estimated at between fifteen minutes and an hour or more) Talbot removed the box, opened the back and carefully extracted the piece of prepared paper. Much to his satisfaction he found that he had at last created his own

very small piece of magic. The ghostly but perfect image of the latticed window had printed itself onto the paper with such accuracy that each tiny diamond-shaped pane of glass – some 200 in all – was visible through a magnifying glass, as was the leaded lattice work and even some trees outside the window – though all were reversed in tones. Complete in every detail, this first fragile image – so small and almost unearthly that it 'might be supposed to be the work of some Lilliputian artist' as Talbot later put it – had been achieved without fanfare in a rural backwater.[5] It was the world's first photographic negative. This one small piece of purple-tinged paper with its ghostlike capture of a window would be the foundation stone on which photographic innovation would stand for the next 160 years.

Did Henry Fox Talbot immediately shout 'Eureka' and run out into the world to reveal his great discovery to his peers? Far from it; he said nothing and made no mention of his achievement in his notebooks. As the archetypal gentleman amateur he gave no thought at that stage either to historic significance or the potential value of his discovery. Although he took more equally successful images of the same window later that summer, as well as other locations elsewhere at Lacock Abbey, he was soon diverted from photographic experimentation back to his many other scientific and literary interests. He had a paper on mathematics to write for the Royal Society, of which he was a fellow, and was eager to get back to sharing with Herschel his observations of Halley's Comet, which would reach its high point over England, in all its glory, in October.

Had Talbot known of Daguerre and his work in Paris at this time it might have been a different story. But for now there were many other things on his mind. Perhaps his failure to announce his achievement immediately was also a reflection of

Talbot's innate dissatisfaction with the technical results achieved: the slowness of the exposure time; the size of the images – 'though very pretty . . . were very small, being quite miniatures', as he noted; the limitations in suitable subject matter – which had to be entirely static and located in bright sunlight.[6] Perhaps the scientist in Talbot decided to hang back, in hope of improving and speeding up his process, which to him, as a perfectionist, still seemed too embryonic.

To a man of Talbot's arcane scientific training and knowledge, that first photographic negative probably seemed at the time merely another stage in the series of experiments that he had begun back in 1833 and whose ultimate objective was still uncertain. So, for the time being, he contented himself that he had achieved something that might be of interest to a few fellow scientists; perhaps at some point in the future he would get around to writing up his findings to share with them, but there seemed no urgency to do so.

Such was the isolation in which scientists – most of them amateurs rather than academics – worked at this time, without the immediate and easy interchange of ideas that we enjoy in the modern internet age, that, in 1835, Henry Fox Talbot truly believed he was the sole originator of the idea of capturing the image of the camera obscura. It is hard now to credit it but he was totally unaware, not just that Daguerre was at work on his own method in Paris, but that more than thirty years earlier, and even closer to home, another Englishman, Tom Wedgwood, had also taken the first steps on the long trek down the road to the invention of photography.

The history of scientific breakthrough is often accompanied by intense debate over who got there first and Talbot's case is typical of what happens when there is a clash between the followers of different practitioners laying claim to the same process. In an attempt to minimize Talbot's accomplishments,

there are some who have since suggested that because the Wedgwood experiments were published by Davy many years earlier, Talbot had probably read them and developed his photographic method on the back of their research. The article by Davy, however, was published when Talbot was only two years old and there is no evidence that he ever became aware of it. Even Wedgwood's biographer, R. B. Litchfield, who rightly championed his subject's pioneering work in photography, scotched any idea of plagiarism, pointing out that the *Journal of the Royal Institution* in which the article was published had been short lived and with a very small circulation. As Litchfield asserted, it 'would have been read, apparently, if read at all, only by the small circle of members and subscribers to the institution, of whom, we may be pretty sure, only a small minority can have been scientific people'.[7] The article is never mentioned in Talbot's early notebooks, where he often quotes books, journals and other sources consulted during his experiments, nor does it appear in any of his other writings. Indeed, Talbot himself said later that if he had read that a scientist as eminent as Davy had tried such an experiment and failed, it was unlikely he would have attempted to find a solution.

One thing is clear: in that brilliant summer of 1835, Henry Fox Talbot had captured the light, but, to the eternal frustration of his later admirers, he then failed to capture the moment.

*

During the year that followed, Talbot spent time seriously contemplating selling Lacock Abbey so that he could move somewhere closer to the south coast of England, an idea which grieved his mother greatly as she had thoroughly taken to living there. In the end the plans came to nothing, interrupted

as they were by other family concerns, particularly the sudden and unexpected death of Talbot's mother-in-law, which took Constance away for a number of weeks to care for her father and her sisters. Meanwhile, Talbot filled his time with other subjects that he enjoyed: he spent much of the year working on a paper on integral calculus and exchanging botanical letters and specimens with various colleagues around the country and on the Continent. The high point of the year for him, and one that reflected his standing in the scientific community, was perhaps one of the least known and yet most important events ever held at Lacock Abbey – a gathering of great minds in advance of a meeting of the British Association for the Advancement of Science, held that year in Bristol. Lacock Abbey threw its doors open to scientists and intellectuals including Sir David Brewster, Charles Babbage, Peter Mark Roget and Sir Charles Wheatstone for a few days of recreation and informal discussion. There was no agenda, and those present were able to discuss their work without worrying about its appearing in print or being subjected to criticism by others. Talbot in particular spent time with one of his favourite correspondents, Sir David Brewster, and their discussions went on for hours. Constance was delighted to see her introverted husband, who in her opinion had developed a preference for far too much solitary work, so animated in the company of others. Seeing Henry so enlivened by the company of other scientists, Constance wrote to her mother-in-law:

> You are perfectly right in supposing Sir David Brewster to pass his time pleasantly here. He wants nothing beyond the pleasure of conversing with Henry discussing their respective discoveries & various subjects connected with science. I am quite amazed to find that scarcely a momentary pause occurs in their discourse. Henry seems to

possess new life & I feel certain that were he to mix more frequently with his own friends we should never see him droop in the way which now so continually annoys us. I am inclined to think that many of his ailments are nervous – for he certainly does not look ill. I hear from Sir David that he distinguished himself at the meeting in a conversation on the Improvement of the Telescope . . . When I see the effect produced in Henry by Sir D. B's society, I feel most acutely how dull must our ordinary way of life be to a mind like his! And yet he shuts himself up from choice.[8]

It would be wrong, however, to think of Talbot as cold and aloof around anyone other than fellow scientists. He thoroughly enjoyed spending time with his family and revelled in his children, finding great pleasure in telling others about them either in person or in his letters. On such occasions, his dry wit and underlying sense of humour shine through, such as in a letter he wrote to his sister Horatia when Ela was just learning to talk. The little girl had, he told her, 'got hold of a picture of Mary queen of Squats. I must endeavour to correct the pronunciation, for among all the faults imputed to Mary, I never heard that she deserved that reproach.'[9]

The informal gathering of scientists at Lacock that August of 1836 would have provided the perfect opportunity for Talbot, had he so chosen, to introduce his friends to his experiments in photography of the previous year, if only to gauge their reaction and for them to offer suggestions or support. Sir David Brewster, a fine scientist and later one of the most avid of amateur photographers, would certainly have been thrilled to see Talbot's photographic work. But it was not to be. Perhaps Talbot was afraid that he had not perfected it sufficiently to share it with others and that in its present state it might seem trivial – too little advanced from the photographic

parlour amusements that had been around for years. We shall never know, but if that August of 1836 he had chosen to share his work with Sir David, history would probably have been quite different.

In March 1837 the Talbot family was blessed with the birth of a second daughter, Rosamond Constance; it brought happiness in the wake of the death of Talbot's stepfather in September of that year. In his will, Captain Feilding, who had been promoted to the rank of Admiral not long before his death, requested that he be buried in a coffin made of the wood from a ship of the Royal Navy. Talbot was able to fulfil this wish through the Admiralty, as a mark of respect and gratitude for a stepfather who had shown him as much love and encouragement as any natural parent. In the meantime, he appears to have made no further photographic experiments. The contents of his notebooks between 1836 and 1838 indicate that, at this point in time, Talbot's process was as complete as he was ever going to make it. He subsequently asserted that in late 1838 he had been busily engaged in finally writing up his experiments in photography, with the objective of publishing them in 1839, but events in Paris at the beginning of that year would catch him unawares and dramatically change the course of his future scientific activities.

Chapter Fourteen

THE MAGIC CABINET

The years between Niépce's death in 1833 and the comple-
tion of Daguerre's eponymous process is a dark age in the
history of photography in France. Without any surviving
paper trail on Daguerre's lone work in the laboratory, we are
left with few clues to the steps which finally turned him away
from working to improve Niépce's heliograph process to the
work that eventually brought the daguerreotype to the world.
A brief but revealing glimpse of Daguerre at work did, how-
ever, appear in 1835 with publication of an article in the *Journal
des Artistes* introducing some new paintings at the Diorama,
where Daguerre remained active both as director and creator
of the actual paintings. Almost as an afterthought and buried
at the end of the article was a startling statement informing its
readers that:

> He [Daguerre] has discovered, we are told, the means of
> collecting on a plate prepared by him, the image produced
> by the camera obscura, in such a way that a portrait, a
> landscape or any view projected on this plate by an
> ordinary camera obscura, leaves its impression in light
> and shade, and thus presents the most perfect of all
> drawings . . . A preparation applied to this image preserves
> it for an indefinite time . . . Physical science has perhaps
> never presented a wonder comparable to this one.[1]

Such was the concluding proclamation of this statement but its author did not reveal himself. Some experts suspect it was the work of Daguerre himself, either that or the self-proclaiming showman putting his own words into the mouth of another. Is it possible that his friend Charles Chevalier, having years before been indiscreet with Niépce's name and address, had once more said more than he should? Or had he done so with Daguerre's tacit approval? Either way it was a tantalizing statement to dangle before a scientific community eager to see someone achieve what still seemed the unachievable.

The greater mystery is why this announcement met with such stony silence from the public, as though the idea of photography held no interest either for them, the author, or for that matter the publishers, who decided to append this statement to an article on a different subject. What was Daguerre working at just two years after the death of his partner that would encourage such an emphatic statement? Surely such a breakthrough deserved not just an article of its own but to be splashed across the front page of this and other journals. The ellipses in the article (which are in the original) indicate that the information may have been taken from a longer article that appeared elsewhere, but no trace of it has ever been found. And it was a year before a response to the article finally appeared in the same journal. It was written by a young architect named Alphonse Eugène Hubert, who apparently had also been experimenting with photography. He wrote:

> I doubt whether M. Daguerre has really accomplished all that has been attributed to him by officious friends; if he had, as is claimed, obtained the most perfect of all drawings, he would no doubt have shown it publicly even without the second condition – that is to say, the prep-

aration to preserve it for an indefinite time; he would have to make a night-album,* enclosing his results between black paper and only showing them by moonlight.[2]

In his rebuttal, Hubert went on to claim that he had not only conducted his own researches on the subject seven or eight years previously, but that having 'spoken to several chemists and artists' he doubted that 'even if we assume that a substance more sensitive than chloride of silver has been discovered, one would still have great difficulty in obtaining the most perfect of all drawings'. Such was the confidence of Daguerre's new and unexpected rival that he brashly stated that 'I so much doubt M. Daguerre's anticipated results that I find myself almost tempted to announce that I, too, have discovered a process, the possibility of which has recently been questioned in the *Journal des Artistes* – a process, namely, for obtaining the most perfect of portraits, by means of a chemical composition which fixes them in the mirror at the moment one looks at oneself!'

It was a bold claim, without any detailed scientific explanation to back it up; nevertheless, Daguerre must have reeled with shock to read it. For in his statement Hubert managed, comprehensively, to discuss the use of silver chloride, the problem of shifting shadows in long exposures (just as Niépce's first plate had shown), the difficulty of fixing the image once made and even the use of plaster casts placed in bright sunlight to maximize the shadows and highlights of the photographs taken – all issues that must have plagued Daguerre time and again in his own experiments. It was as though Hubert had been looking over his shoulder for all these years.

* Night-albums were books where experimenters like Tom Wedgwood would secrete their unfixed silver nitrate images and were so called because you could only look at them at night and by candlelight in order not to ruin their exposures.

But why had his rival waited a year before throwing down his challenge if, as it seemed, he was as far along as Daguerre in his own independent research and, if anything, appeared more knowledgeable than him to boot? We shall never know. Unable to refute Hubert's assertion, Daguerre took the only option open to him. If you can't beat a rival, then invite him to join you; he had done as much with Niépce and he now did the same with Hubert, enlisting all his natural charm and, somehow or other, persuading him to agree to work with him as his assistant. Hubert remained for the next four years, until after the daguerreotype process was publicly announced. And then, extraordinarily, fate once more struck at the point when the hitherto unknown Hubert, like Niépce before him, was on the point of sharing the laurels and the limelight with Daguerre. He died not long after the announcement was made. But like Niépce he left a tenuous legacy; there is at least one daguerreotype in existence known to be by Hubert and a pamphlet titled 'Le Daguerréotype considéré sous un point de vue artistique, mécanique et pittoresque' published in 1840, has also been attributed to him.[3]

The obscure Alphonse Eugène Hubert, whose name rarely gets more than a mention in major histories of the photographic process, should now, at the least, be acknowledged as the world's second daguerreian artist. Yet in none of the public or printed statements made by either Daguerre or François Arago does Hubert's name ever appear. He must have been of some material help to Daguerre in finalizing the daguerreotype process, thanks to his own obvious understanding of the science involved, but he never sought independent credit for his contribution. And there was of course a precedent: in the long tradition of the artist's studio it was quite normal for the master to put his name to the work of one or several pupils who

carried out the groundwork, and perhaps the assumption here was much the same.

One thing is certain: the daguerreotype process – as far as Daguerre was to take it – had been perfected by late 1837, at the identical point at which Henry Talbot in England had got as far as he could with his own process. But how Daguerre took the final steps necessary to make the process as practical as it is beautiful remain lost. In the most basic terms, the daguerreotype is an image made on a highly polished silver plate made sensitive to light by fuming it with the vapours of iodine. The sensitive plate is then exposed in the camera obscura and the latent image developed out over a pot of heated mercury. The remaining, unexposed silver iodide is removed by fixing the plate in a bath of hot salt solution. Wash; dry; frame. *Voilà!* It sounds simple and straightforward but how did Daguerre get from point 'A' – Niépce's heliograph – to point 'B' – the daguerreotype? Few plates remain of Daguerre's earliest work, fewer than would certainly have been expected, and he published nothing other than an instruction manual to give any insight into his experiments or thinking during these seminal years.

How and why Daguerre came to use the chemicals and materials that he did is certainly unique in the history of photographic experimentation, for the path he followed appears to have been not just the path less travelled but a path that he alone pursued. The stories that have come down to us are often discounted as too simplistic and unscientific – the stuff of myth, in which the lucky Daguerre, with little or no education in the sciences, stumbles serendipitously onto a great secret. They tend to make him appear less intelligent than he certainly was and imply that he was as surprised as everyone else that his process actually worked. But the fact that Daguerre

persisted, in the face of repeated failures over many years, testifies to an orderly and intelligent mind.

The use of a sensitized metal plate rather than sensitized paper to accept the image is unique among all of the early experimenters, but it is clearly down to Daguerre's collaboration with Niépce, as too his use of iodine, although Daguerre's introduction of this chemical into the process was not just a new twist but a giant step forward in creating an image. The story of the spoon left on an iodized plate sounds plausible enough, if perhaps apocryphal, but the next step in the process achieved by Daguerre – and it was the crucial one of bringing out the latent image – is the stuff of genius. Either that, or it was yet another lucky break.

All experimenters in photography prior to Daguerre had tried to make images on salts of silver solely by the action of the sun – the 'printing out process' as it was later called – and all of them had found it far too slow for reasonable results to be achieved. Niépce's eight-hour exposure was never going to create an image with believable or even comprehensible shadows. There had to be a way to speed up the process – by finding either a new substance that was exponentially more light-sensitive than any so far used, or a way to intensify the faint images produced with the camera obscura. The best bet would be to find another chemical or process to bring out the image after the initial exposure – later referred to as the 'developing out process' – for this was the key component in making photography practicable.

Talbot's camera images were printed out until his Calotype process of 1840, but with that exception, all other camera photography from 1839 up to the digital age has used a short exposure time to capture just enough light energy to initiate the creation of an image. This hidden or latent image, whatever the process – be it Kodak, Polaroid or Tintype – is

then brought out by chemical development. Those who saw Niépce's first plate commented on the fact that the angle of the sun had changed so much during the eight-hour exposure time that the shadows were obliterated; Alphonse Hubert had also mentioned the problem in his 1836 response to the premature announcement of photography. Daguerre overcame it by achieving dramatically shorter exposures – from three to fifteen minutes – thereby securing the shadow in one fixed direction only. He was able to do this because the short exposure was sufficient to *capture* the image – even though it was still invisible to the human eye – leaving it to be developed out later in the laboratory.

The 'magic' developing agent needed to reveal a latent daguerreotype image turned out to be mercury. Daguerre has rarely been credited with discovering how to develop the latent image, yet photography could not have progressed without it. How this came about is often referred to as the 'Magic Cabinet' story, and is just as often decried as pure fiction, but it is now a firmly established part of the apocrypha of photographic history and one that, in a story crowded with scientific jargon, makes the subject accessible to the layman.

The story goes that, one day in 1836 or 1837, Daguerre had exposed an iodine-sensitized plate in-camera but found that when he removed it there was no image visible. With a sigh, he put the plate away in his chemicals cabinet and went to bed. The next day when he opened the cabinet he was shocked to find that the image had mysteriously developed out over-night. Almost by magic, the vapour from one of the chemicals in the cabinet must have caused the latent image to emerge. In order to work out which it was, Daguerre prepared another plate and placed it in the cabinet, this time removing one of the chemical bottles at random. The next day an image had

again appeared. He therefore patiently repeated the experiment over a period of days, each time removing another chemical. At last the cabinet was empty, but when he placed one final plate in it, yet again the image appeared. Daguerre knew that there had to be a logical explanation. On inspecting the seemingly empty cabinet he discovered that the mercury from a broken thermometer had spilled out inside it. The fumes of the mercury had, quite simply, 'developed' the images. Whether it was luck, fate, or just another myth, from here on the future of the daguerreotype was assured.

Yet even now Daguerre still had one final technicality to overcome: and it was one that had frustrated all of the earlier would-be inventors of photography. After making an image on light-sensitive material, how do you fix it – that is, stop the entire surface, image and all, from continuing to darken until all you are left with is a black sheet of paper or a dark metal plate? According to Daguerre's process, perfected during 1837, he first tried a heated solution of salt water as the fixing agent. This solution will remove the unexposed silver iodide from a photographic plate, but very slowly and not always very effectively. At some point between the beginning of 1839 and the publication of his manual in August of that year, Daguerre switched from using salt water to sodium thiosulphate, commonly referred to in the nineteenth century as 'hyposulphite of soda' and popularly known as 'hypo'. But how did he make this final leap in the perfecting of his process?

The most plausible explanation comes from a documented visit made in May 1839 to Daguerre's studio by Sir John Herschel (later to be knighted and made a baronet). Back in 1819, during his own chemical experiments, Herschel had discovered that hyposulphite of soda in solution was a perfect agent for dissolving silver salts, which could then be washed away. As recently as January 1839 Herschel had been conduct-

ing further experiments in photography and when he visited Daguerre and examined his plates just four months later, it seems logical that he would have mentioned his own earlier work with hypo. Whether the suggestion came from Herschel or not, we shall never know, for Daguerre remained quiet on the subject, as he did on so many other aspects of his invention. Yet here, at last, was the crucial stage in the entire photographic process: a bath of 'hypo' was, in the end, all that was needed to fix the image. It was so simple yet it was the one thing that had eluded the two men who might have beaten Daguerre and Talbot to the post – Tom Wedgwood back in the 1800s and Nicéphore Niépce in the 1820s.

Having finally solved the problem, Daguerre now believed that his method could be made public and sold. He knew from his experience with the Diorama, which he had patented in England through his brother-in-law John Arrowsmith (although not in France), that once his photographic process became public it would be quickly followed by numerous imitators and competing processes. The patent system in England was far more effective than in France and he was worried that the French system, as it then stood, had too many loopholes and would never protect him either creatively or financially. Once it was revealed to the world anyone would be able to take up his method and he would not receive a penny. Daguerre also had to re-evaluate his situation in regard to his contract with Isidore Niépce. He decided unilaterally to revise the contract based on his belief that the process he had now perfected owed little to the original tentative experiments that he had made with Niépce prior to his death in 1833.

The younger Niépce was appalled at what he saw as the marginalization of his father's contribution but in the end financial need proved stronger than filial loyalty. Isidore signed the new agreement in order to protect his own financial stake,

with Daguerre offering the palliative that Nicéphore Niépce's name and original heliograph process would be prominently mentioned when the daguerreotype was announced; the proceeds of the sale of both the heliograph and the daguerreotype would be shared equally. Daguerre is often criticized for his self-interest at this point, claiming sole authorship of the process and naming it after himself, but the process he had arrived at by 1837 really had little in common with the heliograph. Had he so chosen, he could have opted for a far more ruthless response, which was to wait until their contract expired in 1839 and then cut the young Isidore Niépce out of the profits altogether.

Their initial problem was how best to profit from this valuable invention. If a French patent wouldn't protect them and allow them to claim licence fees from those who used the process then Daguerre and Niépce would have to find another way. The first option was simply to sell the process in its entirety to a single buyer who would then himself have to deal with the issues of patents and licences. Daguerre and Niépce let it be known that they would be willing to sell the process for 200,000 francs but at this stage no one was willing to part with that amount of money on something so new and untested. Another option was to sell their patent by subscription but the idea never took off and by midsummer 1838 Daguerre decided on a different tactic. Showman that he was, he went on his own publicity campaign, touring Paris with a wagonload of photographic equipment, stopping to make impromptu daguerreotypes of bridges and street scenes and inviting people to inspect the results. But the public response was wary: wasn't Monsieur Daguerre, the illusionist par excellence of the Diorama, simply conjuring up yet another clever optical illusion when he hid himself under the dark cloth?

When Daguerre's impromptu demonstrations across Paris

still failed to drum up any subscribers to his patent, he decided to try again the following January. In order to enhance the chances of success he proposed mounting an exhibition of 40–50 of his daguerreotypes and began galvanizing interest from within the scientific and artistic community by meeting with several French scientists as well as the artists Paul Delaroche, Henri Grevedon and Alphonse de Cailleux, curator of the Louvre. But it was the leading academician and scientist François Arago, a member of the Republican opposition in the Chamber of Deputies, who immediately grasped the huge potential of Daguerre's invention. In his view, it would not hold up as a patented idea; once the secret was out anyone could make use of it and Daguerre would be left without financial compensation for all his years of dedicated work. Far better, in Arago's estimation, was that the daguerreotype process should be put to the service not just of science and the arts – but the nation too. Daguerre could personally oversee the training of operators, thus enjoying an authorial position as such, but being free from the day-to-day grind of its commercial promotion. With this in mind Arago offered to take up Daguerre's cause directly with the government, convinced that it should buy his process outright and release it to the world for the betterment of all – and the greater glory of France.

Chapter Fifteen

THE MOST WONDERFUL DISCOVERY
EVER MADE

On 7 January 1839, in a speech at a meeting of the Académie des Sciences, François Arago proudly announced Louis Daguerre's creation of a process to capture and preserve the images seen in the camera obscura. Instead of being greeted with the scepticism that Daguerre had expected, the *gravitas* with which the respected Arago made his announcement left the members of the Académie at first in a state of disbelief that such a thing could have been accomplished and by the end of his speech in no doubt that it had.

After making his momentous announcement, Arago promised that further details of the daguerreotype process would soon be released. But this was not to be the case; it would remain a secret until an agreement with the French government had been reached. But official government agreements come very slowly, allowing a stunned Henry Talbot time to count the cost of his own incorrigible tardiness. 'I was placed in a very unusual dilemma (scarcely to be paralleled in the annals of science),' he recalled a few months later, 'for I was threatened with the loss of all my labour, in case M. Daguerre's process proved to be identical with mine.'[1]

Talbot now had to contemplate how best to respond to Arago's unexpected announcement. It had clearly pained him,

remembering as he did their past association in Paris, to see the 'zeal and enthusiasm of Arago, whose eloquence, animated by private friendship, delighted in extolling the inventor of this new art', to everyone who would listen; nor did Talbot fail to see the obvious and strongly patriotic impulse behind it.[2] The announcement had taken him totally by surprise, pre-empting publication of his own entirely different line of photographic research, and one that had already led him to the invention of what in the long run would be the basis of a far more versatile process. Henry Talbot had, for some time, been well ahead of Louis Daguerre's game. But it was entirely his own fault that he had been caught well and truly napping.

It still seems incomprehensible to us today that a man who was already publishing learned articles and readily engaging with fellow scientists on such a regular basis had not immediately written up the results of his experiments and made them publicly known. Talbot's failure to do so would dog him for the rest of his life, leaving him in the end often ridiculed and even despised by many of the photographers who later made their living from his pioneering work. Worse, even today Talbot's failure to lay claim then and there to his invention, conveys the lingering – and erroneous – impression that he was photography's second inventor – and never its first.

On 6 January 1839 the *Gazette de France* made the momentous announcement of Louis Daguerre's discovery of a photographic process, pre-empting the official announcement the following day. This was reprinted verbatim by the British press over the next couple of weeks and quickly spread across the British scientific community. We have no record of Talbot's initial response when the news reached him but he must have been completely shell-shocked by it. All those years of work; the careful, insightful observations that had led him finally to a way of preserving photographic images; all his natural scientific

flair and the ready technical grasp that had allowed him to see the advantages of a negative–positive process – none of this mattered any more. He had been pre-empted. An afternoon's musings on the shores of an Italian lake in 1833 and a serendipitous sunny day in August 1835 at Lacock must have seemed like a dream from which he had been rudely awoken. The stable door was wide open; the horse was gone. What was he to do?

Talbot and his wife had, by Christmas 1838, established themselves in London as Constance was in the last month of her third pregnancy. With no time for careful preparation and with many of his best samples still back in Lacock, Talbot quickly pulled together his jottings from Notebooks L and M, dug out the first images he had made in the summer of 1835 and made haste to present them to the public. His embryonic idea that had been quietly gestating for the past four years was now to be thrust into the world, prematurely, in response to the shock of Daguerre's announcement. In his response, Talbot's primary concern was not the glory that his own invention might bring; that sort of fame would place demands on him that he characteristically chose to avoid. What mattered was his scientific integrity in the eyes of his peers and the urgent need to establish the priority of who had conducted the key experiments first – himself or Daguerre. It was a simple matter of securing proper credit where due.

In a flurry of activity Talbot sent samples of his images to Michael Faraday at the Royal Institution and asked that they be displayed at the members' meeting to be held there on 25 January. They weren't a coherently thought-out exhibition but simply random examples of what he had to hand, including several contact prints of leaves, lace and an engraving and – more importantly – some camera obscura views of Lacock Abbey. He also enlisted the support of his colleague

Sir John Herschel, writing to him on 25 January from London to inform him that he was

> having a paper to be read next week before the Royal Society, respecting a new Art of Design which I discovered about five years ago, viz. the possibility of fixing upon paper the image formed by a Camera Obscura; or rather, I should say, causing it to *fix itself*, I should be most happy to show to you specimens of this curious process. If you could not make it convenient to call here, Slough has now become so accessible by the railway that I would take a drive there any day if you would appoint an hour.[3]

Talbot then wrote to the two scientists whom he knew best in Paris, the physicist Jean-Baptiste Biot, and his old acquaintance François Arago, informing them that

> In but a few days I shall have the honour of addressing to the Académie des Sciences, a formal claim of precedence, of the invention announced by M Daguerre in its two principal points:
>
> (1.) The fixing of the images of the *camera obscura*
>
> (2.) The subsequent preservation of these images, in such a way as they might withstand direct sunlight.[4]

At the least, Talbot wanted the French Academie to be aware that he had, quite independently, created his own images in the camera obscura – so that if his process and Daguerre's proved to be one and the same there could be no room for allegations that he had simply copied Daguerre's process. It was principle, not profit, that counted.

The third phase of Talbot's hastily organized response was to write a paper outlining his own process, which was presented on his behalf at the Royal Society meeting in London on 31 January. All of these steps were necessary to protect his work

from charges of plagiarism. Talbot's paper, 'Some account of the art of photogenic drawing or, the process of which natural objects may be made to delineate themselves, without the aid of the artist's pencil', laid out his own claim to the invention, gave a brief history of his experiments and suggested ways in which the process could best be exploited. He managed to say all this in only twelve pages; there was no time right now for a detailed explanation of all the chemistry involved. But one thing he did at least concede, in a nod to his own English precursor: 'it appears that the idea was originally started by Mr Wedgwood'.[5] It was a passing allusion that still failed to register in the scientific community forty years after Wedgwood's pioneering work.

Without pause for thought about profit or patent, Talbot hurried to publish complete details of his photogenic drawing process less than a month later, on 21 February 1839. The experiments he conducted in 1834, as he now outlined them, had been based around the common understanding that silver salts, such as silver nitrate, would darken on exposure to light, the point at which Wedgwood, Niépce and Daguerre had abandoned their own experiments on paper. Talbot's contribution was to take this common observation as the springboard for the next giant leap. Back in 1835, when he had successfully captured the image of the oriel window at Lacock, he had greatly enhanced the light-sensitivity of his paper by switching from a silver nitrate coating to one of silver chloride, which turned out to be much more sensitive to light, as he observed in his Notebook L:

> Two facts are singular. That a weak solution of salt
> discolours faster than a strong one: and a small quantity
> of it acts much better than a large one. The strong
> solution makes a slate colour, but the weak solution
> makes it nearly black.[6]

Talbot's observation that a strong salt solution retarded the discoloration process was the inspiration behind his method for preserving the image. He deduced that if a strong solution of salt combined with silver was fairly inactive in light, then a bath in a saturated solution of salt after the image had been made might desensitize the paper to the extent that the image might be preserved. He hadn't removed the sensitive layer completely but had desensitized it to the point that it could be examined in light without an immediate and significant change occurring. And this was the key, for at last Talbot had moved beyond the traditional stumbling block – the impermanence of images so far achieved – by perfecting a way of capturing 'the most transitory of things, a shadow, the proverbial emblem of all that is fleeting and momentary'.[7]

On the whole, Talbot's process was a great deal simpler than Daguerre's; so simple in fact that it could be accomplished by anyone with minimal chemical knowledge and skill. But his paper announcing his own method was, in contrast to all the ceremonials in Paris, modest and unflamboyant and decidedly lacking in fanfare. At the heart of it Talbot's thoughts were not of commerce, or self-advancement, but of science – the science that was the driving force in his life. With typical modesty he concluded his paper:

> I have thus endeavoured to give a brief outline of some of the peculiarities attending this new process, which I offer to the lovers of science and nature. That it is susceptible of great improvements I have no manner of doubt; but even in its present state I believe it will be found capable of many useful and important applications besides those of which I have given here a short account.[8]

In Britain, with Daguerre's 'Most Wonderful Discovery Ever Made'[9] being trumpeted in the press, and evoking stunned

admiration, no one was more bitterly disappointed than Talbot's unerringly ambitious mother. 'I shall be very glad if M. Daguerre's invention is proved to be very different from yours,' she told him. But what, she asked, had been the point of withholding his invention for five years only to now be faced with a competitor?

> If you would only have made it known *one* year ago, it could never have been disputed, or doubted, and there are many people entirely ignorant of *the details* of the discovery who will run away with the idea that it is the same.[10]

In short, Lady Elisabeth had no doubts: her clever son, who had promised so much, had quite wilfully 'squandered his possibilities'.

Chapter Sixteen

FROM TODAY, PAINTING IS DEAD

In most standard histories, the year 1839 is generally looked upon as marking the birth of photography. The yet-to-be-defined role of this new art, after its official announcement by François Arago on 7 January, appears to have left everybody either in wonderment or – for those whose livelihoods would be threatened by it – shocked and apprehensive. What would its impact be for those whose living and social status depended on their artistic talents? None was more shocked than the celebrated realist painter Paul Delaroche. Renowned for his depiction of great moments in history – such as the execution of Lady Jane Grey, the Princes in the Tower and Napoleon crossing the Alps – Delaroche was reported to have been filled with dismay when he saw a daguerreotype for the first time. 'From today, painting is dead,' he is said to have exclaimed in painful astonishment, a quotation so often repeated since that it has inevitably taken on the patina of truth.[1]

The quotation is, however, merely another facet of the mythology that grew up around the birth of photography in France. Unlike the majority of apocryphal stories surrounding Daguerre's invention, this quotation can in fact be traced to an 1874 book – *Les merveilles de la photographie* – by the French chemist Gaston Tissandier. Whether myth or hyperbole, the statement certainly encapsulates both the sense of wonder and

the professional and creative anxieties expressed by many in the artistic community when they saw a photograph for the first time. Certainly the first broadside in the whole artistic debate over photography's potential ascendancy over painting was fired by the *Gazette de France* when it declared in its 6 January announcement of the daguerreotype: 'You will see how far from the truth of the daguerotype [*sic*] are your pencils and brushes.'[2]

On the other side of the Channel all was quiet for a few days after Arago's announcement. It is still not clear if the *Literary Gazette* was the first to announce the process in England; French and English newspapers travelled daily by steamer between Calais and Dover, and visitors brought news and gossip along with them all the time. But the news soon spread and within weeks the rest of Europe and America became aware of the invention of photography, whether under the name 'daguerreotype' or 'photogenic drawing'. It would be a year that saw intense debate on the subject; in England, Queen Victoria had yet to see her twentieth birthday at a time when her army was involved in the second year of a bitter war in Afghanistan and the most popular novelist of his day, Charles Dickens, was publishing his latest novel *Nicholas Nickleby*; in Provence, Paul Cézanne, the giant of French impressionist painting had only just been born while the great French writer Stendhal had just produced his second great novel, *The Charterhouse of Parma*. The world didn't lack conflict, creative innovation or new discoveries, but the first announcements of the invention of photography – so full of promise but lacking in specific detail – sparked a deluge of questions from press and public alike. What were these 'processes' – the daguerreotype and photogenic drawing? Could they really capture the sun's rays? Were they the same? Had one of the inventors merely copied the work of the other? Daguerre's discovery was nothing short of a miracle. But how

could the public be assured, asked the *Globe*, that this 'drawing by sunshine' was not just 'the work of a clever draughtsman'? For once, Monsieur Daguerre, who liked nothing better than revelling in the public acclaim for his work, was surprisingly silent on the matter.

Only a few of these questions would be answered definitively by the end of that first year; some of them are still argued today. The first shot in the controversy had actually pre-empted Arago's announcement on 7 January. It was fired in the *Gazette de France* the day before, by journalist Hippolyte Gaucheraud, who leaked word of Daguerre's discovery, announcing that 'M. Daguerre has discovered a method to fix the images which are represented at the back of a camera obscura; so that these images are not the temporary reflection of the object, but their fixed and durable impress, which may be removed from the presence of those objects like a picture or an engraving.'[3] Gaucheraud was lyrical in his praise of the views of Paris he had seen and even that of a dead spider, made by Daguerre using a solar microscope. The scientists Francois Arago, Alexander von Humboldt and Jean-Baptiste Biot, he said, had all seen these images and attested to the scientific method of their production. Six days later Gaucheraud's article was published in English by the *Literary Gazette*.

Soon after these announcements were made the inevitable happened: numerous other people came forward, claiming to have performed the same experiments years earlier. Speculation was rife as newspapers throughout Europe and America began to carry their stories. Some claimants had probably used silver chloride paper, which was the starting point for many proto-photographic inventors, but had failed to bring their experiments to a successful conclusion. Either that, or they had encountered insurmountable obstacles that suggested that no

viable method would ever be found. Most, however, were honest enough to admit that their results had been unsatisfactory.

But what of Daguerre's collaborator Nicéphore Niépce; didn't he deserve some of the credit? Surprisingly, it was in the English not the French press that the earlier, pioneering work of Niépce was first raised – by his friend from Kew, Franz Bauer. One of Tom Wedgwood's friends and former acolytes also drew attention to the experiments that Wedgwood had carried out at the end of the eighteenth century. Meanwhile, and on a more profound, theological level, questions were already being asked about the morality of this new discovery. Was it God's will that man should seek to capture the most fleeting and temporal of his creations – the shadow? One of the first discordant notes in the rapturous reception came from Germany in a dour and pious article in the *Leipziger Stadtanzeiger*:

> The wish to capture evanescent reflections, is not only impossible, as has been shown by thorough German Investigation, but the mere desire alone, the will to do so, is blasphemy. God created man in His own image, and no man-made machine may fix the image of God. Is it possible that God should have abandoned His eternal principles, and allowed a Frenchman in Paris to give to the world an invention of the Devil? . . . The ideal of the Revolution – fraternity, and Napoleon's ambition to turn Europe into one realm – all these crazy ideas Monsieur Daguerre now claims to surpass because he wants to outdo the Creator of the world. If this thing were at all possible, then something similar would have been done a long time ago in antiquity by men like Archimedes or Moses. But if these wise men knew nothing of mirror pictures made permanent, then one can straightway call the Frenchman Daguerre, who boasts of such unheard of things, the fool of fools.[4]

Centuries of entrenched religious thinking might prompt a few other clerics to join in this condemnation (predating Darwin's later battle with the creationists over evolution), but it could not stem the flood of international excitement at the news, heightened by the fact that although the existence of a successful photographic process had now been revealed, nobody but Daguerre and his assistant Hubert knew how the images were made. And they, for the time being, were saying nothing.

*

While the French press was full of praise for Daguerre and his wonderful invention and the British newspapers seemed to pick up and repeat every word, Henry Talbot and his equally startling announcement received little if any mention in France. Nor were the British able to report on his work without mentioning Daguerre in the same breath. No one made any great drama out of Talbot's invention and those who did refer to it were fairly reserved in their compliments. On 2 February, the *Literary Gazette* was the first to ask which nation could rightfully lay first claim to the invention, pointing out that 'with national and personal characteristicness' the French had chosen to call their process the 'Dagueroscope' [*sic*] after its inventor, while, with typical modesty, 'our unpretending countryman, Mr Talbot' had chosen to call his method merely 'Photogenic'. In reporting Talbot's paper, the *Liverpool Mercury* was quick to take up the defence of British national interests in the growing controversy: 'although we are cosmopolites in a tolerably extensive sense of the word,' it reported, 'we are by no means destitute of national *esprit de corps*, and it is therefore gratifying to us to learn, that an Englishman will participate with M. Daguerre in the honour which will attach to the name of the man who first, either by some happy chance or by the

result of patient investigation, discovered the secret of making nature delineate her own works'.[5]

Such press announcements were important if precedence were to be established but they brought their own problems. While preparing his paper for the Royal Society, Talbot was contacted by both the *Literary Gazette* and the *Athenaeum* seeking permission to publish his article. This would have ensured that Talbot's message would reach the widest audience possible, and at an earlier date. But to allow publication in either of these journals would preclude his paper from being published in the prestigious *Transactions of the Royal Society*, a privilege that Talbot hated to pass up on as it was where all of the great scientific discoveries of his day were first published. The society's rules were clear: only previously unpublished papers were eligible for this honour. Talbot sought the support of Herschel and Roget in an attempt to have this rule waived, but in the end the need for faster publication in the weekly papers won out over the quarterly journal of the Royal Society.

Despite the positive and complimentary reports published in the English press, Lady Elisabeth still found reason to be frustrated at her son's inexcusable tardiness. In a letter of 3 February she told him 'I shall *ever* wish it had been otherwise. This is *at least* the second time the same sort of thing has happened,' adding ruefully,

> how I do wish it might operate in future as a spur to make you do yourself justice. Few things would give me more pleasure than to have you *known* and *prized* in the scientific world as Nature when she gave you those talents intended you should be, as for the *Mundane* world that is too insignificant to care about.[6]

Talbot responded in his own defence two days later, explaining that 'It appears that in point of fact M. Daguerre's experiments

were prior to mine.'[7] It was a painful admission to have to make, but he had by now received a letter from Biot, explaining that Daguerre had been known to have been working on his process for at least the previous fourteen years.

The phlegmatic Talbot's low-key response to the crushing disappointment of being pre-empted continues to baffle to this day. Any other man in his position would have been furious, distraught or both. But even Talbot's letter of 30 January to William Jerdan, editor of the *Literary Gazette*, enclosing the account of his own photogenic drawing for publication, was extraordinarily restrained, if fatalistic:

> Although I am very far indeed from being of the opinion, that *'Chance rules supreme in the affairs of men'*; yet I cannot help thinking that a very singular chance (or mischance) has happened to myself, viz that after having devoted much labour and attention to the perfecting of this invention, and having now brought it, as I think, to a point in which it deserves the notice of the scientific world, – that exactly at the moment when I was engaged in drawing up an account of it, to be presented to the Royal Society, the same invention should be announced in France.[8]

It wasn't his intention, Talbot assured Jerdan, 'of rivalising with M. Daguerre in the perfection of his process . . . but to preclude the possibility of it being said hereafter, that I had borrowed the idea from him, or was indebted to him, or any one, for the means of overcoming the principal difficulties'. It was all down to a matter of pride, and confidence for that matter, in a process which he had perfected entirely independently. The words are those of an old-fashioned man of honour, who ultimately had a sense of humility about how his images were achieved. It was the picture, he insisted, 'which makes itself'; people might imagine that 'one has at one's call

the Genius of Aladdin's Lamp' in order to execute them.[9] But that was not the case, and he was only sorry that 'Fortune did not smile' on his precursor, Sir Humphry Davy, in his 1802 experiments and that he had abandoned them.

Early in February Talbot received much valued support in his bid for recognition from Sir David Brewster, who, while he was 'delighted beyond measure, both from personal and national feelings that you had anticipated the French Artist in his beautiful process', urged him to protect the details of his own process.[10] 'You ought to keep it perfectly secret till you find you cannot advance farther in the matter, and then it would be advisable to secure your right by a Patent.' Brewster thought for Talbot to do so was perfectly reasonable and legitimate: 'a Patent would give a more fixed character to your priority as an Inventor, and I do not see why a Gentleman with an Independent fortune should scruple to accept of any benefit that he has derived from his own Genius'.

Talbot agreed with Brewster that he needed to shore up his own claim – either of precedence of invention, if his process were different from Daguerre's, or at least proof of independent discovery should they turn out to be the same. He decided therefore to go ahead and publish the working details on his process for sensitizing the paper and fixing the images. His initial paper to the Royal Society had described his discovery and what it could do, but was noticeably lacking in the science needed for others to replicate his experiments. This second paper, entitled 'An Account of the Processes employed in Photogenic Drawing', was read by Samuel H. Christie FRS and secretary of the society at the regular meeting held on 21 February.

Somewhat mollified by her son's latest letter, but with her ambitions still firmly fixed on the monetary value and scientific praise to Henry of his invention, Lady Elisabeth was neverthe-

less dismayed by his decision to publish details of own process, pointing out that it 'precludes entirely all chance of your making your fortune by selling it as M. Daguerre intended or getting a patent'.[11] Like any proud mother, she remained fiercely ambitious for her son and consoled him by adding that 'At any rate your name will be disseminated over Europe.' She could not help but find it ironic that 'M. Daguerre has done more for your ambition than your own countrymen.' Indeed, Lady Elisabeth noted with pleasure that the race to lay claim to being the first to perfect this ground-breaking process 'has already been compared to the Young & Champollion controversy' – an allusion to the much-publicized controversy over the first successful translation of the Egyptian hieroglyphs of the Rosetta Stone. The Frenchman Jean-François Champollion had published his sensational findings in 1822, but it turned out to be on the back of years of laborious, unsung research by others – most notably the English Classicist Dr Thomas Young, who had first presented a paper on the subject to the Royal Society of Antiquaries in 1814.

Lady Elisabeth refused to abandon her lone campaign to secure due recognition for her brilliant, if reluctant son. It was a constant battle but she had the tenacity of several mothers rolled into one. All year long, she continued her resolute assault on Talbot's crippling lack of will, beating him over the head in letter after letter: 'I enclose you a bit from the Leipsic Gazette which shews they are pirating you in Bavaria *without* any acknowledgement,' she wrote to him in early April.[12] What was he going to do about it? She was incensed at unfounded criticism of Henry's challenge to the Daguerre claim of precedence, particularly when he had 'betrayed anything but *soreness*' over his huge disappointment. 'On the contrary,' she went on, 'many people thought you did not defend your priority with sufficient strenuousness'. Instead he had offered

nothing but 'gentleman-like courtesy'. That just would not do. Lady Elisabeth was like a bull at a red rag. Henry must send copies of his work as soon as possible to Dr Hamel of Hamburg, a corresponding member of the Russian Academy of Sciences* who happened to be in town and was anxious to send some to Russia 'for the Emperor's second son, a very scientific young man'.[13] Everyone was badgering her for copies of Henry's work; he must get more copies to her. His equipment needed replacing; he must go out and 'chuse the very best Camera Obscura that is to be had, & let me give it to you.[14] I am sure your discovery would be perfect dans son genre if you had a better instrument to work with.' She knew what she was talking about: 'it is worth *anything* to your celebrity to possess such a one'. Everywhere she went Lady Elisabeth acted as her son's personal PR lady: on the London social scene, she solicited the attention of Mr Babbage, the celebrated inventor, who told her, much to her satisfaction, that Henry's was 'a reputation that *would last*'.[15] Meanwhile she urgently needed four of his photographs for the diplomat Baron de Neumann to send to Count Metternich in Austria. 'Whatever it costs, she concluded, 'money is nothing in the balance with *Fame*.'[16]

In the midst of all this nagging from his mother and the turmoil surrounding the announcement of the invention of photography, Talbot did at least have something to celebrate. He had become a father again on 25 February, when Constance had given birth to their third daughter. He had had to take time out to write to family members about the blessed event. Witty suggestions came back from Talbot's cousin Harriot that their daughter should perhaps be named Photogena in honour of her father's discovery. Lady Elisabeth suggested

* See note on Joseph Hamel on p. 69.

Iodine as a 'pretty' name, although it 'might be still more softened into Ioline'.[17] Fortunately for the little girl, neither suggestion was taken seriously and she was given the far prettier name of Matilda Caroline, in honour of the late Admiral Feilding's sister Matilda and Talbot's elder half-sister.

Chapter Seventeen

PHOTOGENIC DRAWING

What was Daguerre doing meanwhile in Paris during these first turbulent months of international debate and uncertainty? It is hard to believe that the gregarious artist would have sat quietly by while such a storm over precedence swirled around him, but in order to protect his chance of receiving a lucrative reward from the French government he could not make any public statements or reveal the secrets of the process. He did, however, entertain a few members of the press in an effort to keep his invention in the news; various men of science and art also were invited to pay calls on the celebrity inventor to see what all the fuss was about.

One of the first foreign notables to visit Daguerre, on 3 March was Robert Walsh, Jr, an American writer and publicist living in Paris, who spent an hour in his studio examining his images and found it impossible to 'express the admiration which they produced' in their 'exquisite perfection'. 'There is one view of the Seine, bridges, quays, great edifices, etc., taken under a *rainy* sky,' he told the *New York American*, 'the graphic truth of which astonished and delighted me beyond measure. No human hand ever did nor could trace such a copy.'[1]

Walsh was followed four days later by the American painter and inventor Samuel Morse, who had come to Paris in March 1839 to arrange a patent for his telegraph system, which he

had first publicly demonstrated in New Jersey the previous year. As a painter of some standing, Morse was curious to see this new art form and sent a note to Daguerre requesting an audience. When he called on him at the Diorama on 7 March he was treated to a private view of some of Daguerre's plates. Morse was completely bowled over. He recalled his own experiments on paper and how he, like so many others, had been defeated at the final hurdle by his inability to find a way of stabilizing his images and preventing them from turning black. Like Daguerre, he had noted they were reversed in tone (i.e. negative) but, unlike Talbot, who crucially had recognized the negative as a matrix from which to produce multiple positives, Morse had not realized its significance and had abandoned his work as a lost cause. On seeing Daguerre's work he wrote to his brother in America: 'The exquisite minuteness of the delineation cannot be conceived. No painting or engraving ever approached it.'[2] In short, Morse had no doubt that the 'Dageurrotipe' was 'one of the most beautiful discoveries of the age'. The plates Morse saw surpassed all expectations, in particular a view of the Boulevard du Temple, which, extraordinarily, included the distinctive figure of a man who had stopped in the street to have his boots polished by a boot-black, his feet and legs remaining still long enough to register on the plate, while movement in his upper body had resulted in a faint blur. As a fellow inventor, Morse invited Daguerre to come and inspect his own innovation, which Daguerre did two days later, when they discussed the telegraph's design and its potential uses.

The very same day and at the exact time that he visited Morse, however, there was a dramatic turn in Daguerre's fortunes – and one that perhaps, unexpectedly, despite being the disaster it first seemed, solved a major problem that had been hanging over his head for some time. When Daguerre

returned to the Diorama later that day he found it completely engulfed in flames. A fire had broken out at about 12.30 in the afternoon, its progress having rapidly been accelerated by the large amounts of combustible material inside the building; fortunately it had not yet spread to his house next door in the rue des Marais. There was little that the detachments of the municipal and national guard could do to stop the fire, although members of the public joined them in forming chains to hand buckets of water from the river for filling their fire engine. Soon the flames had burst through the five windows of the Diorama facing the street. Daguerre begged the firemen to leave it to burn – as far as he was concerned it had become more of a liability than an asset – and instead to try to save his house and studio next door, where all of his daguerreotype apparatus and his collection of images were stored. Half an hour later the Diorama building came crashing down, as the wind blew the flames in the direction of the Faubourg du Temple and the rue des Marais. At about 2 o'clock in the afternoon the fire burst out of the roof of one of the houses there, mingling belching clouds of smoke with the 'enormous greyish clouds which were then rising over the ruins of the Diorama'.[3] Fortuitously, the firemen had been able to rescue Daguerre's apparatus and many of the precious daguerreotypes on which his fortune was now staked.

The loss of the Diorama, which in its day had been the key to his fame and fortune, brought to a close a phase in Daguerre's career that was already in decline, the Diorama's profits having fallen steeply in recent years. It is possible that Daguerre could have sold it, but on its loss-making record by 1839 it wouldn't have brought him much money. Several of Daguerre's great Diorama paintings – 'The Sermon', 'The Temple of Solomon' and 'The Valley of Goldau', along with a new painting that Daguerre had just completed and was about

to put on show – were lost in the fire but these, at least, were insured and in the end he may well have collected more in insurance than the Diorama was worth as a going concern. A far greater loss – though experts are still uncertain whether they ever existed at all – were Daguerre's working notes on his photographic experiments. They certainly have never been cited and if they were not destroyed in the Diorama fire, their whereabouts remain a mystery.

*

While equal amounts of praise and pity were being heaped on Daguerre in France, Talbot was already experiencing the first backlash to his own announcement. Other British photographic experimenters were already trying to cash in on his invention. In late March an article appeared in the *Literary Gazette* stating that two English engravers, William Havell and James Wilmore, had already come up with a new use for photogenic drawing. They had taken sheets of glass and blackened the surface, scratching a design through the black, which they then used as a negative from which to print images. Indeed, as the article stated, so successful had Havell and Wilmore been in their method that they had sought to take out a patent for it.

Talbot was quick to respond: 'I fully expect that great improvements will hereafter be made which I have never so much as thought of,' he wrote in the *Literary Gazette* at the end of March, 'but this is not one of them.'[4] In fact, such was Talbot's indifference to this method that he added that 'I should not have considered it worth while to say anything on the subject, if they had not gone so far as to apply for a patent.' This etched glass process – later known as *cliché verre* – was not new to Talbot: he himself had tried it during his visit to Geneva late in 1834. He had covered his brief experimentation

with this medium, albeit rather loosely, in his first paper to the
Royal Society. In response, James Wilmore asserted that as the
idea was original to him and that he hadn't known of any
other attempts at it, he thought it reasonable that he should
be able to apply for a patent. His present claim, he asserted,
was also an act of self-preservation; photogenic drawing and
the daguerreotype were now threatening his livelihood as an
engraver. But Havell had had the same thought in mind and,
equally, opposed Wilmore's application for a patent when he
heard about it.

Initially, Talbot had hoped to make his process free to all,
but finding that rivals such as Havell and Wilmore – having
assumed that he was a man of independent means who did
not need or want remuneration – were eager to hijack it for
their own financial gain, he decided to oppose their applica-
tions. Had he ignored this threat and allowed the patent to
go through, he could then have found himself in the unwel-
come position of being forced to pay a fee to use his own
process. The challenge from Wilmore was the first of many;
in the years to come, Talbot, the reclusive gentleman amateur
who hated fuss and cringed at being dragged into the public
eye, found himself up against it from the moment his paper
was published in early February and he would have to
develop a thick skin, as one by one a succession of people
took him to task.

While Daguerre's process was still securely under wraps in
Paris, Talbot's was already in the public domain and other
experimenters were free to take it up without permission and
even make money on it by selling the photogenic paper and
other equipment needed. To this Talbot had no objections.
By April of 1839 several English chemists and booksellers had
jumped on the lucrative bandwagon, with advertisements such
as this by suppliers in Clifton, Bristol:

Superior Photogenic Paper, prepared by Mr West, and warranted to be of a clear, uniform rich brown tint, may be obtained, in Shilling Packets, at the Observatory; of Mr Giles, Chemist, Crescent; of Mr Lancaster, Bookseller, Gloucester-row; of Mr Hartland, Chemist, 12 St Augustine's Parade; and of Mr Lancaster, Bookseller, Broad-street.[5]

In London, the enterprising Thomas Dawson was soon selling photogenic drawing paper 'as prepared by H F Talbot' in packets of 'eight large sheets' for six shillings – 'with full directions enclosed'.[6] For those eager to do it themselves at home the *Magazine of Domestic Economy* published its own 'Plain Instructions for Making and Using Photogenic Paper' in its sixpenny May issue, as a 'preliminary step for young persons' to carry out their very own magical photographic experiments:

Go to the most respectable chemist's in your neighbour-hood, and purchase *a dram of lunar caustic*: this will cost a shilling, and be wrapped in coils of paper, and must be carefully handled, as it blackens the skin wherever it touches it. Get a common phial, which holds nearly a wine-glassful of liquid, and one of the usual draught-bottles of the apothecary is about the size required: Slip into it the lunar caustic, and then fill up the bottle with *soft* water, or rain water, and cork it, shaking up occasion-ally until dissolved. This solution washed over any piece of white paper, converts it into the *photogenic paper*.[7]

Everyone with the few shillings needed could now create their own bit of magic, and stain their hands and their clothes black in the process, so much so that silver nitrate stains on the hands would soon be the tell-tale sign of the amateur photog-rapher. For the professionals, Ackermann's in the Strand, London – a noted dealer in artist's supplies and stationery – was advertising its complete photogenic drawing kits to artists

and amateurs in the *Athenaeum*.[8] Even now, other, more fanciful (and usually unworkable) suggestions for this the newest party trick were coming thick and fast. It was suggested in one news story that people should try tying a sheet of photogenic paper to the tail of a kite, on the promise that 'when it comes down you will have a view of the earth upon it'.[9] By July the new mania for photography had taken London by storm: the Gallery of Natural Magic, at the Colosseum in Regent's Park,[10] was pulling in the crowds with its sensational exhibition of photogenic drawings and the Polytechnic Institution on Regent Street followed suit in September. But this was such a giant step forward in representing the world around us that a considerable air of incredulity persisted about how these photographs had been achieved. When Talbot had sent his first photographic samples out for examination people found it hard to credit their accuracy and he had to explain how they were made. One letter written to him in May 1839, by George Butler, his old headmaster at Harrow, wondered in a mock chiding voice whether there was not some trickery involved in the astonishing levels of veracity achieved. 'You are an errant cheat or, at best, an aider and abetter in deception,' Butler told him.[11] 'Upon opening your packet of Photogene drawings, I was so completely taken in by your lace-picture, that, like a dutiful husband, I was actually handing it over to Mrs Butler as a lace-pattern, – intended for her, – before I discovered my mistake.'

With photogenic drawing being picked up and practised by all kinds of people, including a number of Talbot's male – and female – cousins in Wales, he himself still had no idea of what a daguerreotype looked like, or how they were made. English press reports had said little: only that they were made on metal plates and when they were viewed through a magnifying glass, they yielded up yet more detail too small for the naked eye to

see. Gaucheraud's article introducing the birth of photography to the French, and through translation, the English, had spoken of views of boulevards and bridges and even dead spiders, but reading descriptions of something one has never seen is no substitute for the experience of viewing it oneself. Talbot was deeply frustrated, but he would not have the chance to see his first daguerreotype until the late autumn.

Meanwhile, in the late spring of 1839, he enjoyed the next best thing when Sir John Herschel, his friend and fellow experimenter in photogenic drawing, made a trip to Paris and, like every other scientist given half the chance, took the opportunity of calling upon Daguerre. The Frenchman welcomed Herschel and several other English gentlemen into his studio to examine his pictures. These included Sir John Robinson, secretary to the Royal Society of Edinburgh, and James Watt, the engineer son of the inventor of the steam engine. This meeting is the most likely event that gave Daguerre the idea of using Herschel's hyposulphite of soda to replace his salt water fixer. Whatever Talbot had expected to hear from his friend, he could not have been prepared for the unqualified praise for the daguerreotype that Herschel sent him from Paris on 9 May:

> I have this moment left Daguerre's who was so obliging as to shew us all his Pictures on Silver saved from the fire which burned his house and also one on glass. It is hardly saying too much to call them miraculous. Certainly they surpass anything I could have conceived as within the bounds of reasonable expectations [. . .] In short if you have a few days at your disposition I cannot command you better than to *Come & See*. Excuse this ebullition.[12]

Talbot's reaction to Hershel's 'ebullition' is not known, as no reply to this letter survives. But it clearly did not dampen his

enthusiasm for continuing to experiment on the various stages of his own process throughout that summer. During this time he concentrated in particular on the fixing of the image, as some of his chemical formulations had till now produced indifferent results. He experimented with ways of speeding up the sensitivity of the paper so that it would work better in the camera obscura, in hopes that portraits from life would soon become possible. This was the next big leap that photography would need to make, but at this early stage neither Talbot nor Daguerre had progressed beyond being able to depict inanimate objects such as buildings and still lifes.

Access to information on the new invention seemed a one-way street at present, with the English hearing some of the details of the Daguerreotype but little being said or published in France about Talbot's method of photogenic drawing. Arago never replied to the letter Talbot had sent him in January, but Von Humboldt and Biot had both sent letters of sympathetic support that seemed to reassure him that his own work was being taken proper note of on the Continent. Biot even read a letter from Talbot into the record of the Académie des Sciences, which was published in its scholarly *Comptes Rendus*. But the lack of support from Arago was a huge disappointment after Talbot had for so long nursed fond memories of working with him in Paris in the 1820s. 'There can be no doubt of the great injustice of M. Arago,' he wrote to his mother with an air of restrained disgruntlement: 'he does not seem to recollect that candour would be as great an ornament to his character as scientific eminence, and that the want of it, when conspicuous & evident to the whole scientific world, must result in injury to his own reputation.'[13]

The disappointing lack of any support or even acknowledgement from Arago was compounded by a further and far more serious setback for Talbot in June, when Daguerre and

Isidore Niépce quietly engaged Miles Berry, a London-based agent, to take out a patent on their process for the whole of England and Wales – and this despite Arago's campaign to persuade the French government to buy the process and donate it freely to the world. So why this sudden need to patent the process in England? Was it a case of professional jealousy, or was it spite – a crude attempt to cripple any profit Talbot might make from his own process? Or was there a bigger issue at play here – one of national rivalry, reflecting the long-standing enmity between the French and British nations? It was after all only fourteen years since the end of the Napoleonic Wars. No one has yet been able to fathom the motivation behind this act, and Arago himself never explained it. It may simply have been a reflection of Daguerre's earlier bad experience with the Diorama. He and Bouton had not patented it in France and it soon had many imitators – good and bad – whereas in London, where a patent was secured, there were no attempts at copying their work.

The patent application might in part have been a response to Daguerre's changing fortunes after the tragedy of the fire at the Diorama. Meanwhile, in Paris, after months of delay, Arago had worked hard to convince Tanneguy Duchâtel, French Minister of the Interior, that the government should purchase the process and then release it free to the world as a symbol of France's superiority in the arts and sciences. In a letter to Duchâtel, he spoke movingly of the sacrifice and expense that Daguerre had gone to in order to create this scientific and artistic miracle. He also alluded darkly to powerful foreign sovereigns having made significant offers to him to reveal his secret for the benefit of their own nations. (A rumour had certainly circulated in the English press in February that 'the Emperor of Russia has offered 500,000 francs for [Daguerre's] secret'.[14]) Such claims appear to have no basis in

fact and may have been an invention of the moment to enhance support for Daguerre's award. Arago certainly used all the ammunition at his disposal, reminding the minister of Daguerre's recent losses in the conflagration of the Diorama: Daguerre was not just a genius and a national hero, he was also the victim of a terrible personal loss. Would not M. Duchâtel revel in the opportunity of being the one to put this wonderful invention forward to the Chamber of Deputies? If he was not prepared to do as much, then, with the greatest respect, Arago would bring the bill forward himself.

Duchâtel rose to the bait and immediately formed a committee consisting of Arago, Ludovic Vitet (another member of the Chamber of Deputies), and the artist Delaroche (representing the Académie des Beaux-Arts). Ten days later, after examining the daguerreotype process and evaluating its importance to the French nation, the committee reported back to Duchâtel, unanimous in their belief that the proposal should be put forward to the full Chamber for consideration. Daguerre and Niépce would be required to turn over to the government not just a detailed description of the daguerreotype process but also full disclosure of the late Nicéphore Niépce's heliograph process and any improvements that Daguerre had made to it. The written description of these processes would be placed in a sealed envelope, certified by Arago to be correct. If the bill was passed, the processes would be published and Daguerre would be required to make a public demonstration in the presence of a commission appointed by the minister and to undertake to inform the government of any subsequent improvements to his Daguerreotype process; he was also expected to give up the secrets of the Diorama too, as well as pass on to the French government any subsequent refinements he made to his process.

The major issue at stake was whether the patent should be

purchased outright with a once-and-for-all payment – which Daguerre thought sounded too much like a mercenary business transaction – or by means of a lifetime pension. The latter option was decided on. In return for revealing his process, Daguerre would receive 6,000 francs and Isidore Niépce 4,000 per annum, the additional sum to Daguerre taking account of his promise to reveal the secrets of his Diorama painting as well – something that was unlikely to concern him as he had already decided that he would not re-establish the Diorama elsewhere after the fire. Upon their deaths, the amounts were to be reduced by half and paid to Daguerre's and Niépce's widows. If, however, the bill was not passed, the sealed envelope would be returned to Daguerre and Niépce, and the agreement would be null and void.

In order to assist the two Chambers of the legislature in their deliberations, Arago presented a 5,000-word report in which he described the four criteria that had persuaded him to support Daguerre's method. The first was 'novelty': was the invention truly new? Undoubtedly it was. Nobody could point to a similar invention (unless they looked across the Channel to Talbot). Secondly, did it have 'artistic value'? Arago left this to his colleague Delaroche, who argued that the invention was of great value for 'the immense service it would render to art', particularly in preparatory sketches for painters: 'The painter will obtain by this process a quick method of making collections of studies which he could not otherwise procure without much time and labour.'[15]

Arago's third criterion was 'speed of execution', which he claimed made it possible for anyone with sufficient care to create pictures of a quality equal to those of a great artist. The final criterion was 'usefulness in scientific research'. Arago, himself one of the most respected scientists in France, had no problem in assuring the Chamber that the process would

indeed contribute much to the realm of scientific study. In unanimously recommending that the bill be passed without alteration or amendment, Arago's committee concluded that the invention of the daguerreotype was one of the greatest of their times, was not protectable under the usual patent laws and if adopted by the state and given freely to the world would speak volumes about the liberality of France and the genius of its great inventors. 'Gentlemen, we hope that you will concur in a sentiment which has already awakened universal sympathy,' said Duchâtel in his address to the Chamber of Deputies, adding that he hoped that 'you will never suffer us to leave to foreign nations the glory of endowing the world of science and art with one of the most wonderful discoveries that honour our native land'.[16]

That very same day, the Chamber of Deputies voted unanimously in favour of the bill. In mid-July it had its first reading in the Chamber of Peers, although the actual vote on that reading was delayed until the end of the month. By this time the peers had heard the opinion of Louis Joseph Gay-Lussac, a highly revered chemist, who urged them to take this invention to heart and give it and its inventors the protection it deserved, asserting that 'It is the beginning of a new art in an old civilization; it will constitute a new era and secure for us a title to glory.'[17] The call to patriotism once again won the day and the peers voted 237 in favour, with only three dissenting votes. With both houses having given their approval, the bill only required the signature of King Louis-Philippe, which was added on 1 August. In effect, the daguerreotype process was now the property of the French government; it could have been revealed then and there but its release was delayed a further nineteen days in order to allow Daguerre time to set up the manufacture of the equipment needed and to publish the handbook – *Historique et description des procédés de daguerreotype*

et du diorama. Within weeks the booklet had been translated into English and German. Though the writing of the manual and arrangements for the equipment were entirely the work of Daguerre, the profits from this and sales of the photographic equipment were to go to Daguerre and Niépce equally as partners. They had already signed an agreement with Alphonse Giroux – a relative of Madame Daguerre who had a stationer's shop in Paris – granting him exclusive rights to supply both the equipment and handbook in France and to the rest of the world – excluding England. Daguerre's friend the optician Charles Chevalier, who had supplied most of the equipment used during his long years of experimentation was – not surprisingly – extremely annoyed at being excluded from what was obviously an extremely lucrative deal. 'An optician was needed, a stationer was chosen!'[18] he complained, but his anger was tempered when he learned that Giroux would be buying all his photographic lenses from him.

Chapter Eighteen

THE ACADÉMIE DES SCIENCES, AUGUST 1839

At a joint meeting of the Académie des Sciences and the Académie des Beaux-Arts held at the Institut de France on 19 August, Daguerre and Niépce took their place on the dais alongside Arago. In addition to the membership of the two Academies, every notable scientist, artist and literary figure who found themselves in Paris that day crammed into the chamber to hear the formal announcement. Hundreds more clambered up the walls outside, trying to get a look in; well before the designated time, all the important and famous dignitaries of the artistic and scientific world had been unceremoniously squeezed in closely together on the hard benches and into every available inch of standing room too. Many more were left outside in the courtyard, straining to hear. The atmosphere was extraordinary, recalled a German visitor, Ludwig Pfau, who was there that day. 'The crowd was like an electric battery sending out a stream of sparks,' he wrote. 'There was as much excitement as after a victorious battle . . . Truly a victory – greater than any bloody one had been won; a victory of science . . . In the kingdom of unending progress another frontier had fallen.'[1]

Much to the surprise and consternation of those gathered inside the academy, it was not the now celebrated Louis

Daguerre who rose to his feet to explain his process, but Arago who addressed the assembled crowd. He apologized for this unexpected substitution for Daguerre, explaining that 'This morning, even, I begged – I entreated the able artist to yield to a wish which I well know is universal; but a bad sore throat, fear of not being able to make himself understood without the aid of illustrations – in short, a little nervousness – proved obstacles which I have not been fortunate enough to overcome.'[2]

What, Louis Daguerre nervous? The consummate showman, overcome with stage fright? This is yet another imponderable that has left photographic historians scratching their heads. It may be that Daguerre, finally forced to get up in front of an audience of his peers and explain his method to the leading lights of the scientific and artistic world, doubted his ability to do so coherently. He may in particular have been acutely aware of his lack of formal scientific training and feared that questions would be asked that he either couldn't answer or perhaps didn't even understand.

Whatever the reason, Arago took it upon himself to explain the process and the events leading up to its discovery, but having stepped into the breach without prepared notes, he managed to make the Daguerreotype process sound a great deal more complicated than it really was, straying off onto points of scientific minutiae that would certainly have left the artists in the audience wondering if this process was an art form at all or rather a branch of physics and chemistry. To make matters worse, he extolled the work of Daguerre at the expense of Nicéphore Niépce, informing the audience that Niépce's heliograph required a three-day exposure, which must have infuriated Niépce's son Isidore, sitting there alongside Daguerre on the dais.

As Arago's speech was never transcribed verbatim during

the lecture, it is hard at such a remove to be certain of its precise content but the audience at least were visibly enraptured by what he said and broke out into a spontaneous cheer as he ended his speech. When the meeting finally broke up, crowds of people were waiting outside on the Pont des Arts for news. 'Dense circles form[ed] round single speakers,' recalled Ludwig Pfau, 'and the crowd surge[d] forward in order to snatch bits of news here and there.'[3] Soon word went round from one person to the next. Silver plates! Vapour of iodine! Fumes of mercury! It all sounded exciting, but highly dubious – more like alchemy than art.

By the end of the day every chemist in walking distance of the Institut de France had been besieged by those eager to buy the magical chemistry needed and opticians were raided for the required lenses and camera boxes. Ludwig Pfau later recalled visiting Giroux's that day, but, being unable to afford the equipment, had bought only Daguerre's handbook, so that he could 'at least make the daguerreotype in imagination'.[4]

Marc-Antoine Gaudin, who was later to become one of the first great daguerreian artists, was in the courtyard of the Institut de France that day and heard the news at second hand. He immediately hurried to a local chemist, where he bought iodine and mercury; by the following morning he was ready to make his first image, using a camera obscura made from a cardboard box with a spectacle lens attached to the front. His first effort produced a dark, almost black silhouette of the houses outside his window but he was so pleased that he rushed off to show it to his business partner, another noted Parisian optician, Noël Paymal Lerebours. Others reported similar results and the pleasure that any image they achieved, no matter how fuzzy, brought them. Within a few days of the details of the invention being announced, cameras were being erected on their stands in squares and public places all across

Paris, as everyone turned their hand to the new craze for photography.

In December 1839, a now-famous lithograph by the artist Théodore Maurisset entitled 'La Daguerreotypomanie' provided a humorous take on the pandemonium provoked by Daguerre's invention. Cameras are pointed in every direction, with portraits being attempted in one area by a mother and nursemaid trying to hold a squirming child still in a chair, while in another a sitter is pinned into a contraption that holds the head and body still in a stock-like device, with a large clamp on the head. A group in the distance is seen ceremonially dancing around a steaming mercury pot, while a series of gallows is set up for hire – on which the now redundant engravers and etchers who have been ruined by the new process can put an end to themselves. Every cliché is included and even some that appear to predict the future – such as the hot air balloon whose basket is itself a camera. Aerial photography was yet to be attempted but it would come – and not that far into the future.

*

All was madness in Paris that year, with the French positively giddy celebrating the new art. Talbot's rival process seemed old news and had already been forgotten. Even in London news of the working details of the daguerreotype and the easy availability of the equipment needed brought a sense of urgency and excitement, as people anticipated making their own pictures by the action of the sun. Daguerreotypes had yet to be displayed in London, but nevertheless there were attempts to make them as soon as details of the process were known. In September 1839 a Frenchman named Saint Croix (often styled 'Ste Croix') began giving demonstrations in London. The first sight Londoners had of daguerreotypes

were those exhibited by him at the Royal Gallery of Practical Science near Trafalgar Square, popularly known as the Adelaide Gallery. The English were to learn very quickly, however, that although details of the process were available and cameras could be purchased along with the chemicals needed, they were not to have the same freedom to produce them as the rest of the world. For even as the French bill to give Daguerre and Niépce their rewards had been winding its slow way through governmental channels in Paris, Miles Berry had begun the procedures necessary to obtain a patent on the daguerreotype in England.

On 15 July, the same day that the French bill had its first reading in the Chamber of Peers, Berry had received instructions to petition the British government to issue Royal Letters Patent for the exclusive use of the daguerreotype in England and Wales. After just a fortnight a favourable report was made, recommending that it be granted. This seems an odd coincidence: the French bill had been sent to King Louis-Philippe for his signature on the 1 August and the English patent was sent to Queen Victoria for her signature just one day later. The certificate finally received its royal seal on 14 August. The daguerreotype was now legally protected. Those in England who had followed the discussions in France were baffled as to why an invention that Arago – as late as 3 July – had suggested to the Chamber of Deputies be liberally presented by France 'to the whole world' should now be patented in England.[5] When quizzed on this by the English artist John Pye – engraver of Turner's work and teacher of the artist Edwin Landseer – Daguerre asserted that the agreement he had signed was to sell his invention to the French government and that it made no stipulations about what the rest of the world was to do. He therefore believed that he had every right to patent his process outside France.

Over the years, the question has often been raised as to why Arago – or one of the other scientists or government ministers involved in the recommendation process – had not spoken up and challenged either Daguerre or the rest of the world on this issue. As *The Times* reported when describing a later violation of the Daguerreotype patent, 'to a Frenchman, France is the whole world'[6] and the decision was seen by many as insular, if not xenophobic. Why the British government made no attempt to quash the patent and make it free to all English practitioners is also yet to be explained. In any event, a patent does not provide cast-iron protection. It would not have prevented others from pirating Daguerre's process, for the patenting procedure requires an inventor to reveal all the secrets of their invention when registering it. The patent therefore only provides the patentee with a means of legal redress to demand compensation if this happens.

Saint Croix's exhibition and demonstrations at the Adelaide Gallery therefore enjoyed only a few days of public excitement and attention. The minute he heard about them, over at his offices in Chancery Lane, Miles Berry sought an injunction to close Saint Croix's operation down and published notices to that effect in *The Times* and elsewhere. Before Saint Croix was finally forced to shut up shop in late October, Talbot had, however, had a chance to meet him and to form his first impression of Daguerre's process. He reported back somewhat grudgingly to his mother that Saint Croix 'certainly makes bungling work sometimes, but at other times he succeeds, enough to let one see that it is not *very* difficult to execute it very well'. Bungling or not, Talbot thought enough of Saint Croix's views of London to purchase one of his plates – a view of All Souls Church, Langham Place, where he and Constance had been married almost seven years before (the daguerreotype has survived and can be seen in the British Library today). But

in Talbot's view there was a major technical problem, and in this respect he enjoyed having the last laugh. 'The chief embarrassment,' he told Lady Elisabeth, was that 'London plated copper will not answer (nobody knows why) & that it is therefore necessary at present to import the plates from Paris.' If M. Arago knew this, Talbot concluded with a smile, 'he would say that it was a new proof that the invention was "*vraiment Français*" [truly French] since the Art itself evinced an antipathy to England'.

No matter the inevitable technical problems involved, by the end of the year, daguerreotypes were being made on at least three continents and all over Europe. Except, of course, in Britain, where the only operator, Saint Croix, had been closed down. Such was the excitement at the prospect of this new process opening up knowledge of the world in a radically new way that the enterprising optician Noël-Paymal Lerebours had already set up an ambitious project to photograph the known world. He built the equipment and kitted out a team of adventurous daguerreotypists who then travelled across southern Europe and North Africa making images that they sent back to Paris, where they were quickly copied as engravings for public consumption. *Excursions Daguerriennes*, published by Lerebours in 1841, was well received; the accuracy of the engravings was accepted because they were based on daguerreotypes, thus lending the new process a veracity that the subjective renditions of landscape by artists could never achieve.

By August 1839, the daguerreotype was public property in France and its inventor was riding high on the acclaim it had brought him. A photographic process that had taken Henry Fox Talbot less than a month to bring fully to the British public had taken the French government almost eight months to ratify. Talbot's photogenic drawing process had already

been in the public domain for six months before the daguerre-
otype was finally revealed. It was slowly being picked up on by
British scientists and amateurs, many of whom enjoyed it and
were already producing good results, but it had yet to make an
impact on the public at large. For now the daguerreotype
reigned supreme and would do so for some time to come.

Chapter Nineteen

DAGUERREOTYPOMANIA

In the months after Daguerre's process was released to the world in August 1839, the popular perception we have now of a frenzy of amateur photographers all rushing round with their camera equipment and falling over each other's tripods would appear to be something of an exaggeration – the stuff of the cartoonist's imagination rather than reality. But there is no doubt that the enthusiasm for this new-fangled toy was intense, and some were already finding novel, if not ambitious, ways of exploiting the new medium.

At the opening of the new railway station at Courtrai in Belgium that September, a daguerreotype was taken of the ceremony, the assembled dignitaries being forewarned that the discharge of a cannon would be the signal for 'a general immobility', lasting 'the seven minutes necessary for obtaining a good representation of all the personages present' – a considerable physical feat in itself.[1] The plate, so the papers reported, was afterwards enclosed in lead and deposited under the foundation stone of the station for the benefit of posterity. In Barcelona, a fête was staged to celebrate the invention of the daguerreotype that same month. An immense crowd gathered on the city square, 'where the instrument was set up, with banners and music', prior to a daguerreotype being taken of the gathering. The press reported that 'so great was the contest

for the impression when taken that it was disposed of by lottery'.[2]

It is unlikely that anyone who was there that day would have been able to spot themselves in the resulting daguerreotype. The length of time needed to make it would have produced a blurred image much poorer in detail that the typical CCTV camera of today. While public occasions and ceremonial were an obvious subject for the new medium, the crowd scene would remain one of the most difficult events for the daguerreotypist to capture, for, of all subjects, this was one that in practical terms was beyond the medium's scope. However, one of the first of its kind was made by the English daguerreotypist William Kilburn in April 1848, when he photographed the great Chartist meeting on Kennington Common in London.[3] These daguerreotypes were later acquired by Prince Albert for the Royal Collection. Meanwhile, in France a more inventive use for the new medium was struck on – and one which prefigures one of the photograph's more sinister fringe uses – by a jealous French husband who had reason to believe his wife was having an affair with a neighbouring landowner. Monsieur X, so the French legal paper *Audience* alleged in October, went out and bought himself a camera obscura, placed it in a window opposite where he knew his wife and her lover had secret assignations and on their next meeting exposed a prepared plate when they came into view. 'The sun was so bright that a most correct drawing of the dishonourable meeting at the window was obtained,' observed the paper, after which Monsieur X offered this 'undeniable evidence' of his wife's infidelity in his petition for a separation at the civil tribunal in Versailles; Daguerre and Arago themselves, so the paper asserted, would be 'summoned to supply the tribunal with all the scientific information that may be required'.[4] This rather astonishing

story, like other fringe uses of the daguerreotype circulating at the time, reveals something of the dream of what photography might accomplish, though it offers little proof that these images actually had been made.

Such imaginative use of the new medium was, however, rare in those first heady days. We do not know how many people tried the daguerreotype process in Paris; nor how many of them actually succeeded in making images worth looking at. It is probable that many tried and gave up quite soon. The fact that there was no outbreak of deaths due to mercury poisoning – one of the dangers of the daguerreotype process – can be taken as an indication that at least novice daguerreotypists were either very careful with their experiments or in reality carried out few of them. For it all looked too deceptively easy. In practice, making a daguerreotype could be extremely frustrating if the detailed instructions, particularly the cleaning and buffing of the silver plate, were not followed to the letter. Jules Janin, the highly regarded writer and critic, who had been present at the public announcement on 19 August, wrote in *L'Artiste* six days later that the process as described by Arago seemed so complex and full of pitfalls that either it was an art for the few or Arago's report had misled people.

This article alarmed Daguerre; indeed, he was so worried that he immediately went to the critic's house and invited Janin and his friends to come to his studio to watch him in action. Within an hour Daguerre had taken an unpolished plate and worked his way through the procedure, ending up with an image shot from his studio window, so beautiful that Janin exclaimed that it looked 'as if it had been drawn by the brush of the fairy queen Mab'.[5] He changed his mind there and then and became a stalwart supporter of the daguerreotype thereafter.

After the initial flush of excitement at the birth of photo-graphy had worn off, expectations of what the two processes might offer had begun to rise. The problem was that the reality of what Daguerre and Talbot were able to achieve at this stage could not keep up with public demand: the two inventors had progressed so far and then seem to have hit a wall. In truth, Daguerre had taken his own experiments as far as he could by late 1837, when he felt his process was good enough to market. The only improvement he had made since then was in the spring of 1839, when he had switched from using a salt solution to fix the plates and adopted Herschel's suggestion of hyposul-phite of soda. In essence Daguerre's contribution ended here and he seems to have lost interest in pursuing it further; improvements to the daguerreotype process after mid-1839 were made by others.

*

In the midst of so much concerted effort to bring his process into the market place as a viable commercial product Daguerre himself rested on his laurels, content to bask in the glory accorded him by scientific and artistic academies around the world. He had by now been presented with numerous valuable gifts by the crowned heads of Europe – including Tsar Nich-olas I of Russia, Emperor Ferdinand I of Austria and King Ludwig of Bavaria – such as diamond-encrusted snuffboxes and gold medals, in acknowledgement of the daguerreotypes he had sent them just after the process was purchased in August. In France King Louis-Philippe had elevated him from Chevalier of the *Légion d'Honneur* – a high enough honour in itself – to the superior status of 'Officier' of the legion. By the end of 1839, he had collected the first instalment of his pension and the insurance payout for the paintings lost in the Diorama fire, and was focusing his attention on buying a house with

private grounds at Bry-sur-Marne, a small town nine miles east of Paris. Daguerre was only fifty-two but he was already settling down to a comfortable retirement.

Throughout the 1840s he would often meet up with his neighbour and friend Armand-Louis Mentienne, the mayor of Bry-sur-Marne, for a morning stroll round the town square. Returning to his original draughtsman's skills, he spent much time and energy designing the gardens of his home and supervising their completion. He occasionally entertained a visiting daguerreotypist who would coax him into having his portrait made, although he turned down far more requests than he allowed. There are at least six of these portraits still in existence today. In around 1845, Daguerre finally returned to photography, now using the vastly improved version of his original process, but he did so for pleasure, making a few portraits of family members and friends at Bry-sur-Marne. He also made one final foray into Diorama painting, executing his last canvas on the grand scale, though not as grand as those of his prime. The image was executed to hang behind the altar of the church of St Germain and St Protais in Bry-sur-Marne, but it required some modifications to the apse of the church to allow light to enter behind the painting, thus augmenting its translucent nature. When it was finally unveiled in June 1842 the villagers were amazed to find that the exquisite perspective of Daguerre's painting, combined with the illusion of light falling on it from behind, appeared to give this small provincial church the dimensions of a great cathedral. Looking down the apse the viewer saw what appeared to be a large Gothic transept extending back for a great distance, complete with stained-glass windows and row upon row of columns and arches. In the limited space of just a few feet, Daguerre had miraculously created what appeared to be an enormous and deep expanse – a fitting artistic achievement at the end of his long career.

Daguerre seemed to find great contentment in his retire-
ment. He occasionally contacted Arago with suggestions on
possible improvements to the daguerreotype process but none
of them came to anything and eventually he abandoned them.
In the meantime, Isidore Niépce, whose name appeared on all
of the agreements with the French government, had remained
a silent, non-active partner. He had contributed nothing to the
development of the daguerreotype, though he did continue to
receive a pension and an equal share of the profits. In agreeing
to this, Daguerre had felt that he had more than honoured his
debt to Niépce senior, but in 1840 Isidore became resentful that
not enough due had been given to his father, whose name had
not been added to the official 'daguerreotype' process. The
newspapers were full of the name Daguerre, but not that of
Niépce, and it rankled with Isidore that the manual written by
Daguerre and published by Giroux seemed to point up the
disparity in the two original inventors' processes by emphasizing
that Niépce's heliograph was slower and produced a less appeal-
ing image than the faster and more delicate daguerreotype.

Isidore Niépce began publicly to criticize Daguerre and in
1841 published a hostile booklet entitled 'Historique de la décou-
verte improprement nommée daguerréotype' ('History of the
discovery improperly called daguerreotype'), though there is no
indication that Daguerre ever replied to these charges publicly.
There was, however, one other person whose role in the inven-
tion of the daguerreotype remains a mystery, who received no
honours or pension at all. This was Alphonse Hubert, who had
first been Daguerre's challenger and then became his assistant,
never seeking glory for himself or recognition of any part that
he might have played in perfecting the daguerreotype process.
Although he was dead by 1840, Hubert's contribution was never
publicly mentioned by Daguerre or Niépce, either before or
after his death. Nor does he feature in any standard history of

photography. But while his precise role remains unclear one thing is certain: at the beginning of 1839 there had been only three known practising photographers in the world; Talbot, Daguerre and Hubert.

*

In 1859, looking back on the meteoric rise of the daguerreotype twenty years earlier, the French poet Baudelaire mocked those who had thought that perfectly replicating nature and, in particular, the human face, was the ultimate art: 'A vengeful God has given ear to the prayers of this multitude. Daguerre was his Messiah ... From that moment our squalid society rushed, Narcissus to a man, to gaze at his trivial image on a scrap of metal. A madness, an extraordinary fanaticism took possession of all these new sun-worshippers.'[6] Fanaticism or not, the new discipline of photography was spreading its tentacles across the world. In tandem with the explosion of portraiture, landscape photography was also blossoming. Lerebours' intrepid daguerreotypists had by now travelled south across the Mediterranean to Spain and Italy and on to the much more exotic scenery of North Africa and Turkey. A French Huguenot named Joly de Lotbinière had photographed the Acropolis in Athens and the Pyramids at Cairo. By April 1840, the greatest natural phenomenon yet was captured: Niagara Falls – which was as far from civilization as even the most intrepid of North American tourists travelled. The daguerreotypes of the Falls taken by an English visitor and chemist named Hugh Lee Pattinson were shipped back to Lerebours to become the only North-American images in *Excursions daguerriennes: Vues et monuments les plus remarquables du globe*. From three practitioners at the beginning of 1839, the world a year later had perhaps one hundred active photographers and probably a few hundred more amateurs of different levels of competence and activity.

Chapter Twenty

PORTRAITURE

After the flurry of the Daguerre announcement and Talbot's rush to publish his still nascent process prematurely, Talbot had allowed his photographic experiments to languish. Having produced numerous shadow pictures and a few in-camera, he was yet to achieve the one thing that still eluded all practitioners at this point – a successful portrait of a live sitter. In a letter dated 14 March 1839, to his friend and neighbour Sir Thomas Moore Talbot proclaims: 'We do not mean to be satisfied until we make every man his own portrait painter . . . but adieu to flattery in portrait-painting.'[1] Daguerre's inadvertent capture of a blurred human figure on the Boulevard du Temple had been seen as a coup, but the public were soon asking why the process hadn't yet accomplished portraiture. Granted the daguerreotype was good at capturing marvellous landscapes and cityscapes, and people with property and wealth might want to commission an image of their own residence, or a traveller on the Grand Tour might want to buy a picture of one of the sights to take home, but photography at this point did not fill the obvious – and most marketable – area of consumer demand. If it was to grow into the monolithic new art form that it had seemed to promise, it would need to find a way of capturing the human face. But the face, as any artist knows, is an ever-changing canvas, reflecting a moment-by-

moment capture of the inner feelings of the sitter. The photographic portrait was something all people aspired to own as a source of both pleasure and consolation: an image of a loved one that could be held and treasured and looked on time and time again. The ever-changing nature of fashion and the ageing of the sitter meant that not just one portrait would define an individual, but a succession of portraits taken over the years would tell the story of that person's life. The potential for the photographer who could pull this off – providing the world with a cheap and accessible form of portraiture – was therefore enormous.

Portraiture had of course been one of the basic money spinners for the artist for centuries, but only those wealthy enough to hire one and who had the leisure time to sit for days, sometimes weeks, for their portrait to be completed had made use of it. Because the process was time-consuming and complex, portrait painters could only complete a few such canvases each year and therefore had to charge quite high prices, certainly out of the reach of the majority of ordinary people. Even miniature paintings, which had become popular during the eighteenth century, were too expensive. Photography, on the other hand, made it possible for everyone to have their portrait made. Even a humble worker would be able to save enough to visit a daguerreotypist or photographer, though it might involve climbing several flights of stairs to an atelier and standing in a queue before being ushered in to sit rigidly still and look at the camera. But that one solitary, precious portrait – in many cases the only image someone's family would ever have of them – was the beginning of the creation of a level playing field between rich and poor. Photography was to become the first democratic art.

In order for photography to be a financially viable new profession, a typical photographer would need to take numer-

ous portraits every day, adding up to hundreds, perhaps thousands of images every year, which in turn would drive down the price. But although portraiture was technically feasible, how to make it efficient and cost-effective was a different matter entirely. Both the daguerreotype and photogenic drawing processes were still inadequate, requiring a minimum of a ten- to fifteen-minute exposure in direct sunlight. For a building, cityscape, or piece of sculpture this was not a problem, of course, but it was not a reasonable proposition to expect a human subject to remain perfectly still for the full amount of time required, as well as maintaining an attractive expression. Talbot knew this and was anxious to make the process more viable.

In the midst of continuing French and British arguments over who had invented this great new art form and which process was best, a third country entered the fray, caring little for who got the credit as long there was money to be made. As soon as all the details had been announced and the two processes were up for grabs, the USA had joined the battle for supremacy in picture-making, as experimenters eagerly tried to push the two new processes beyond the limits even conceived of by their inventors. Daguerre himself believed that portraiture was not possible with his process as it stood in 1839 and he appears to have made no attempts at it himself. Talbot, however, did begin experimenting with portraiture in 1840 and created a beautiful, if faint, portrait of his wife Constance later that year. But the results were still so varying in quality that it was not yet the goose that might lay the golden egg of his fortunes.

In the United States of America, the new mercantile, Yankee spirit of taking up a challenge and running it for all it was worth took hold rapidly, with several entrepreneurs determined to make the new process financially viable. They were not prepared to sit and wait for the original inventors in the

Old World to improve their own processes, and even the obstacle of long exposures, requiring the sitter to stare into the sunlight for up to a quarter of an hour, didn't deter them. It is therefore no surprise that evidence suggests that the first daguerreotype portrait was actually taken in America soon after information on the process arrived there in mid-September 1839. Samuel Morse, working with Dr John Draper, a noted English-born chemistry professor, began attempts in October, working in a glasshouse on top of New York University in Greenwich Village. Meanwhile, a New York dentist and scientific instrument maker, Alexander Wolcott, had gone into collaboration with his friend and partner John Johnson. On 6 October 1839 they claimed to have made the world's first photographic portrait when, using a camera made by Wolcott, they created a daguerreotype of Johnson. Sadly this image has long been lost, although going on the description of those who saw it, it would certainly be credited as a technical success. But it was very small – about three-eighths of an inch – and even a miniature portrait would have dwarfed it. That same month, October 1839, Robert Cornelius, an amateur in Philadelphia who was working with the chemist Paul Beck Goddard, achieved what is probably the world's first successful photographic portrait – of himself – an astonishing image full of life and character, which is preserved in the collection of the Smithsonian Institution in Washington.

The problems encountered in portraiture were many in the early days. One of the biggest was the discomfort in which a sitter had to be restrained to accommodate the long exposure time, as a certain Mr Chittenden of Boston recalled. He had been talked into sitting for his daguerreotype on the promise that he would be given it free, 'if I would endure the trial'. It was with some apprehension that he submitted himself to the ritualistic procedure that followed:

The operators rolled out what looked like an overgrown barber's chair with a ballot box attachment on a staff in front of it. I was seated in the chair and its Briarean arms seized me by the wrists, ankles, waist and shoulders. There was an iron bar which served as an elongation of the spine, with a cross bar in which the head rested, which held my head and neck as in a vice. Then, when I felt like a martyr in the embrace of the Nuremberg 'Maiden', I was told to assume my best Sunday expression, to fix my eyes on the first letter of the sign of a beer saloon opposite, and not to move or wink on pain of 'spoiling the exposure'.[2]

Poor Mr Chittenden had been obliged to remain in this position of discomfort for ten minutes, without closing his eyes, until 'the anguish ended'.

But it wasn't just the physical inconvenience that made potential customers reluctant at first about having their portrait taken. Practitioners also had to overcome the total lack of public understanding of the process itself and how their image was captured. One photographer reported being asked by a would-be client who lived some distance from his studio whether he actually had to attend in person. Perhaps he could simply send in a description of himself by post, he suggested. The required presence of the sitter was a common misunderstanding. A daguerreotypist in Yorkshire recalled how a lady who had travelled some distance for her portrait had been settled down in the chair and told to sit there while he left the room, it being rather a bore for him to have to stand around for the fifteen or twenty minutes' exposure time required. When he came to examine the plate after the lady had left, he discovered that there was no image on it, only the empty chair. He could not explain it: the lady had been sitting in the chair when he left the room and was still there when he came back.

It was only when his client returned to collect her portrait that she admitted that she 'got up and walked about as soon as he left her, and only sat down again when she heard him returning'.[3]

The lady from Yorkshire was not alone in her lack of comprehension. Another nervous client asked a photographer whether 'there was no danger of his being poisoned by the various vapours in which he would have to be "enveloped"'.[4] Mothers were anxious too about the possible side effects: would a child be able to stand the strain, they asked, of 'being exposed to the rays of the camera for such a long time'?

In response to customer apprehension and in order to make the photographic portrait a viable commercial product, American inventors tried a variety of often eccentric methods in attempts to bring down the exposure time. These included powdering the face of the sitter so that it was bright white and soaked up the light faster; painting the walls of the photographer's studio with white plaster to reflect as much light back onto the sitter as possible; and employing mirrors to multiply the amount of light falling on the subject. Finally, in a nod to the discomfort of the poor sitter obliged to tolerate staring into direct sunlight, it was suggested that if the windows of the studio were covered with flask-shaped bottles of blue liquid, this would act like sunglasses, protecting the sitter's eyes, while still allowing the most active rays of the light to filter through for the extended exposure time. Daguerre had proposed using blue glass for this in the announcement of his process in August but had not tried it himself.

It was clear, however, that adjustments to help the sitter tolerate the long exposure time were not the answer; there had to be a technical solution that would make the camera work faster. Light seems constant because we are used to bright electrical lights to supplement sunlight. In the nineteenth cen-

tury people knew that it was only possible to read by the light of a single candle if that candle was very close to the text. If you move it more than a foot away the light is so diminished that reading becomes impossible. Talbot understood that the quantity and intensity of light diminished the further it travelled, even over short distances, and that likewise it would also be diminished when it passed through the glass of the lens.

This knowledge prompted him to have the local carpenter at Lacock make his miniature 'mousetrap' cameras, because he knew that a smaller camera required a shorter exposure, simply because the distance between the lens and the sensitive paper it projected the image onto – unlike in bigger cameras – was much less, thus allowing for less light to be lost in creating the image. Several camera-makers moved in that direction, modifying Daguerre's cameras and equipment, which were based on a plate size of $6^{1}/_{2}$ x $8^{1}/_{2}$ inches, which soon became known as a 'whole plate'. If that was too large and too slow, perhaps a 'half plate' in a half-sized camera would work faster; or maybe even a 'whole plate' cut into four pieces, making 'quarter plates'. Several enterprising Parisian opticians began to sell these smaller cameras along with other pieces of equipment equally scaled down in size and in price. The next logical step was that if the camera could be made faster and more efficient, then so could the lens. This was the view of the Czech mathematician and experimenter in optics Josef Petzval. As professor of mathematics at the University of Vienna, Petzval began using mathematical computations in his experiments with optics and in May 1840 created a much faster lens, produced by combining higher-grade glass with a wider diameter, both of which allowed more light into the camera, while still remaining in focus. The Petzval lens rapidly became the standard and because it wasn't patented it was soon copied and manufactured by commercial opticians. Petzval lenses were

so successful that many were still in use at the end of the nineteenth century.

Undeterred by the limitations of their first attempt at portraiture, over in the USA Alexander Wolcott and John Johnson came up with a completely new type of camera in October of 1839, having found, as Petzval had, that the quality of most lenses was inadequate and did not allow in enough light. In response Wolcott tried a completely different approach by creating a camera that needed no lens at all. Instead of a lens on the front of his camera there was simply a hole about five inches in diameter that allowed plenty of light to fall onto a concave mirror at the back. This mirror in turn focused the image back onto a small daguerreotype plate positioned between the hole and the mirror. As unlikely as it seems, this lens-less camera was a vast improvement and reduced exposure times to around five minutes. The images it made were small – only about $2^{1}/_{2}$ inches in length – but they were sufficient in size to please the sitter and at this early stage that was enough. With their new camera system in place Wolcott and Johnson opened the first commercial portrait studio in the world in New York in March 1840.

Over in Europe, it was another year before portraiture was finally taken up commercially, when an enterprising businessman, Richard Beard, who had started out as a grocer, opened his first portrait studio on the attic floor of the Royal Polytechnic Institution in London's Regent Street on 23 March 1841. The studio was circular in shape with a raised dais below a flat glass roof on which the client was seated in a chair which could be revolved to face the changing direction of the sun.

Beard's new venture was a huge success, and, having bought Daguerre's patent rights for Britain for the next twelve years, as well as the exclusive rights to use the Wolcott–Johnson camera, he invested more than £20,000 in opening a string of

portrait studios in provincial cities across England, though he hired others to run them and take the photographs. Many found the experience of seeking out Beard's studio 'a wonderful mysterious operation'. Talbot himself climbed those stairs in around 1842 to have two portraits made by the Wolcott–Johnson camera in Beard's London studio, as did the Irish writer Maria Edgeworth a year before him:

> You are taken from one room into another up stairs and down and you see various people whispering and hear them in neighbouring passages and rooms unseen and the whole apparatus and stool on high platform under a glass dome casting a *snapdragon blue* light making all look like spectres and the men in black gliding about.[5]

Despite its undoubted business potential, not everybody was immediately won over to this new form of portraiture. Anxieties were expressed early on about the threat to the living of traditional portrait painters. While the photograph was certainly acknowledged as 'a most perfect icon of the sitter', as the *Art-Union* noted, 'none know better than artists themselves how rarely a very close resemblance is readily pleasing to the person painted, or even to his immediate circle of friends'.[6] People were apprehensive about the sometimes alarming results achieved by Beard in this new medium; for the daguerreotype presented the sitter warts and all, as opposed to the painted portrait, which could, when necessary, be economical with the truth. In the words of a satirical poem written at the time – 'A Lady to Her Lover, on Receiving His Photographic Portrait':

> Is this your likeness? Well I never
> Saw such a fright! How could you ever?
> You've broken troth: Oh George, for shame!
> You swore you'd always be the same,
> And now how changed! Take back your present!

To me 'tis anything but pleasant.
Those black and guilty looks reveal
That you've been tempted on to steel . . .
'Tis someone else, – it can't be you;
Or you are false, if this be true.
I loved you youthful, fresh, and florid;
Not pale, cadaverous, and horrid . . .
Your portrait, sir, has lost my heart:
I hate this *foe*-to-graphic art![7]

For now at least, the consensus was that 'the fidelity of a Daguerreotype reflection has by no means the effect of robbing an artist of that truth for which his hand and eye have already been distinguished'.[8] While Beard was enjoying his monopoly in England, Paris, the birthplace of the daguerreotype, was not lagging behind: in early 1841, Louis-Auguste Bisson opened the city's first portrait studio. By this time Bisson not only had the advantage of using faster cameras and lenses, but the benefit of the advances made in the chemistry of the process over the preceding two years. These were undoubtedly the key to speeding up the daguerreotype process and making it perfect for portraiture, for they not only made it faster but improved the look of the images as well. By the mid-1840s, chemists in both America and Europe had added the use of a second sensitizing chemical. Where Daguerre had relied only on iodine to sensitize the silver plate, Paul Beck Goddard in the USA and, coincidentally, John Frederick Goddard of England (no relation) added a second sensitizing step using bromine fumes. Similarly, the French daguerreotypist Antoine Claudet – who was now working in England – found that using chlorine fumes in combination with iodine would also speed up the process by making the daguerreotype plate a great deal more sensitive to light than Daguerre's original process using only the fumes of

iodine. Using standard cameras with Petzval-style lenses, all these photographic pioneers had, within a year, succeeded in reducing the exposure time from minutes to mere seconds.

The final chemical improvement that enhanced the overall look of an image was that of gold-toning the finished plate. The French physicist Hippolyte Fizeau had discovered this while trying to hit upon ways to turn the daguerreotype into a printing plate from which additional copies of the image could be made. He found that heating a solution of gold chloride on the plate after fixing made the image bolder and brighter with stronger contrast. It also created an image that was less susceptible to abrasions and smudges, for one of the great dangers with daguerreotypes was the damage that could be caused by inadvertently brushing against the image. So delicate was it that it was often equated with the dust on a butterfly's wings, which just as easily could be wiped away.

For the time being, however, the daguerreotype continued to dominate in portraiture. For what more precious object was there than this, 'a memento of remembrance or token of affection' as one practitioner at King's Cross argued in his advertising campaign.[9] Nothing could now supersede the photographic portrait as 'a consoler in hours of anguish and absence, a breathing representative whose silent eloquence whispers spiritual thoughts of love and hope'. No home could be without one.

Chapter Twenty-one

THE PENCIL OF NATURE

While many photographers were already vigorously engaged in the lucrative possibilities of portraiture, what of Henry Fox Talbot and his own process, photogenic drawing? Did no one attempt to take it up as a business proposal or seek to improve it? Had it really not made its mark somewhere in the world? The answer, seemingly, was a resounding no. Such was the international focus on Daguerre's triumph that Talbot was virtually ignored. But he doggedly continued to work at his process, keeping up his correspondence with other scientists and passing on a steady stream of samples of his work to anyone who requested them. Lady Elisabeth of course continued to lead the field, constantly writing and requesting more photographs and advising her son on which were the most popular among those she showed them to.

One of Talbot's most valued correspondents was Sir John Herschel, whom he had met by chance in Munich in 1824 while travelling with his family. A graduate of Cambridge like Talbot, Herschel had attained the much coveted Senior Wrangler award in 1813, after which he had taken up astronomy and built his first telescope. His father, Sir William Herschel, a German scientist and composer who had immigrated to England in 1757, was one of the most famous astronomers of the day, having discovered the planet Uranus in 1781. At the age

of eight, as he recorded so meticulously in his journal, Henry Talbot had visited Sir William's house to view his telescopes, where he had met Herschel's sister Caroline, who was a noted astronomer in her own right. By the mid-1820s John Herschel was clearly following in his father's footsteps, having already attracted the approval of the British Royal Society and the French Academy. With Talbot he shared – among their many scientific pursuits – an interest in optics and the study of light and had introduced him to the Scottish physicist and astrono-mer Sir David Brewster, another of the great figures in British nineteenth-century science. Herschel remained a champion of Talbot's work through the difficult years; his response to a letter from Talbot enclosing some images in June 1840 was charmingly enthusiastic about the progress Talbot had made in such a short space of time:

> I am very much obliged indeed by your *very very* beautiful Photographs. – It is quite delightful to see the art grow under your hands in this way. Had you suddenly a twelvemonth ago been shewn them, how you *would* have jumped & clapped hands (i.e. if you ever do such a thing).[1]

But if Talbot's inner circle of family and friends were aware of the slow but certain progress he was making, the world at large was not. Talbot's professional orbit remained small and exclusive in comparison with that of the superstar Daguerre. Getting the British public to take note of Talbot's work was an uphill climb. All eyes remained firmly fixed on France and the daguerreotype, which for now – certainly in the press and popular journals – reigned supreme. Talbot hardly received a mention, even in his home country, when public demonstrations of the French process were made, or during debates about the legality of Daguerre's patent in Britain and the legal challenges and appeals that followed. Antoine Claudet

managed to continue practising as a daguerreotypist, having been taught by Daguerre himself, and had purchased a licence from him to do so in England but Saint Croix had long been sent packing.

In America where one might have hoped that things would be less partisan, Samuel Morse was instead heading a one-man campaign for the elevation of Daguerre and his art to the highest levels of acclaim. In a letter of May 1839, informing Daguerre that he had just been elected an honorary member of the American National Academy of Design (an organization of which Morse was president), Morse confidently predicted that 'Notwithstanding the efforts made in England to give to another the credit which is your due, I think I may with confidence assure you that throughout the United States your name alone will be associated with the brilliant discovery which justly bears your name.'[2] Yet, in an ironic twist of fate, at around the time Morse wrote this letter to Daguerre, Talbot's process had already made its mark in the history of American photography. But it had done so quietly and without fanfare, so much so that the event, to this day, has been omitted from most histories of photography and was not retold until 1880.

It now seems clear that the first camera image made in America was not a daguerreotype but actually a photogenic drawing, made in a makeshift camera by sixteen-year-old Edward Everett Hale and his eighteen-year-old classmate Samuel Longfellow, younger brother of the renowned poet.[3] The two young men were roommates at Harvard at the time and had learned the details of Talbot's process from press reports in Hale's father's newspaper, the *Boston Daily Advertiser*. In March 1839 they converted a small camera obscura made for artists' use into America's first photographic camera. Following Talbot's published instructions for coating their photographic paper, they had directed their makeshift device from

their dormitory window onto a view of the building across the street. When processed, they found they had an image – albeit a negative – and were delighted with the quality of the detail: a bust of Apollo that was sitting in one of the windows opposite showed up prominently in their image.

While the viability of Talbot's process was already being confirmed by others, the problem was that, compared to the daguerreotype, it was not flashy and made on metal plates, and seemed to lack the more obvious showy attractions of its rival. Talbot himself described the soft tones and heightened contrast of his images as 'Rembrantish'; they couldn't compare with Daguerre's magical mirror with a memory, which prob-ably explains why they had no attraction for those eager to make a living out of photography.[4] Nevertheless a steadily growing number of British amateurs – many of them Talbot's own family and friends – started taking photographs, much as they had earlier taken up collecting botanical specimens or seashells. As Talbot had no plans to market the cameras, equipment or supplies that went with his process, which was done by others, there was effectively nothing to keep him in the news. Photogenic drawing – easy, simple and inexpensive compared to the daguerreotype – remained the purlieu of the amateur and hobbyist; only a handful of scientists really under-stood the potential of Talbot's positive–negative process at this point in time.

After his initial month-long burst of energy in January and February 1839, following Daguerre's announcement, Talbot had settled down to re-examine his work. But he had also wasted time trying to guess at the nature of Daguerre's as yet unseen process, working on a false premise found in the 6 January article in the *Gazette de France* that his images were made on copper plates. No mention had been made of the silver surface on the copper and Talbot spent the better part of

a month trying to find out how to sensitize copper to make images. Now, a year later, he was distracted from his work by another call on his time as a member of the local gentry. In late January 1840 he was appointed High Sheriff of Wiltshire, an honour to be sure, coming as it did from the queen, but one that carried a burden of expense and time away from his own interests. The appointment usually ran for a year and demanded that he be present at numerous county meetings and public events. He was also required to furnish himself with all the necessary personnel and equipment as befitted someone in his position, which in Talbot's case included upgrading to a better carriage, hiring two footmen and supplying them with livery and wigs, as well as hosting a number of to him tedious social events during his year in office. Somehow or other, Talbot managed to find time for further experiments during that year and his notebooks lead us step by step through the different chemicals and combinations that he tried. By early summer he seems to have realized that he was not going to enhance the photogenic drawing process any further, beyond the obvious improvements of good technique and better cameras.

Then, in September 1840, Talbot hit on a distinct combination of chemicals that at last promised a significant step beyond photogenic drawing – which had created the picture solely by action of sunlight and was then fixed. What he came upon was a chemical that he had had in his laboratory for some time and whose usefulness had been recommended to him by Herschel and another amateur photographer, the Reverend Joseph Reade. The chemical was gallic acid, made from the galls of oak trees. Talbot had found that by coating a piece of paper as he would for a regular photogenic drawing and then washing it over with gallic acid the paper became significantly more sensitive. In an episode that sounds strikingly

like Daguerre's 'Magic Cabinet' story when he discovered the developing ability of mercury, Talbot described in a letter to the *Literary Gazette* in February 1841 how he discovered the development of the latent image.

> One day, last September, I had been trying pieces of sensitive paper, prepared in different ways, in the camera obscura, allowing them to remain there only a very short time, with the view of finding out which was the most sensitive. One of these papers was taken out and examined by candlelight. There was little or nothing to be seen upon it, and I left it lying on a table in a dark room. Returning some time after, I took up the paper, and was very much surprised to see upon it a distinct picture. I was certain there was nothing of the kind when I had looked at it before; and, therefore (magic apart), the only conclusion that could be drawn was, that the picture had unexpectedly *developed itself* by a spontaneous action.[5]

In his letter Talbot went on to say that he repeated the experiment several times, on one occasion watching the image actually appear by candlelight, and that this spontaneous action occurred every time. He deduced from this that the paper had received a latent image, brought out by the action of the chemicals still remaining on the paper. This was the process Talbot had been looking for. It required a short exposure in-camera – a few seconds in sunlight to five minutes in full shade – and then the image was developed out by chemical action. In a statement that will be familiar to anyone who has since worked in a darkroom, Talbot talked of the pleasure for the photographer in being able to 'receive on paper the fleeting shadow, arrest it there and in the space of a single minute fix it there so firmly as to be no more capable of change.'[6] Thanks to the addition of gallic acid, these negatives, after fixing and

washing, were much more stable than his earlier ones and less prone to fading. Talbot even found that if fading occurred you could treat the negatives again with the same chemical; it would 'revive' the faded image which could then be used for more printing. This was the great strength of his process over Daguerre's: using these far more robust negatives, the photographer would be able to make dozens, if not hundreds, of positive copies simply by using his regular photogenic drawing formula for the printing paper. Talbot named this new process the calotype from the Greek word *kalos*, meaning beautiful. Typically, his mother as well as some of his acquaintances, tried to get him to call the process Talbotype in response to Daguerre's eponymous process, but he declined to do so. Soon after, Talbot added a further improvement which was to wax the negative after it was made. This made the paper more translucent and gave greater detail to the positive prints, as well as lessening the exposure time needed in the sun for making them.

In a move that surprised many of his contemporaries, and which angered those in the English photographic community already frustrated by the patent controls on the daguerreotype, Talbot decided to take out a patent on his new process and charge a fee to anyone who wished to make commercial use of it. In a letter to Herschel he explained that he had, however, intended that 'the use of it shall be entirely free to the scientific world'.[7] Herschel supported him in this: 'You are quite right in patenting the calotype,' he told Talbot. 'With the liberal interpretation you propose in exercising the patent right no one can complain.'[8] In this Herschel could not have been more wrong; the abuse heaped on Talbot – in the photographic press in particular – when he made this announcement was fierce and unrelenting.

It is hard now to see why Talbot should have suffered such

opprobrium from his fellow countrymen for the more than justified defence of his process from commercial exploitation by others. The failure to patent his first creation in 1839 had brought him no credit, and with Daguerre having patented his own process now in England, Talbot must have felt that this move would raise his process in the public's estimation. His work on photography had taken up a great deal of his time and the purchase of cameras, lenses and chemicals had cost him a lot of money, so why should he not try and recoup his costs? If others wished to make money from his process, there was no reason for him not to share in this windfall. It certainly made good business sense, but this decision was to be the source of a great deal of trouble and additional legal costs for him over the years to come. Having a patent is one thing, but protecting one's intellectual property and pursuing anyone in the law courts who makes use of it illegally is quite another. If Talbot had licensees who had paid their fee in good faith, it was unfair to them that others might get away with using it for free.

Yet in defending his process Talbot was portrayed by his critics as a wealthy man who put such a high price on it that honest tradesmen couldn't make a living out of it. In the end it made little difference; when the calotype process came out in February 1841 the daguerreotype was still in its ascendency, with English practitioners still paying a fee to use that process. The public still loved it, so why should practitioners pay out another fee for a different process that might not make back the money invested? This was certainly the view of Richard Beard, the holder of the British patent for the daguerreotype. Talbot asked him to act as his agent in selling licences for the calotype as well, but Beard could see no commercial advantage and declined the offer. This was a bigger setback than it seemed; for in response Talbot took on the job of agreeing fees and issuing the licences himself.

Unlike Richard Beard, Talbot was not a natural entrepreneur and his frequent absences from home on official business or on one of his jaunts to the Continent meant that those seeking information on the calotype licence often had a long wait before receiving a reply; either that, or the terms were often too complicated or demanded too much money up front for the prospective operators to take up the offer. Talbot's lack of business acumen completely let him down. He did manage to sell a licence to Henry Collen, a London-based miniaturist, but Collen, like Talbot, encountered a great deal of trouble with fading and his images were often touched up so heavily that they ceased to look like photographs. Antoine Claudet, the first daguerreotypist in London, also took out a licence from Talbot in 1844 but by this time he was famous for his daguerreotype portraits and found that he rarely had any call for the calotype.

Such is the arcane nature of British law, that a patent for England and Wales did not include Scotland, and it was there that the calotype eventually found its first enthusiastic home and its greatest success, for along with the daguerreotype it could be practised without a licence. Thanks to the introduction of the process by Talbot's Scottish friend Sir David Brewster, and through him its adoption by a number of academics and students at St Andrews University, the calotype blossomed in Scotland and some of the finest images in that process were made there. In 1842 the scientific establishment in Britain finally got round to recognizing the virtues of Talbot's work, only not for his photogenic drawing – which had received no prizes or official recognition – but for the calotype too. In a belated move that year, the Royal Society awarded Talbot the Rumford Medal 'For his discoveries and improvements in photography', an honour bestowed every other year on a scientist who had made inroads in the field of

thermal or optical properties of matter. It was one of the highest honours that the society awarded and Talbot was pleased to receive it, but coming as it did three years after the official announcement of his invention it could not but feel like an afterthought on the part of the official scientific community.

Sometime around 1846 Talbot sat, somewhat reluctantly, for his second daguerreotype portrait session, which this time produced three daguerreotypes. Interestingly the only known portraits of Talbot from that decade were made using the process invented by his rival. These images, by Claudet, show an anxious, rather preoccupied-looking man, his baldness hidden under his trademark Victorian stovepipe hat and sitting in profile. He was well dressed, as usual, but he could not compete in sartorial elegance with his rival Daguerre and dressed rather sedately like any country doctor or lawyer of his day. These images, in contrast to the first taken by Beard in 1842, show a more self-possessed man, obviously more aware now, as was Claudet, of the aesthetics of the photographic pose. Even so, Talbot did not seem to enjoy being photographed. The eyes are pensive and unresponsive to the camera, the face jowly and flaccid. There is about him the unmistakable melancholy of the eighteenth-century scholar preoccupied with 'floating philosophic visions', as he himself once described them.[9] He had by now become the pre-eminent calotypist in England but judging from his face in these photographs, it brought Henry Talbot little satisfaction.

In developing the calotype, he had turned to photographing various locations in and around his home at Lacock and then, with the assistance of his Dutch valet Nicolaas Henneman, whom he trained himself, taking the process on the road and photographing the picturesque architecture of Oxford and Paris. He executed a few portraits and group shots, but, typical of Talbot's reserved nature, it was the landscape and cityscape

that attracted his interest. In 1844 he set to work on disseminating the details of the calotype process, by devising a book, to be published in serial form as six individual booklets or fascicles, each containing actual photographic prints from his own calotype negatives. The series was called *The Pencil of Nature* and its purpose was twofold: first, to bring the calotype to the public's attention by showing that photographs could be published in book form; and second, to set out and describe the various modes in which Talbot believed that photography in the long term would prove most useful. These included views of architecture; landscapes; still lifes; the cataloguing of scientific objects; genre scenes; and the copying of works of art. He did not include portraiture, no doubt thinking in terms of the scientific rather than personal or recreational use of his process. Perhaps he wished to elevate the calotype above portraiture, which to him seemed the realm of the everyday, jobbing photographer and not that of the artist. Or perhaps Talbot himself had privately recognized that the better results in portraiture were achieved by the daguerreotype, and that it was sensible therefore not to engage in direct competition with it in this respect.

In order to provide the great quantity of pictures that he intended to include in *The Pencil of Nature*, Talbot worked closely with Henneman, whom he had now promoted to full-time photographer. They set up a printing studio at Reading, about halfway between Lacock and London. Known as the Reading Establishment, it was able to turn out dozens, if not hundreds, of prints every day (certainly in sunny weather) and had no problems producing the images needed for Talbot's book. Sadly though, the series was not a success and in April 1846 Talbot had to abandon it after only six issues, despite a small review in *The Times* 'earnestly commend[ing] this work to the notice of the public'.[10] What remains of *The Pencil of*

Nature, however, is a thing of exquisite beauty. The cover for each fascicle was an intricate image by Owen Jones, an influential designer whose interest in Arabic geometric designs was beautifully combined with neo-Gothic fonts and flourishes to create the distinctive look of the series. Overall it contained twenty-four Talbot calotypes, many of which are now iconic in the history of early photography. The few surviving copies of the entire series today are, of course, worth many thousands of pounds.

In between compiling *The Pencil of Nature*, the Reading Establishment also offered a service to other photographers who wished to have their negatives printed by professionals. During its three-year operation, it also took on two more large Talbot projects. The first was a series of prints to illustrate a book called *Sunpictures in Scotland*, the record of a trip taken by Talbot and Henneman through the places made famous by Sir Walter Scott's poetry, which was privately printed in 1845 and sold by subscription. The second project was producing 7,000 prints to accompany copies of the June 1846 issue of the *Art-Union Journal*. The short amount of time allowed for the work to be done meant that a number of the prints were not up to the standards they would have liked and this advertising coup turned into a decided failure when many of the prints began to fade quite soon after release.

It wasn't just the prints that had begun to fade. Talbot's own interest in making photographs seems to have ground to a halt in 1846, which coincides with the death of his mother. Lady Elisabeth Feilding had always been so proud of her son and his achievements and had wanted the best for him. He hadn't always taken her advice, but her persistence usually paid off, if only because Talbot generally found it easier to capitulate than go against her. Undoubtedly, however, Lady Elisabeth's desire for her son to achieve fame and fortune had

on occasion propelled Talbot in directions that he might best have avoided, including his mission to patent the calotype process, a decision that would colour the world's perception of him to this very day. But there is no doubt that the loss of this loving and formidable character in his life must have been a body blow.

With Daguerre's retirement from the field in 1839 and Talbot's withdrawal seven years later in 1846, the two pioneers had nevertheless set in motion a process that by the mid-1840s was not only rapidly expanding but was now making the important transition from a hybrid of art and science to a new and important discipline. Further improvements would come to photography at an increasingly dramatic pace, but not from its original inventors. The 1830s had brought us photography's birth; the 1840s its infancy; but it was in the 1850s that photography truly came into its own.

Chapter Twenty-two

THE MONOPOLY OF THE SUNSHINE

The mid-point of the nineteenth century was very much a time for taking stock of the great changes of the preceding decades. France had come through the aftermath of the Revolution followed by the years of Napoleon Bonaparte's First Empire, to see the restoration of the House of Bourbon in 1815. Then, once again, it had entered a period of turbulence, at the epicentre of the wave of revolutions that rocked Europe in 1848. A short-lived republic was once more replaced by an empire, this time under Napoleon III, which in 1851 finally brought with it hopes for a return to a period of stability and growth.

Britain had been fortunate to be spared revolution, though the industrial and economic upheavals of the 1830s and 1840s had seen serious social and political unrest. In 1837 a young and untainted queen had come to the throne, marking a significant national and psychological transition from a century or more of the increasingly dissolute Georgians to the stability of what proved to be a long Victorian period promising better things to come. In the first twenty years of the queen's reign there was a dramatic shift from an agrarian economy to a rapidly expanding, industrial-based one that brought with it considerable population movement from rural areas into the urban environment, so that by 1850, for the first time, more people in England lived in cities than in rural areas.

All of these changes might, on the surface, seem incidental to the history of photography and yet they were precisely the forces that encouraged its rapid expansion at the mid-century. The movement from agrarian to industrial work saw many people receiving wages for the first time, instead of living off the land – wages that could be spent on more than just the necessities of life. The transition into an urban environment also meant that people were much more aware of the inventions and innovations of the Industrial Revolution and among these new marvels was photography. Expensive at first, but quickly coming down in price, by 1850 a photographic portrait cost about one pound sterling, the average weekly wage for a skilled worker in London. In America, however, the cost was a tenth of that, making photography far more affordable to the general public. Photographers were already rushing to cater to this growing market. In March that year, an enterprising photographer in Dundee named Brown had already announced special facilities at his own Photographic Institution to cater for the sensibilities of lady sitters. He was now devoting every Wednesday 'for taking ladies' portraits only', assuring his clientele that 'on these occasions the background is to be tastefully decorated with flowers, &c., which will lend an additional charm to the pictures'.[1]

With the spread of photographic studios, such as Brown's, debate continued on whether the new genre was a science – or in fact an art. Mr Brown in Dundee was the perfect example of a former artist adapting to the new medium. Portraiture seemed the perfect amalgam of the two disciplines, with Brown's portraits providing 'not only literal accuracy which the mere mechanical process gives', but also a degree of artistry, which in the finished product added 'such additional improvement as makes the likeness more striking, and also gives it a positive value as a piece of art'.[2]

By the mid-century, Daguerre's process was still cornering the market and had outstripped Talbot's calotype, not just in Britain, but also on the Continent and in America. The daguerreotype was by now synonymous with photographic portraiture, just as in the twentieth century the Hoover would become the generic name for all brands of vacuum cleaner; people would talk indiscriminately of having a daguerreotype taken even when in fact a different process was used. Such was its widespread misuse as a catch-all for any kind of photographic method that Talbot suffered the indignity of learning that his calotype process was often referred to as a '*daguerréotype sur papier*' in France.[3] Nevertheless he doggedly kept his own process alive through the work of a few London-based photographers such as Henry Collen and Nicolaas Henneman, who attempted to make a living with the calotype, even though Antoine Claudet, one of the most significant early photographers in London had tried and failed to make the process popular. In the USA, the Langenheim Brothers of Philadelphia – innovative photographers themselves and photographic artists on a par with any studio in the country – had negotiated the purchase of Talbot's calotype rights for North America in an attempt to interest the market, but the process didn't take off there and in the end the Langenheims were driven into bankruptcy.

Photographic practitioners freely admitted that the calotype's facility for almost unlimited reproduction was a great advantage, but the softness of the image produced – compared to the sharp, more lifelike quality of the daguerreotype – was still failing to raise public interest. Nevertheless, one thing was clear: if the quality of the negative–positive system of photography could be improved it had a very good chance of surpassing the daguerreotype and even of capturing the market. Attempts had already been made to move away from paper as

a base for negatives. In 1848 Niépce de St Victor, a cousin of Daguerre's business partner, had found a way to coat glass with salted albumen (egg white) to create a photographic surface.

The process certainly worked, but it was as slow as photographic techniques of a decade earlier – requiring five- to fifteen-minute exposures – which precluded its use in portraiture. This of course was a fatal flaw, and would remain so for any process; for portraiture was the only branch of the photographic art that was as yet making money. As things turned out, 1850 would prove to be the last year that the two original processes would hold a monopoly on the interests of photographers. For, as inventive and controversial as the 1840s had been, the 1850s brought inroads in techniques that truly changed the face of the art. The initial argument over priority: who was the true father of photography – Daguerre or Talbot – and one that is still not settled even today, shifted to outright legal battles in the courts, focused on the protection of patent rights, and in the main, those of Henry Fox Talbot.

A number of technical breakthroughs came in 1851, including the first truly instantaneous photograph, another innovation by Talbot. In an experiment carried out at the Royal Institution he mounted a page from a newspaper on a rotating disc in a darkened room and set the camera up in front of it. He then spun the disc as fast as it would go and set off a spark discharged from a battery, the light from the spark thus working in the same way as does today's electronic camera flash. The negative, when processed, showed that the newspaper page had been frozen by the spark and captured in-camera, so that every word was readable. The spinning of the disc had shown how short but bright the exposure of the spark was and that it was the spark rather than a long exposure that captured the detail so fully.

Now aged fifty, Talbot was as active as ever, always on the move, travelling back and forth between Lacock and London as well as to the Continent on a regular basis. He struggled on with his experiments, still unable to find the elusive improvements to his process that would bring it to the masses. But he was also plagued by other, more pressing concerns, being constantly harassed by those who opposed either his calotype patent or, more commonly, the whole issue of patenting itself, at a time when invention was racing ahead in Britain.

The patent system had never been popular among entrepreneurs and businessmen who wished for a quick financial return on their capital in new inventions, and after 1850, at the height of the Industrial Revolution, there were frequent attacks in the press both on the patenting system and on those who used their patents as a way of trying to recoup the money they had spent in developing a machine or process. Such a highly contentious issue aroused strong feelings. In 1850 the London-based magazine *The Economist* had published an editorial arguing against patents on both moral and intellectual grounds:

> Before the inventors can establish a right of property in their inventions, they ought to give up all the knowledge and assistance derived from the knowledge and inventions of others. That is impossible, and the impossibility shows that their minds and their inventions are, in fact, parts of the great mental whole of society, and that they have no right of property in their inventions. Patents were 'injurious to the progress of production and to the common welfare and, thus, illegitimate in the light of the principle of property rights'.[4]

Talbot was attacked on a number of fronts: why should he need to profit from his invention? Wasn't credit where due enough for him? Some claimed that he wasn't the true inventor

of the calotype or that only parts of what he claimed were innovative enough for his patent to hold up to scrutiny. The protection of his patents cost Talbot a great deal of money, but worse, it affected his good reputation. Litigation was a tedious distraction not just from photography but everything else that he was working on. But once he had set this in motion he could hardly throw up his hands and give up on the defence of his own rights. How could one make a living from photography without paying for a licence? Well, in Britain at least, you simply could not. Only in America, where no patent existed and there were no troublesome national rivalries, did photography really thrive at this time.

The most scathing and spiteful of the attacks on Talbot came just as his suits against two photographers were being heard in Chancery. An article published anonymously in the *Art-Journal* of 1854 bewailed the fact that 'The most beautiful art of photography, for which we are indebted to the researches of science, appears doomed to contend with all the miserable annoyances and lamentable hindrances which arise from the doubtful character of our patent laws.'[5] After a mild swipe at Daguerre for taking out a patent in England the article homed in on its real target: 'William Henry Fox Talbot, Esq., of Lacock Abbey in Wiltshire, has lately commenced a series of actions at law, against several gentlemen in London and elsewhere, whom he represents as infringing certain patents which he has obtained, and which he appears to imagine secures to himself a complete monopoly of the sunshine.' The article proceeded to demolish Talbot's years of devoted experimentation with a condescending sneer:

Reviewing Mr Fox Talbot's labours as an experimentalist, we find him industriously working upon the ground which others have opened up. He has never originated any

branch of inquiry; and, in prosecuting any, his practice is purely empirical. It is the system of putting this and that together to see what it will make. It is progress by a system of accidents, without a rule. Thus it is, that we find that the calotype process was the result of an accident; and, in no respect has even the combination of which it consists the slightest claims to a scientific deduction.

This final statement was totally untrue and perilously close to libel. Talbot had been attacked and ridiculed in the press throughout most of the 1840s for taking out a patent on the calotype process but his skill as a scientist had never till now been questioned. Indeed, with hindsight – and bearing in mind today's highly litigious world – Talbot's attitude seems extremely liberal. He had always allowed scientists and amateurs to use his process for their own research without a licence or payment of a fee. His only and perfectly reasonable stipulation was that those who thought to make money from it should pay – but only until his patent expired.

Chapter Twenty-three

THE GREAT EXHIBITION OF 1851

In 1851, despite the unwanted distractions of his patent battles, which meant that photography was taking up more time than he would have liked, Talbot was greatly cheered by the advent of the Great Exhibition, held in London's Hyde Park, thanks in large part to the vigorous support of Prince Albert and Queen Victoria.

The royal couple were already well aware of Talbot's work thanks to the efforts of Talbot's half-sister Caroline, now married as the Countess of Mount Edgcumbe, who had been appointed a lady of the bedchamber to Queen Victoria in 1840. At Windsor Castle, early in August that year, Caroline had showed an album of her brother's work to the queen and Prince Albert. She was delighted with their response, telling her mother that they both had expressed an interest and had 'really admired the great progress that [Talbot] had made'.[1] Not only that, but Caroline went on to report this prescient comment: 'Prince Albert has a great knowledge of the Arts & thinks your discovery will be of great consequence to them.' Caroline told the royal couple that her brother would be pleased to make some images specially for the queen, to which she had responded that 'she should like it very much'. Thereafter the opportunistic Lady Elisabeth had, till her last gasp, constantly prodded Talbot into getting his work 'hung up at

Buckingham Palace'. 'Why do not *you* do this for her Majesty,' she wailed in frustration when hearing of the commission another photographer had obtained from the royal couple.[2] She also quite brazenly solicited the custom of other aristocratic contacts, triumphantly informing Talbot in June 1845 that the 6th Duke of Devonshire, a notable collector of photographs at Chatsworth, 'is become one of your greatest *puffers*'.[3]

The first sight of the Talbot album in 1840 had no doubt tapped into an early interest taken in photography by Prince Albert that had not needed any encouragement from Talbot. The genre had, from its invention, played an important role in his life with Victoria, following as it did only two years after the queen's accession. In fact, as the queen recorded in her journal, she had shown Albert some daguerreotypes recently sent to her from France on the very day – 15 October 1839 – when she had proposed marriage to Albert.[4]

In the spring of 1840 Prince Albert had already examined and purchased some daguerreotypes from the firm of Claudet & Houghton in London. Two years later he was the first member of the royal family to sit for his daguerreotype, at the 'Photographic Institution' of William Constable – one of eight British photographers operating under licence from Beard – at his studio on Marine Parade, Brighton. That first tentative image showed a very handsome young husband, slightly uncertain of himself, as he had been in the early days of his marriage to Victoria. Prince Albert's patronage did wonders for Constable's business; in London in late March 1842 the prince visited Richard Beard's by now acclaimed studio in Parliament Street, where further daguerreotype portraits were taken of him. Several of these first images were successful but only one survives today in the Royal Archives, albeit in a perilous condition.

There is no doubt that the prince's early interest in and

patronage of photography in Britain did much to encourage its blossoming there in the 1850s. The new art form was central to the record of his and Queen Victoria's family life, as one by one nine children were born to them. Many of the first informal, domestic photographs of the royal family were taken, not by professionals, but by Prince Albert's librarian, Dr Ernst Becker, himself a keen amateur, who joined the royal household in 1851. A darkroom was set up at Windsor, where Albert and even the queen had learned the early techniques of calotype printing with him, although none of their own photographs appear to have survived. But the family passion persisted, in their children, with Bertie the Prince of Wales, Prince Alfred, Prince Leopold and Princess Beatrice all becoming keen photographers. It was, however, Bertie's wife, Alexandra, Princess of Wales, who was probably the most accomplished of them all. She attended lessons at the London Stereoscopic School of Photography, exhibiting some of her work in an exhibition at the New Gallery in Regent Street in 1897, and later published many of them in 1908 in her *Queen Alexandra's Christmas Book*.

The inclusion of photographic exhibits at the Great Exhibition, together with the continuing royal patronage of the new art, had not just made photography socially desirable by 1851, it had elevated it officially to one of the wonders of the modern age. From May to October that year, London was at the epicentre of worldwide innovation and ingenuity, during an event of unparalleled scale and importance to British manufacturing excellence as well as national pride. It wasn't the first of its kind in England – smaller-scale exhibitions had been held in northern cities in the 1830s and 1840s – but this was the first truly *international* exhibition and on such a scale that it left its indelible mark as the cultural high point of the mid-century.

Prince Albert was, from the very first germ of the idea, one

of the prime movers behind the Great Exhibition, for when he was appointed to the position of president of the committee overseeing it, he had had no intention of being purely its figurehead. He took an active role in the design and management of this great endeavour, championing Joseph Paxton, a former landscape gardener turned architect who won the coveted commission to design the innovative exhibition building. As its full title implied, 'The Great Exhibition of the Works of Industry of All Nations' was hugely ambitious in its concept and exhibitors from around the world were welcomed. But Prince Albert's objective from the start had been a predominantly national one: for 'Great Britain [to make] clear to the world its role as industrial leader'.[5]

The exhibition hall was a wonder in itself. Made of iron and glass, it was quickly dubbed the 'Crystal Palace' by *Punch* magazine, a name that stuck for ever after.[6] The building was so revolutionary in its design and construction that it soon became a monument to the superiority of British creativity and innovation, and it is impossible to understate the impact it had on the public at the time and the continuing influence it would have on architecture to this day. It covered almost a million square feet of space and because it was designed to be modular – a temporary building for the duration of the exhibition – it took only eight months to erect. It was built tall enough to encompass two fully grown elm trees, so that when the building was dismantled at the end of the exhibition's run, the park would remain unspoilt.

Exhibits included machinery and manufactures of every kind, from agricultural to textile machines, steam engines and many objects from the growing industry for scientific apparatus. Fine Arts exhibits ranged from the exotic Koh-i-Noor diamond to the finest china, tapestries, silks, carpets and mosaics from around the world. Although it included works of

art and statuary from a number of nations and photographs were on display throughout the exhibition, a section of the ' south gallery was also specifically set aside for photographic equipment and photographs, the latter dominated by daguerreotypes. Not surprisingly, neither Talbot nor Daguerre exhibited any images at the Great Exhibition; by 1851 it had been five years since Talbot had last taken a photograph and longer than that for Daguerre. The focus of the Great Exhibition was not on past innovators but those working now, and on how the science and technology of photography would progress after 1851. Talbot's former assistant Henneman, who was still working hard to make a success of paper images, did, however, exhibit a few items as well as photographic equipment.

Talbot himself could not resist paying a visit to an event promising the very best in science and the arts. When he left his hotel in Jermyn Street on the morning of the opening ceremony, he encountered a long line of carriages obviously heading towards the exhibition, or at least trying to move in that direction. The traffic jam was immense; the whole of London was at a standstill on this historic day, 1 May 1851, and Talbot wisely decided it would be quicker to walk the two miles from his hotel. He arrived in Hyde Park early, entering through the eastern gate, and once inside chose a spot from which he could see the platform on which the royal family would be seated for the official ceremony at noon. The crowd was already enormous and more and more people were pouring into the park as every minute went by. The crush was intense, as Talbot later wrote to his half-sister Horatia, when he was back in the safety of his hotel: 'I had some difficulty in maintaining my post . . . against the assaults of Goths & Vandals & the still more difficult to resist, appeals of fair ladies who however by a delightful caprice soon "were sure that they could see better further on".'[7]

'At near 12 o'clock loud shouts announced the approach of the Queen,' Talbot continued, noting for his half-sister's benefit Victoria's pink and silver dress, her necklace of diamonds and 'in her hand, a fan & a large bouquet'. In a letter to Constance the following day, he described how, once the royal family had taken their place on the dais, 'Prince Albert then advanced with a paper in his hands and made a speech, of which we could not hear a word but which we comprehended to be an account of what the Royal Commissioners had done, & what a building they had reared – The Queen made a reply, which I have no doubt was a very gracious one.'[8] After a long and admonitory address by the Archbishop of Canterbury, the royal party rose and were led off on a tour of all the exhibits. The queen adored the exhibition; it was for her 'the happiest, proudest day in my life', the apogee of her beloved Albert's civilizing influence on British cultural life; she would return to it on more than forty occasions, including her birthday later that month.[9]

With something like 100,000 exhibits laid on by 13,000 exhibitors across a site three times larger than St Paul's Cathedral there was tremendous competition for the attention, and custom, of the many visitors to the exhibition. As many as 60,000 people a day paid the shilling entrance fee, but it would have required several miles of walking over many days to see every exhibit, and photographs were but one relatively small feature. Six countries – England, the USA, France, Italy, Germany and Austria – exhibited 700 photographs between them. But it was the daguerreotypes of Antoine Claudet (who now had premises in Regent Street) and the Englishman John Mayall (who had made his name as a daguerreotypist in Philadelphia in the 1840s) that got the lion's share of the attention in press write-ups. Daguerreotypes from France, Austria and Germany were noted without much interest – as

far as the correspondent of the *Morning Chronicle* was concerned, the daguerreotypes on show in the United States section of the exhibition, were of 'a very superior character. In the arrangements of the groups, and in the general tone of the pictures, there will be found an artistic excellence which we do not meet with in many others.'[10] There were enough calotype exhibitors in the English Department to show that Britain too had played a major role in the development of the art form. The Scottish pioneers David Octavius Hill and Robert Adamson were singled out for the artistic skill of their beautiful landscapes, which were admired for their 'Rembrandt-like effect of exceeding beauty'.[11] But the only mark Talbot indirectly left on the exhibition was in the appointment of Henneman as head of 'a staff of the best European calotypists' commissioned to create a photographic record of the objects exhibited at the Crystal Palace, 'thus preserving for future years truthful pictures of this great event'.[12] This, one of the first uses of photography as an important tool in preserving and archiving the past, might well have had a nod from Prince Albert who himself had initiated the photographing of the priceless drawings by Raphael and other works of art in the Royal Collection. Thirty Mayall daguerreotypes of the interior of the Crystal Palace were also copied and engraved as a record of that extraordinary and unforgettable six months in London.

In the awards made to exhibitors when the exhibition closed, Claudet won the highest for portraiture, with the Council Medal in his category. But although France had been the birthplace of the daguerreotype and Britain the host of the exhibition; the British photographer Mayall received only an Honourable Mention for his work. Three of the five medals handed out for the best daguerreotypes on show and commended as being 'super-excellent'[13] went to Americans: Matthew Brady, Martin M. Lawrence and John A.

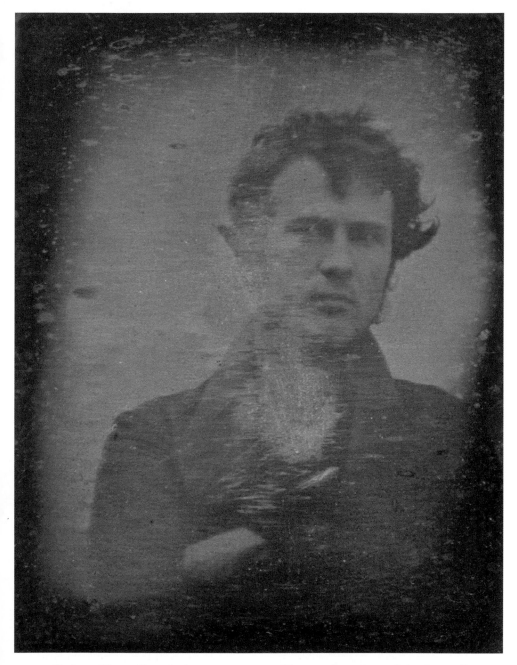

19. Robert Cornelius. A daguerreotype self-portrait and possibly the earliest extant portrait, October 1839.

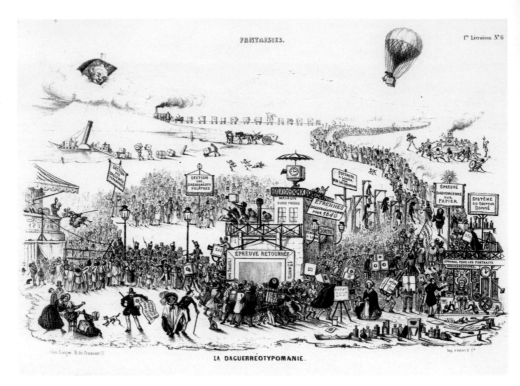

20. *Daguerreotypomanie.* Lithograph by Théodore Maurisset, 1839, satirizing the frenzy of interest in the daguerreotype at the time.

PHOTOGRAPHIC PHENOMENA, OR THE NEW SCHOOL
OF PORTRAIT-PAINTING.

"Sit, cousin Percy; sit, good cousin Hotspur!"—HENRY IV.
"My lords, be seated."—*Speech from the Throne.*

21. *Photographic Phenomena, or the New School of Portrait-Painting*, a view of Richard Beard's London Studio, by George Cruikshank, 1842.

A PHOTOGRAPHIC POSITIVE.

Lady Mother (loquitur). "I shall feel obliged to you, MR. SQUILLS, if you would remove those stains from my daughter's face. I cannot persuade her to be sufficiently careful with her Photographic Chemicals, and she has had a misfortune with her Nitrate of Silver. Unless you can do something for her, she will not be fit to be seen at LADY MAYFAIR's to-night."

[MR. SQUILLS *administers relief to the fair sufferer, in the shape of Cyanide of Potassium.*]

22. 'I shall feel obliged to you, Mr Squills, if you would remove these stains from my daughter's face.' Cartoon of lady amateur photographer by Cuthbert Bede, *Punch,* 30 July 1853.

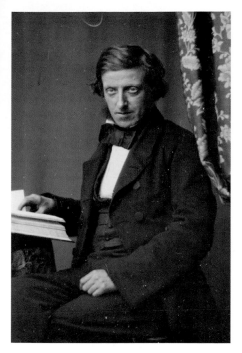

23. Frederick Scott Archer, the inventor of the wet collodion process, *c.* 1852.

24. Multiple image tintype of a young girl, shot with a multi-lens camera.

25. Xie Kitchen by Charles Dodgson, wet collodion negative and modern albumen print, *c.* 1873.

26. Portrait of a young family. Daguerreotype, *c.* 1850.

27. Thereza Dillwyn Llewelyn, Fox Talbot's cousin and a keen amateur photographer, leaning from her window to inspect a printing frame. Calotype by John Dillwyn Llewelyn.

28. Self-portrait with his son Francis, by Antoine Claudet, *c*. 1853.

29. *Fading Away*, a photograph by Henry Peach Robinson created from printing multiple negatives onto a single sheet of photographic paper.

30. Post-mortem tintype of a baby, *c.* 1855.

31. Asylum Patient at the Female Department of the Surrey County Lunatic Asylum, by Dr Hugh Welch Diamond, Resident Superintendent of the Asylum, *c.* 1852.

32. The portable photographic van of Roger Fenton, with his assistant, Marcus Sparling, somewhere in the Crimea, 1855.

33. Campaign pin with a tintype of Abraham Lincoln, one of the first successful uses of the microphotograph during his campaign for the American presidency, 1860.

34. *A Harvest of Death* by Timothy O'Sullivan, one of the photographers who worked for Mathew Brady in documenting the American Civil War of 1861–5. Taken at Gettysburg, July 1863.

Whipple. Horace Greeley, editor of the *New York Tribune*, was cock-a-hoop at this recognition of American supremacy: 'In Daguerreotypes it seems to be conceded that we beat the world where excellence and cheapness is both considered – at all events, England is no where in comparison.'[14] It was a typically overstated claim but one that would presage where the next big leaps in photographic innovation would take place. Henry Talbot certainly had no doubts of the impact of the exhibition on the future: 'Ever since the Great Exhibition,' he wrote to his friend Lord Rosse, 'I felt that a new era has commenced for photography, as it has for so many other useful arts and inventions.'[15]

By the time the Great Exhibition closed on 15 October more than six million people, from all over the world, had been to see it, not only paying back the initial costs, but raising a substantial profit. These excess funds were used in the construction of the Victoria and Albert Museum and other buildings in the South Kensington Museum complex that would later become popularly known as Albertopolis. The Crystal Palace itself was too grand and too much loved simply to be consigned to oblivion at the end of the run; as it had been built in separate sections the decision was made to dismantle it and move it elsewhere. A site was chosen on Penge Common at the top of Sydenham Hill in South London, where the Crystal Palace remained, albeit in a state of slow decay and decline, until 1936 when it burned to the ground.

*

In that same busy summer of 1851 a new opportunity presented itself to Talbot that provided a welcome break from the patent wars he was still fighting and offered him further recognition in yet another field of science that was close to his heart. As a child, he had developed an interest in astronomy and in

particular he had long been interested in the movement of the sun and moon, often writing in his letters and journals about lunar eclipses. By the age of seventeen he was already creating complex mathematical calculations to predict when the next lunar eclipse would happen, and with surprising accuracy. In the summer of 1851 there was to be a total solar eclipse that would be seen across parts of Europe but unfortunately not in England. Talbot decided to travel to the Continent to see it for himself. Upon learning of his impending trip, the Royal Astronomical Society asked him to prepare a report on it for them. Talbot's friend George Airy, the Astronomer Royal, also asked him if he could make a series of photographs of the event but as this was Talbot's first chance to observe a total solar eclipse he opted not to do so; even photography had to take second place to his now greater interest in astronomy. He was intent on finding somewhere in Europe where the eclipse could be viewed in full and preferably where no other official observers would be based. These, he knew, had already made their way to Danzig, Frauenburg and Königsberg, so he opted instead for the little medieval town of Marienburg, arriving there on 26 July. The trip was an unequivocal success both personally and professionally for Talbot, for he was never happier than when submerged in the world of pure science. His 'Account of a Total Eclipse of the Sun'[16] was well received by the society and was published in the *Memoirs* of the Royal Astronomical Society for 1852. It was a welcome respite from the circumlocutions of the patent office and the courts. But it was followed soon after by tragedy.

On 16 August, when Talbot arrived in Brussels on his way home, a letter was waiting for him at his hotel informing him of the death of his dearly loved half-sister Horatia. She had died on 10 August, just ten days after giving birth to her only child, at the age of forty-one. Horatia had been married little

more than a year and of his two sisters Talbot was closer to her. She shared his humour and understood his wit, as their letters to each other – rarely serious and usually ironic – testify. Talbot was 'overwhelmed by the sad, sad intelligence which has met me at this place'[17] and returned to England with a heavy heart.

Chapter Twenty-four

THE RELUCTANT INVENTOR

In Paris in the 1850s, as elsewhere, the number of practising photographers was rapidly growing and, in collegial style, they had begun to share information and techniques, though in a still random and not yet organized way. Various photographic periodicals also emerged at this time, such as the *Daguerrian Journal*, founded in the USA in 1850, *La Lumière*, which began publishing in France in 1851, and the *Journal of the Photographic Society of London*, published from 1853 and in 1859 becoming the *Photographic Journal*; it is still in existence today. All of these and a variety of other, shorter-lived publications ensured the wider dissemination of information on the subject. This desire had already prompted the setting up of various clubs, even before the Great Exhibition took place, such as the Calotype Club in Edinburgh and a Calotype Club and a Photographic Club in London, but these had essentially been informal gatherings of friends with an interest in photography rather than any kind of established society.

In this respect, as in so much of the story of the early years of photography, Paris once again led the way, when the Société Héliographique was formed there in early 1851 'to hasten the perfection of photography'.[1] It lasted only a year but was the very first national photographic society and London soon followed its example. In the winter of 1851, a provisional

committee was set up, after which one of its leaders, the photographer Roger Fenton, travelled to Paris to visit the new société. He was much impressed and on his return to London wrote a report, published by the *Chemist* in February 1852, in which he lauded the Parisian society for its generous sharing of information. A month later Fenton published a 'Proposal for the Formation of a Photographical Society' in the *Chemist*, in which he called for a formal constitution and the establishment of permanent meeting rooms. To bring it onto an equal footing with other eminent scientific societies in London he also proposed that the proceedings of the society be regularly published and that a library be set up that would be available to all members. Central to the society's objectives would be the publication each year of an album of images, where members could share their work, but which would also act as a record of the progress that the new art was making.

Back in the spring of 1851 Talbot had been approached by Robert Hunt, a mineralogist who had taken up photography and who was acting for the steering committee of the proposed new Photographic Society, requesting that perhaps a relaxation of his patent restrictions could be granted to club members who wished to take up photography as a hobby. Talbot readily agreed, provided the society acknowledge him as the inventor of photography on paper, and undertook to guarantee that the images made by its members were not for profit. But he still insisted on retaining his patent rights over those making money out of photographic portraits. By now he was concerned that to capitulate and give up his patent entirely would be to lose face. In late May 1852 he wrote to his friend Sir Charles Wheatstone about the dilemma he was in: 'I should undoubtedly expose myself to ridicule by relinquishing the patent right merely because a body of artists objected to it "as well as to all other Patents, on principle".'[2]

The deadlock was finally broken when Lord Rosse, president of the Royal Society representing the scientists, and Sir Charles Eastlake, president of the Royal Academy, jointly requested a relaxation of Talbot's rights in a letter which set out cleverly to flatter in order to win this final concession. Their reference to 'The art of Photography on paper, of which you are the inventor' must have reassured Talbot; fundamentally, what was at stake was national interest, as Rosse and Eastlake explained.[3] The French were now working on improving the calotype and Britain must not be left behind.

Talbot's response was hopeful. He was, he said, perfectly prepared to give his process 'as a free present to the public', but in one respect he remained adamant: '"The exception" which I am desirous of still keeping in the hands of my own licensees, is the application of the invention of taking photographic portraits for sale to the public.'[4] There was still no getting past Talbot's stubborn defence of this point. Nevertheless, with his agreement in every other respect, the Photographic Society was founded at a public meeting on 20 January 1853 held at the Society of Arts, though Talbot judiciously declined the request to be its first president. Unlike its short-lived French counterpart, the Photographic Society thrived, thanks to the driving energies of its first secretary, Roger Fenton, who had enjoyed considerable success with his photographic work at the Great Exhibition.

In the summer of 1853 Queen Victoria and Prince Albert agreed to be patrons of this new society and the following January, they braved freezing weather to attend its inaugural exhibition, taking a genuine interest in many of the 800 works on display. They were greatly impressed with the rapid advances that photography had been making and bought many of the seventy-three photographs exhibited there by Fenton, including some extraordinary images of Moscow taken

on a visit he had made in 1852. Soon after, they invited him to Windsor Castle and Buckingham Palace to photograph them with their children. The Photographic Society in the meantime went from strength to strength, becoming the Royal Photographic Society in 1894. It is now the world's oldest continuous society dedicated to the art and science of photography.

An allusion to national pride in Rosse and Eastlake's 1852 letter to Talbot was not gratuitous. By that time the French had indeed taken up the calotype as a more artistic form than the daguerreotype and had begun to make a number of major improvements on the process. However, although Talbot had taken out a patent for the calotype process in France, just as he had in England, it was widely ignored. To enter into lawsuits in two countries was more than he was capable of, so the French continued to practise his method with impunity. Free of legal constraints, they began to make improvements and modifications to both the negative and positive processes originated by Talbot that soon produced superior images. As a result, throughout the 1850s French photographers produced some of the most beautiful photographs made using Talbot's process.

One of the first modifications was a new positive printing paper, introduced in 1850 by Louis Désiré Blanquart-Évrard. He found that the prints from calotype negatives lacked sharpness, not just because the negative was on paper but also because the photogenic drawing paper on which the positive prints were made had a rough texture with the silver image particles embedded into the surface, both of which softened the details of the image. Blanquart-Évrard devised a method whereby the paper was first coated with albumen (egg white), so that when dry it could be sensitized just like photogenic drawing paper. This simple coating lifted the sensitized surface up out of the paper fibres, giving a smoother surface and a

slight gloss. Because the silver of the image sat above the paper layer, in the clear albumen, it gave a much sharper quality to the print. By 1855, albumen paper had almost completely supplanted ordinary photogenic drawing paper and factories were set up to mass-produce it. Photographers could then buy it by the box, but they still needed to sensitize it in their darkrooms. Although daguerreotype plates and cameras were by now being produced in some quantity, the advent of this pre-prepared paper was essentially the beginning of the true mass-production of photographic materials. Such was the growing demand for albumen paper that later in the century one factory alone was using around six million eggs a year in its manufacture.

It was another Frenchman, Gustave Le Gray, who found a way of improving the sharpness of the calotype negative. Talbot had proposed the waxing of the completed negative to add translucency and to minimize the grain of the paper seeping through during printing. Le Gray took this a step further. He waxed the paper before it was even sensitized; like Blanquart-Evrard's albumen paper, this additional step filled the rough surface of the paper and allowed the sensitive surface to sit on the smoother wax surface rather than amongst the rough paper fibres. Although similar in many ways to the calotype, this process was different enough for photographers to refer to it as the waxed-paper process, in order to distinguish it from the earlier one. When waxed-paper negatives were printed on albumen paper they were almost as sharp as if the negative had been made on glass.

*

While the French were busy perfecting the calotype, over in London one of the still relatively obscure figures in early British photography had made new inroads in Talbot's photographic

process and had quietly announced his findings in an article in the *Chemist*. Photography in these first two decades of its history seems populated by self-effacing, unsung pioneers who failed to capitalize on their gifts and the short, sad story of London-based artist Frederick Scott Archer is one of them. The son of a country butcher in Hertford, and thus having none of the benefits of money or privilege, Archer had served an apprenticeship as a silversmith and bullion dealer. This work prompted an interest in numismatics and modelling figures. Archer worked for a while as a sculptor before becoming interested in Talbot's calotype process in 1847. As poor as the proverbial church mouse and working quietly in isolation at his studio in Bloomsbury, Archer had turned his attention to photographic experimentation. A daguerreotypist who once visited him described Archer as thin and pale, 'a very inconspicuous gentleman, in poor health, with a somewhat sorrowful look and angel wife'.[5] The new process that Archer came up with was an artistic cross between the accuracy of the daguerreotype and the reproducible nature of the calotype, but its formulation and techniques were all Archer's own.

As such, the daguerreotype and the calotype each possessed attributes that, if somehow they could be combined, would make a perfect photographic process. The daguerreotype produced a crisp, sharp image with detail that stood up to examination through a magnifying glass, but the image was unique and allowed for no reproduction. The calotype created a negative from which any number of positive prints could be made, but the image was not sharp. The necessity of using a paper negative meant that the light was scattered by the paper fibres during the printing process, diffusing the resolution of the image. In general, therefore, the public had opted for the sharpness of the daguerreotype over the reproducibility of the calotype, but the ideal photographic process – and it was one

that stood to really clean up financially – needed to combine the best aspects of both processes.

Archer's solution was to find a way of putting the negative on glass, rather than paper, which would provide the crispness of the daguerreotype and the reproducibility of the calotype. To do so, he used a new solution known as collodion – a syrupy liquid made from cotton dissolved in nitric acid – that was then mixed with ether and alcohol. Once it is poured onto the glass plate the ether and alcohol begin to evaporate and within a few minutes the collodion layer has dried. The process is generally known now as wet-plate photography, but this descriptive highlights its one flaw. The photographer had to pour the collodion on the plate, sensitize it, make the exposure and then develop the plate – all before the collodion had dried, a process which had to be completed usually within fifteen minutes. This was not difficult to do in the studio, but if a photographer attempted to use this process in the field to make landscape views, he would have to take a portable darkroom and all of his chemistry with him. Various designs for these portable darkrooms came out almost immediately after Archer's process was revealed and generally, because of the usefulness of the process, photographers were willing to tolerate this extra burden. The quality of the image was such that it could reproduce the sharp detail of the daguerreotype without the problematic reflection of the silver plates and was at least as easy and fast to print with as the calotype. In fact it was more versatile than either of the earlier processes. If an underdeveloped negative was backed with black cloth, it took on the appearance of a direct positive, usually called an ambrotype. Housed like a daguerreotype in a case, to mimic its aesthetic appeal, the ambrotype was less magical but cheaper and certainly easier to see. Wet-collodion could also be applied to blackened sheets of iron and an image produced

by this method – and widely known as the tintype – became the cheap and cheerful version of the ambrotype.

Frederick Scott Archer's story has a truly Dickensian end to it. Although he exhibited a few collodion negatives at the Great Exhibition, he resisted the suggestion of calling his images 'Archerotypes'.[6] In stark contrast to the belligerent line taken by Talbot in defending his own process, the shy and self-effacing Archer was 'unusually unassertive about his invention' and never capitalized on it or the publication of his *Manual of the Collodion Photographic Process* published in 1852.[7] He died in Great Russell Street, Bloomsbury, in 1857, six years after introducing the wet-collodion process, and having earned not a penny from his invention. Yet one more brilliant photographic talent was gone too soon, just like Tom Wedgwood before him. As the *Journal of the Photographic Society* noted:

> Another victim has been added to the long catalogue of martyrs of science. Mr Frederick Scott Archer, the true architect of all those princely fortunes which are being acquired by the use of their ideas and inventions, after struggling for some time for a bare existence, has now departed from among us.[8]

Archer was only forty-three at the time of his death and was consigned to an unmarked grave at Kensal Green cemetery. He left behind a widow and three daughters. The Photographic Society organized a collection, appealing to 'lovers and practisers of photography' on the ground that Archer's 'generosity in unreservedly giving to the public this marvellous improvement, disdaining to secure its advantages to himself and family, enhances his well-earned fame, and entitles him to lasting gratitude'.[9] But neither Archer's fame nor the public's gratitude stretched very far. A grand total of £767 was collected for the family and they were awarded a pension of £50 per year.

A request to the distressed widow by another photographer, Jabez Hogg, for her to check whether her husband had left any useful papers or notes about his collodion process produced a touching and distracted response. Mrs Fanny Archer, who had now moved back home to Bishop Stortford, responded several months later in considerable dismay, enclosing a few pages in a grubby notebook:

> You will therein see Mr Archer's notes of iod-collodion in 1849. You may wonder that I could not find this note-book before, but the numbers of papers that there are, and the extreme disorder, defy description.
>
> My head was in such a deplorable state before I left that I could arrange nothing. Those around me were most anxious to destroy *all the papers*, and I had great trouble to keep all with Mr Archer's handwriting upon them, however dirty and rubbishing they might appear, so they were huddled together, a complete chaos.[10]

Fanny wondered her brain 'did not completely lose its balance' when she attempted to sort through them. None of her relatives could help and her husband had been 'of so reserved a character, I had to *find out* where everything was'. She ended her letter in forlorn tones: 'I need not tell you that I hope this dirty enclosure will be taken care of.' Such was Archer's pitiful written legacy of his ground-breaking process; her husband, Fanny confirmed in a second letter, had 'lived in a world of his own',[11] a world that she, like Madame Daguerre, had clearly neither understood nor ever been allowed to enter.

Tragically, the much-put-upon Fanny Archer followed her husband to the grave a year later. It is impossible today to quantify what the patenting of his process might have earned Archer, had he taken out a patent and lived longer. The British

government estimated that its use saved it more than £30,000 alone in facilitating the mass reproduction of campaign maps during the Crimean War of 1854–6.

*

With the advent of the calotype and Archer's wet-collodion process the photographic world was clearly in line for many dramatic changes, but, sadly, one of its two great inventors would not live to see what the 1850s would bring. Now entering his sixties, Louis Daguerre had become the epitome of the *bourgeois gentilhomme*, as daguerreotypes of him testify. With his curly, coiffured red hair, his thick bootbrush moustache above a long, straight, sensuous mouth and wearing his cravat and silk waistcoat with his *Légion d'Honneur* proudly pinned to his jacket, he presented a robust image of the successful, confident, self-made man. It was only the heavily freckled skin that somewhat spoiled the dandified image.

He had now retired gracefully from the cut and thrust of the commercial world to his new home, where he remained ensconced, contentedly tending his garden, tinkering with projects and meeting with his friends. Although he had fallen out of the public eye, his years in the art world of Paris and his eponymous invention had kept his name on people's lips. He and Madame Daguerre seemed headed for a long and happy retirement in the company of their adopted daughter Marguérite. Daguerre's daily walks and his other projects appeared to be keeping him in robust good health, but during lunch with his family on 10 July 1851, he collapsed. His old friend and neighbour Armand-Louis Mentienne was called over and cradled Daguerre in his arms but within an hour, the great inventor had died. A heart attack is thought to be the cause. He was just sixty-two years old.

Daguerre's death hardly registered in the British press

despite its occurring during the Great Exhibition, where the photographic technique that he had invented was being celebrated. There was, however, a massive outpouring of grief in France and elsewhere on the Continent. When Daguerre was buried two days later his funeral was attended by the whole village of Bry-sur-Marne as well as representatives of the Société Libre des Beaux-Arts. Mentienne the mayor, and Louis-Alexandre Péron – one of the great historical painters and a former student of Jacques Louis David – both gave eulogies lauding the great man. Daguerre's old friend Charles Chevalier was there too and through tears declared 'Honour to Daguerre, the inventor of Photography!'[12] He called for a national monument to be raised to his friend and the mood was such that the Société Libre des Beaux-Arts responded quickly, launching a public subscription to pay for it. Just over a year later a fitting memorial to Daguerre was erected over his grave in Bry-sur-Marne. The dedication ceremony was an even larger affair than Daguerre's funeral. A requiem mass was held at the local church, where his final Diorama painting still took pride of place in the nave. Politicians, painters, photographers and other Parisians of note attended, along with the elite of Bry-sur-Marne and Daguerre's widow and niece. After the mass the mourners passed between ranks of National Guard sentries to the cemetery, where Péron, too overcome to read his homage to his friend, had to hand it to the Secretary-General of the Société Libre des Beaux-Arts to read.

Under the terms of his agreement with the French government Daguerre's pension was now reduced by half for his widow. Madame Daguerre found their large house too much to handle in her reduced circumstances and sold it to a religious order, Les Dames de Sainte-Clotilde, but kept a small residence in what had been her husband's former studio for herself and Marguérite.

The loss of Louis Daguerre to the photographic community was strongly felt but his name and reputation were by now an indelible part of history. But the experimentation he had inspired was already leaving his invention behind.

ART OR SCIENCE?

In 1853, after Henry Fox Talbot surrendered almost all of his rights under his calotype patent, one might assume that the voices of criticism would have finally died down. They did not. The patenting of the daguerreotype in 1839 had certainly raised eyebrows in Britain and invited protests, but these had tended to be anti-French rather than personal attacks on Daguerre himself, whose patent also lapsed in England in 1853. Freed from these constraints, photography was about to blossom on a much wider scale. But meanwhile, there remained one stumbling block – Talbot's continuing patent on portraiture. His critics were furious; Talbot's stubbornness was slowing down progress in the genre, which only full-time professional photographers, who worked the process every day, could bring to it. The licence fee was too high, they complained – and worse it was inconsistently administered. Perhaps he was misguided, but Talbot placed greater value on his process than the public did, which often prompted him to make the terms he demanded too complex, by asking for a licence fee up front, followed by additional payments per sitting and per print. The few photographers who did take it up quickly found that it was impossible to make a profit. Only Henneman, late in the decade, made much from the calotype and that was by

adopting improvements as they came along and by exploiting his personal connection with Talbot.

But the problems did not stop there: Talbot made matters worse for himself – and this seems to run totally counter to his personality – by pursuing those he felt had violated his patent right with great vigour and what appeared to be a certain amount of spite. His aberrant behaviour in this regard has exercised photo-historians for years, for Talbot wasn't litigious by nature, nor was he known for aggressive behaviour – rather the reverse. It would seem that he felt compelled to defend what to him was a matter of intense personal principle. As he explained to a young friend, the photographer Nevil Story-Maskelyne:

> I am at present, very much against my inclination, engaged in some legal proceedings with a person who is infringing my patent right. But I cannot help it, since in justice to several photographic Artists who are taking por-traits with my license, I must take the necessary steps for their protection . . . Having presented my invention to the Public, with this sole reservation, I might have expected that it would have been respected, but since it is not, I have no choice but to appeal to the law.[1]

In the course of 1854 Talbot therefore brought two actions before the courts for the infringement of his patent rights, the first against James Henderson and the second against Martin Laroche, both London-based photographers. The complexity of these cases was compounded by the fact that Talbot believed that his calotype patent covered Archer's newly released collo-dion process as well. As far as he was concerned, creating a negative using silver iodide and an organic developer to bring out the image, as Archer did, had been the basis of his own original patent and whether it was executed on paper or glass

made no difference. Howls of protest once more went up that Talbot was not only overprotective of his own patent rights but was now hijacking another man's invention as well. A letter to the *Journal of the Photographic Society* summed up the widespread hostility towards him: 'Talbot,' it stated 'has as much right to prevent Henderson, or anyone else, taking portraits by the photographic or collodion processes, as he has to prevent Sir John Herschel from looking at the moon through a telescope.'[2]

In the case against Laroche, which came to trial first, Talbot called on Sir John Herschel and Sir David Brewster to offer affidavits and Nevil Story-Maskelyne to testify on his behalf. The judge freely admitted that he didn't fully understand the technicalities and the jury relied on his instructions to come to a decision. While they confirmed that Talbot was indeed the first and true inventor of the calotype process, they concluded that Laroche had not violated his patent. Talbot decided against an appeal and hesitated over whether to go ahead with the other case. In the end he was forced to take Henderson to trial when he failed to reach an out-of-court agreement with Henderson's solicitors over payment of his legal fees. It was a poor decision, for the trial ended badly for Talbot on 20 December, with his being ordered to pay both Henderson's legal fees and almost as much again in damages. It must have put the dampeners on the Talbot family's celebrations of Christmas that year.

*

In the wake of Talbot's two court cases, many photographers, even those who had previously been using the daguerreotype process, had quickly taken up Archer's new collodion process. Other new practitioners were entering the field as well, in the main those who had not been able to afford either the daguerreotype or the calotype patent, and who now leapt at

the chance of using a new and better process that was entirely free. For Archer had not taken out a patent. He was, of course, lauded at the time for selflessly offering the collodion process to the world without restrictions, but his decision not to take out a patent was probably an economic one: patenting was an expensive legal process and patents, once granted, were even more expensive to protect. At the time, Archer, unlike Talbot, simply had not had the money. Later, when the full value of the collodion process had sunk in, his became a cautionary tale of how the ingenuous inventor might be treated if he did not have the proper protection of the law. It confirmed that generosity in business is rarely repaid and also, in a way, vindicated Talbot's decision to try to defend his own patent.

By the end of the 1850s a few diehard daguerreotypists remained in business, but most professional photographers had converted to Archer's collodion process by then or gone out of business. Talbot's calotype had never found its feet in England beyond the advocacy of a few enthusiasts, but it was carried on in France as the preferred method of art photographers for a few years to come. Photography had gone through a decade of exciting refinement and reinvention and was now commonplace. The one-off daguerreian image had at last given way to Talbot's more versatile negative–positive process, thanks to a man who never lived to enjoy the acclaim or the financial rewards. And thereby lies the tragedy, for Frederick Scott Archer's collodion process would dominate photography for the next thirty years.

*

The series of patent battles over the calotype that Henry Fox Talbot was drawn into in the 1850s took a heavy toll on him. It was clear after the debacle of the Laroche case that his

patent would no longer hold sway and to keep on attacking in court those he felt violated it would only expose him to further humiliations in the press. He decided therefore to allow it to lapse without renewing it, a decision that the press failed to take note of. Despite this retreat, Talbot was not discouraged from continuing to patent further inventions – this time without controversy – in photographic engraving. But he was growing old and in declining health and so retreated to the quieter waters of his home at Lacock and his old favourites of science, mathematics and the study of Assyrian cuneiform.

It was a wise decision, for in hindsight, those who opposed Talbot's patents were right in arguing that such controls were an obstacle to further scientific invention, by blocking those with no money from being allowed to practise it. The real and less visible battle was in fact not the public one against Talbot in the press, but the one against Richard Beard's monopoly on the daguerreotype patent in England. Before that patent expired in 1853 there had been only about a dozen daguerreotype studios in London, all run by or licensed to Beard with the exception of Claudet's studio. These twelve studios were meant to service a city of 2.5 million inhabitants. At the same time, New York City, with less than one-fifth of the population of London – but where neither photographic process was patented – was home to more than 100 studios, as an article in the *New York Tribune* in April 1853 testified. Photography, it said, was already big business in America, 'giving direct employment to about 250 men, women and boys [in New York alone], though the number who derive support from the art in the United States, in all its branches, is variously estimated at from 13,000 to 17,080, including those working in the manufactories'.[3] If each daguerreotypist in America made just five images a day during a normal working week, then approximately three million daguerreotypes would be made in the

USA in 1853 alone. The crippling limitations on usage in the UK were clear for all to see.

In 1857, Lady Elizabeth Eastlake, a noted art critic and regular contributor to the *Quarterly Review*, wrote a lengthy article assessing the state of photography, in which she looked back over the practices that had changed in the eighteen years since it had first been announced. Photography was now ubiquitous:

> a household word and a household want; is used alike by art and science, by love, business, and justice; is found in the most sumptuous saloon, and in the dingiest attic – in the solitude of the Highland cottage, and in the glare of the London gin-palace, in the pocket of the detective, in the cell of the convict, in the folio of the painter and architect, among the papers and patterns of the mill owner and manufacturer, and on the cold brave breast on the battlefield.[4]

A whole range of varying processes were now vying for the public purse. Lined up against the talbotype and calotype were the amphitype, anthotype, catalysotype, chromatype, chrysotype, energiatype and fluorotype. All of them came and went in competition too with Daguerre's original process – now bastardized in popular parlance as the 'daggertype', 'dagtype' or 'docktype'.

Photography was no longer just a commodity; it had become a unifying force that brought ordinary people together in the shared pleasures of having their photographs taken. It had also given rise to a whole new profession, bringing men and women from all classes and walks of life together in a kind of fraternity with its own language and currency, where they could share their successes and discuss ways of improving their craft.

The Photographic Society of London had elected Lady

Eastlake's husband Charles as its first president in 1853. Already director of the Royal Academy (and later director of the National Gallery), Sir Charles Eastlake declared in the opening lines of the very first issue of the society's journal that 'The object of the Photographic Society is the promotion of the Art and Science of Photography' – an inclusive approach that was approved by many of its members.[5] But four years later, when Sir Charles stepped down and Sir Frederick Pollock took up the reins, attitudes at the top of the society changed. Pollock, who was the Chief Baron of the Exchequer of England and a Tory politician, was not as diplomatic or broad-minded as his predecessor. In his view, photography was a 'practical science' and not an art, a statement that pulled the rug from under the feet of the photographic artists in the society. The brief Utopia of photography as a rarefied art form was over.

Such a change in attitudes was inevitable, given the pace at which photography had progressed in such a short time, provoking more extremes of opinion than most of the other arts and sciences combined. The question persisted: was photography an art or a science? Was Daguerre its inventor, or Talbot? Or was it someone else entirely? – there was no shortage of pretenders to the throne. Photography had created a radical shift in the way people saw themselves and their world and it is no wonder that its role was so contentious. Many other art forms had been in existence in primitive form before humans even left the cave, but this invention was such a giant step forward in representing the world around us that it was truly only believed when seen. This childlike sense of amazement, as striking as it was, couldn't and didn't last. Even before the last accolades for Daguerre had faded away, others were introducing changes and improvements to photography and as each particular innovation was announced it was accompanied by pre-emptive proclamations that the art of

photography had now been 'perfected'. This, of course, was far from the case; during those first twenty years, photography was repeatedly reinvented in the way it looked, the way it was made and the way it was used. Each of these stages of re-invention invigorated the art and kept it fresh, although many were merely improvements on improvements rather than on the original process. When a shortcoming was noted, someone eventually found a way to overcome it. The daguerre-otype was small, critics argued; it was too shiny and expensive. Yes, it was small, but no smaller than the miniature painted portrait that had preceded it for 300 years. Yes, it was reflective and hard to see, but the purity and smoothness of the mirror-like silver surface were what allowed the daguerreotype to capture such accurate detail in an image and what made it seem to float on the surface like a reflection in a pool. Yes, it was expensive, but the expense would soon come down thanks to vigorous competition. The calotype's flaws, on the other hand, were that it was slower and less sharply defined than the daguerreotype and looked too much like a drawing. All of these things could be, and were, modified and improved.

The early descriptions of Daguerre's images made much of the fact that they were not produced in natural colours but as a series of greys, much like engravings or etchings. A way to bring natural colours into the images was one of the first improvements sought. The first step was simply to make use of artists' pigments: American daguerreotypes of the 1840s and 1850s were often enhanced by adding small amounts of pow-dered red pigment to the image on the cheeks and lips of the sitter. When done well such tiny additions could bring a stirring of life to the sitter's image. Gold jewellery could also be enhanced by the addition of pigment – usually bronze powder. English daguerreotypists adopted much the same techniques with minimal colour intervention, but quickly took it much

further than their American or Continental counterparts, achieving quite elaborate additions of colour to the surface of the plate. It was possible in a number of the better studios for a man in Guards uniform to have the bright red of the fabric painted in, as well as the gold braid and brass buttons. Hand-colouring was a definite improvement, if it was done well, but in the end it was still a case of an artist intervening in a process originally promoted by Talbot in *The Pencil of Nature* as being achieved 'without any aid whatever from the artist's pencil'.[6]

For a brief moment in 1850, it appeared that perhaps the photographer's colourist could put away his paintbox for ever. In America an upstate New York Baptist minister named Levi Hill announced that he had made daguerreotypes that repro-duced the colours of nature. He had shown some examples to various people and expectations were running high. The world eagerly waited for Hill to publish his process; there was talk of offers of $100,000 for him to make his secret public. But when in 1856 he did publish a book, called *A Treatise on Heliochromy*, it turned out to be a rambling account of his life and exper-iments with no scientific revelations. This apparent hoax was soon forgotten about, although shortly before his death in 1865 Hill repeated his claim, but he admitted that it had happened by accident and that he had spent the last fifteen years of his life trying to figure out what he had done to create the colours.[7] The quest for obtaining pictures 'in their natural colours' remained; it seemed at the time the ultimate Shangri-la of photography. 'If such a process should eventually be dis-covered, the Photographer could wish no more,' observed *Photographic Notes* in 1858. 'Photography, from the little spring from whence it arose, will at length, after many windings and obstructions, widening and deepening as it flows, have reached its boundary, and flowed into the great ocean of knowledge of which it is doubtless destined to form a most conspicuous part.'[8]

At about the same time as hand-colouring of photographs was introduced, a second enhancement was soon to capture public attention: stereo photography – a technique for making flat images appear three-dimensional, which is simply a way of replicating normal human vision, where the eyes see two versions of the same view at the same time from slightly different angles. Our brain then combines these two views to create a three-dimensional impression. Photographers found that if they took two photographs of the same scene, but from slightly different angles, and the prints produced from the negatives were then seen through a viewer that allowed the two eyes to see one image each, the brain would take these two flat images and create a three-dimensional illusion. Stereo photographs were a huge success and made in great quantities as paper prints throughout the nineteenth and early twentieth centuries; but the first to be made were stereo daguerreotypes, the most lifelike of all. Even the best of the daguerreian artists made them, with the French, like the optician and photographer Jules Duboscq, creating still lifes and the English continuing to focus on portraits. By 1858 the London Stereoscopic Company was offering for sale a stock of 100,000 different stereographs of celebrated landmarks and buildings from around the world, many taken by their own staff photographers. So popular were stereo photographs that they remained a form of home entertainment, as well as being available in libraries and schools, well into the twentieth century.

When Claudet combined his skills at composing a photograph with the talent of his colourist, he produced images that were unparalleled in their beauty and lifelike qualities. His 1853 self-portrait with his son Francis, plus a bird cage and a dog on the sofa, challenged all of his skills as a practitioner and is a tour de force of daguerreian art. To capture all of this in one image was a difficult task for a skilled photographer, but

Claudet's colourist then added exquisitely detailed colours to the image, bringing it as close to life as would be possible with still photography.

A daguerreotype could of course easily be ruined when placed in the hands of an unskilled colourist, but it was the negative and paper prints made from calotype that were soon to succumb to the hand of the retouch artist, long before the sophistications of Photoshop. The introduction of collodion by Frederick Scott Archer had allowed for the creation of larger images, which in turn had given much greater detail of the sitter's face. Such levels of perfection were sometimes a little too revealing, for they betrayed the sitter's every wrinkle and imperfection. In such cases, the multiple prints made possible by the process meant it was more efficient to retouch the negative instead of each print. Any portrait photographer who wished to remain in business quickly learned the art of retouching so that the final print, when necessary, could be perhaps a little economical with the visible truth. Calotypists meanwhile were wrestling with another problem: they had discovered early on that when making a landscape the sky and the ground could not both be satisfactorily captured in one image. If the exposure was short enough to capture details in the sky, there was no detail in the landscape below and if the exposure was prolonged to capture the landscape, the sky was almost completely washed out. Most calotypists solved this by simply painting out the sky with black or red paint on the negative so that when they printed it the sky would come out a plain white. Such techniques were far from ideal in classic photographic landscapes, where the sky was often an important part of the composition. But it was better than the blotchiness that often occurred with over-exposed skies.

The French photographer Gustave Le Gray came up with an ingenious solution to this problem. When exhibited, his

prints caused quite a stir, for his seascapes and landscapes were topped with dramatic cloud formations. Le Gray achieved this effect by shooting two different negatives and then combining them in one print. First he made an exposure for the sky which captured the clouds and streaming rays of sunlight but showed nothing of the sea itself; then he made a second negative, this time exposing for the sea and any ships upon it, but creating a washed-out sky. In the darkroom he simply printed the top of the paper with the sky portion of his 'sky' negative and the bottom of the paper with his 'seascape' negative to create a seamless and dramatic image of a ship on the sea under glowering clouds. Several photographers used this trick to improve their landscapes, although some of them became lazy, reusing the same 'sky' negative in a number of different landscapes, so that there was a worrying familiarity about some of the dramatic cloud formations seen in their photographs.

In the name of art, several photographers took this practice a step further. In 1857 Oscar Gustave Rejlander, a Swedish photographer and well-known portrait painter based in England, turned photography on its head when he combined elements from thirty-two negatives into a large photographic collage called 'The Two Ways of Life' that attempted to mimic traditional narrative painting. In this allegorical *tableau vivant* of posed subjects, the virtuous pursuits of hard work, scholarship and comforting the sick and the poor are contrasted with the vices of gambling, drinking and prostitution. The nudity in the picture caused something of a scandal, so much so that when it was exhibited in Edinburgh, a curtain was hung over the semi-naked half of the picture to protect public sensibilities. Queen Victoria, however, had no problem with it; in her view, nudes were always acceptable when the morals and artistic motive were right, and she bought a copy for ten guineas as a gift for Prince Albert.

Chapter Twenty-six

THE MUTE TESTIMONY OF THE PICTURE

When Talbot first defined photography's uses in his 1844 book *The Pencil of Nature* he had had no concept of the many fringe uses to which the form would make a contribution – beyond a conventional role in portraiture, landscapes and architectural views, and the documentation of works of art and scientific collections. His inclusion of the reproduction of works of art foresaw photography taking on the task that engraving and lithography had long held and was one of the most forward-thinking uses of its unique features. Talbot's notion of keeping a photographic record of one's valuables, as well as legal documents such as wills and deeds, was a prescient insight into photography's future, for if such things were ever stolen, 'the mute testimony of the picture', when produced against a thief in court would, he asserted, 'certainly be evidence of a novel kind; but what the judge and jury might say to it, is a matter which I leave to the speculation of those who possess legal acumen'.[1]

This idea of photography being used in court was truly novel but the photograph's deployment in crime detection was one of the first and most important offshoots of the new genre, though it didn't start – as many people assume – with the Rogues Gallery of mug-shots compiled by the Pinkerton Detective Agency, which was the source of the well-known 'Wanted'

posters seen in westerns later in the century. The Belgian police had been the first to experiment with photography in recording the likeness of criminals around 1843–4, and the Danish police had done likewise in 1851. There is evidence too that in the early 1850s in California the San Francisco Vigilance Committee had daguerreotypes made of offenders, and later in that decade the New York Police Department began keeping a photographic record as well. Nevertheless, in the early days the use of photography in crime detection and prevention was basically down to the enterprise of individual police departments and prison officers. One such in England was Captain Gardiner, the 'ingenious and excellent governor of Bristol gaol', who in 1856 'possessed himself of a photographic apparatus' for taking the photographs – at a cost of sixpence each – of those criminals he believed would be most likely to reoffend, so that these could be circulated to other forces.[2] This principle had already been successfully put into practice in 1855 by a forward-thinking chief constable in Wolverhampton – Colonel Gilbert Hogg – in the pursuit and arrest of a confirmed female con-artist Alice Grey. Grey's daguerreotype had been found among her abandoned belongings in a lodging house, but copies could not of course be made from it. The enterprising Hogg therefore took it to the photographer Rejlander (at that time based in Darlington Street, Wolverhampton), who made a calotype of it and printed twenty copies. When these were circulated to police stations across the country, they revealed a trail of fraud and deception dating back five years; the use of the photograph led directly to Grey's arrest and successful prosecution.[3]

It may be that other English police departments were inspired by the Grey case, when a year later they used photography in pursuit of a railway clerk, Leopold Redpath, who had been selling forged shares in the Great Northern

Railway. When Redpath absconded the police sent out an appeal to any photographer who might have taken his portrait. A negative was found at well-known London photographer John Mayall's studio, was duplicated and prints sent to various detective forces, ensuring Redpath's swift arrest, despite being heavily disguised, when he was on the point of getting away to America by steamer. If ever the huge advantage of Talbot's process over the one-off daguerreotype was demonstrated, then it was here.[4]

It was not long before the ultimate question was asked of the photograph: 'might it be possible,' mused a correspondent to the *Photographic News*, that if the eyes of a murdered person were photographed shortly after death 'upon the retina will be found depicted the last thing that appeared before them' – in other words the face of the murderer?[5] Detective Superintendent James S. Thomson of the Metropolitan Police thought not: 'In conversing with an eminent oculist some four years ago upon this subject,' he responded, 'I learned that unless the eyes were photographed within twenty-four hours after death, no result would be obtained, the object transfixed thereon vanishing in the same manner as undeveloped negative photograph exposed to light.' The detective admitted that he had not put this suggestion to the test, but it was one intangible that would regularly resurface.

If photography had an important role to play on the side of the law, it soon developed an alter ego that proved to be the bane of law enforcement and remains so to this day. What began in the 1850s as a small sideline in photographing nude models for use as figure studies by artists quickly became a lucrative cottage industry that mushroomed on the Continent and in London. One highly respected photo-historian and raconteur once told an audience, tongue firmly in cheek, that he suspected that the first photograph was made to ensure

that the process worked and that the second image made was almost certainly pornographic. It was a natural enough progression; after all, pornographic literature had been doing a roaring trade for the best part of two centuries. Many early pornographic photographs were sold under the counter in London, by a group of print shops and booksellers based in Holywell Street, off the Strand. Despite being regularly raided by the police, these practitioners continued to run the gauntlet of the Obscene Publications Act 1857 to cater to a boom industry.

A surprising number of tasteful, semi-erotic images were produced in the daguerreotype process, by accomplished practitioners such as the Parisian photographer Auguste Bruno Braquehais. Stereoscopes were particularly popular, but most of the early and more explicitly pornographic photographs that survive – and there are still thousands of them out there which are highly prized by collectors – were made by photographers who chose not to sign their name to their work. One of the exceptions was Auguste Belloc, whose images were not only signed but were of a notably higher technical and artistic quality than those of most of his competitors. In 1860, 5,000 of his pornographic images were seized in a raid by French police and only twenty-four survived; a Belloc print today can fetch between £3,000 and £8,000, and one of his stereo daguerreotypes can go as high as £10,000.

As the uses of photography in the artistic and commercial worlds rapidly diversified, there were other, more serious disciplines that from the first had no pretensions at all to art, but which served as a documentary tool, albeit one that in the right hands often created beautiful, heartfelt images. Medical practitioners took up photography fairly early on, as a way of documenting their work. Two of the best-known are a French neurologist, Guillaume Duchenne de Boulogne, who used

photography to record artificially produced facial expressions, and Dr Hugh Welch Diamond, one of the founders of the Photographic Society and resident superintendent of the Female Department of the Surrey County Lunatic Asylum. Duchenne's work was and still is controversial. In his experiments with patients he used electrodes to produce spasms in the facial muscles in order to come to a better understanding of how the nerves in the face allow us to express ourselves nonverbally. Many of his best-known photographs used a patient who had lost all feeling in his face and therefore couldn't feel the electric pulses used to cause the reaction. Another guinea-pig was a young blind woman with full feeling in her face, though Duchenne assured readers of his book *Mécanisme de la physionomie humaine* that she 'had become accustomed to the unpleasant sensation of this treatment'.[6] The photographs Duchenne produced are often tragi-comic, his subjects' faces distorted and exaggerated like those of comedians in silent films; others are even disturbing, due to the extreme contractions he was able to produce on his patients' faces.

The other great doctor/photographer, Hugh Welch Diamond, believed that photography might be helpful in the diagnosis and treatment of mental disorders. Many of his images, unlike Duchenne's, have an air of considerable pathos; others are somewhat eccentric, comical even. But in all cases, Diamond's approach to his subjects was paternal and humane without ever becoming paternalistic. In an 1856 paper he laid out his theory that a photograph of the patient could present an accurate self-image, something that many of them lacked, and that this personal recognition could be used in helping them come to terms with themselves.

It was inevitable that sooner or later photography would reach into the sensitive areas of sickness, death and suffering – as morality pieces on the fragility of the human condition. In

1858 Henry Peach Robinson, a fellow art photographer and friend of Rejlander, had created a now iconic, multi-negative print called 'Fading Away', showing the sickbed of a young woman dying of consumption. Some photographic societies decried this and other similar photographic 'abominations' as voyeuristic and banned them from exhibitions. But photography clearly had a role to play in this, one of life's major rites of passage. Helping people come to terms with the death of a loved one was one of the most profound ways in which photography was increasingly enlisted in the second half of the century. It provided a much cheaper alternative to the painted portrait that few could afford to have made in their lifetimes. The poet Elizabeth Barrett Browning wrote in 1843 of the comfort she found in having a post-mortem daguerreotype of a dead relative:

> It is not merely the likeness which is precious in such cases – but the association, and the sense of nearness involved in the thing . . . the fact of the *very shadow of the person* lying there fixed forever! It is the very sanctification of portraits I think . . . I would rather have such a memorial of one I dearly loved, than the noblest Artist's work ever produced.[7]

In 1850, the *Standard* reported that the successful daguerreotypist Richard Beard had been called upon 'to exercise the skill for which he has attained a merited pre-eminence upon the dead body', by discreetly retouching a photograph of a dead child killed in a fire, so that the features were 'truly and beautifully rendered' as the child once had been and the photograph could be a comfort to the bereaved parents.[8] With so many children at this time dying in infancy – one in five of children in the nineteenth century died before reaching the age of five – the only photograph the distraught parents often had

would be that of the child taken after its death – beautifully laid out on a bed and looking like a sleeping angel, or very often lying in its grieving mother's arms. It might seem a macabre fashion today – a phase in the fetishistic Victorian cult of mourning – but in other cultures, particularly in the southern Mediterranean and eastern Europe, where an open coffin at the funeral was the norm, the post-mortem photographs of adults as well as children became extremely popular as an important way of keeping in touch with the dead. Thanks to its large immigrant population, the genre was thus much more widely accepted and practised in America, even to the extent of – to us now – disturbingly ghoulish photographs being taken of dead adults, dressed in their Sunday best and propped up, open-eyed in the photographer's studio, sometimes with members of their living family, for positively their last photograph this side of the grave.

*

As photographers' studios proliferated so the demand for training in this new lucrative business grew. The art and craft of photography was usually taught by practising photographers as a sideline to their regular work. Training sessions were usually one-on-one, between student and instructor, and rarely lasted for more than a few hours, with the novice then buying equipment and supplies from the tutor at the end of the lesson. This method was the norm in America throughout the early decades of photography. In England, when the prevailing photographic patents expired, there was a sudden rush of people seeking instruction so that they could make a living from this newly liberated art form. To handle the mass of students, a more systematic approach to teaching photography was devised there in the early 1850s. Demonstrations had been a regular event at the Royal Institution throughout the 1840s

but actual, practical tuition in photography became a feature of the following decade, with the Photographic School of the Royal Polytechnic Institution in London leading the way in May 1853, when it announced that:

> The SCHOOL is NOW OPEN for instruction in all branches of Photography, to Ladies and Gentlemen, on alternate days, from Eleven till Four o'clock, under the joint direction of T. A. MALONE, Esq., who has long been connected with Photography, and J. H. PEPPER, Esq., the Chemist to the Institution.[9]

In the meantime, a Photographic Institution was set up in New Bond Street in 1853 with Philip Delamotte, a well-respected photographer, as instructor. Even Talbot's former assistant Nicolaas Henneman began to pass on his skills as a teacher. In 1853 he was hired by the Royal Panopticon of Science and Art, which was based in a rather fanciful Moorish-style building in Leicester Square, where he taught for one hour each morning, in addition to running his own successful photographic studio in Regent Street. One thing is certain: by 1853 sufficient numbers of women were trying their hand at photography at home for the satirical journal *Punch* to publish a cartoon showing the danger of playing with chemicals. A young lady with dark splodges on her face is shown being taken heavily veiled to the apothecary's by her mother:

> I shall be obliged to you, Mr Squills, if you would remove these stains from my daughter's face. I cannot persuade her to be sufficiently careful with her Photographic Chemicals, and she has had a misfortune with her Nitrate of Silver. Unless you can do something for her, she will not be fit to be seen at Lady Mayfair's tonight.[10]

In 1839 Talbot had warned his aunt, Lady Mary Cole, about the staining danger of silver nitrate in her own 'experimentalizing'

and encouraged the use of gloves, explaining that he had
omitted this from his paper to the Royal Society, thinking it
was 'beneath the dignity of Science' to mention such triviali-
ties.[11] In line with then common practice, the good Mr Squills
– as the *Punch* cartoon concluded – promptly 'administer[ed]
relief to the fair sufferer, in the shape of Cyanide of Potassium'.
What was more dangerous to the skin, one wonders: the nitrate
or the cyanide? Yet both professional and amateur photograph-
ers at the time often rubbed their fingers with solid lumps of
cyanide to remove silver nitrate stains.[12] Inevitably, such prac-
tice proved fatal, as it did to one photographer who died after
a tiny piece of cyanide entered broken skin under his fingernail.
Cyanide of potassium was inevitably the poison of choice of
suicidal photographers, such as one in 1860.[13] Despite the risks,
given half a chance, many more young women certainly would
have taken up formal photographic training had the conven-
tions of the day allowed, but for now they were, in the main,
obliged, like the real-life Miss Hussey Pache, on whom the
Punch cartoon was based, to continue running the risk of
chemical use in the privacy of their own homes.

Although the first photographic schools were run as private
enterprises, the government, and educators, did, however, see
photography as a useful practical skill that could be exploited
and the Royal School of Military Engineering at Chatham in
Kent began a series of courses for its students, not just as a
way of documenting the work of the Engineers – particularly
in India and other outposts of the empire – but also as an early
prototype of photo-reconnaissance on military campaigns. In
the lead-up to the Crimean War dozens of officers and some
enlisted men were taught the skills necessary for them to
produce photographs, often in the most inhospitable of con-
ditions across the British Empire. But it was King's College, a
relatively new college established in 1829 at the University of

London, that was the first major institution to elevate photography to an academic discipline, when it opened a Department of Photography there in 1856. This was not simply a reaction to the high profile of photography at the time but testimony to the fact that it was seen as an increasingly important educational subject. The college's decision was extremely forward-thinking, at a time when Oxford and Cambridge would not have entertained such a cutting-edge discipline on their curriculum. And the investment was considerable: large glasshouse studios and darkrooms were built and T. F. Hardwich – who had published *A Manual of Photographic Chemistry* the previous year and was an acknowledged expert on the scientific basis for photography – was appointed the first British lecturer in photography.

It is interesting to note, as the Royal Polytechnic's advertisement testifies, that women were not actively discouraged from pursuing instruction as photographers at this time, though documentation is scanty on any who took the leap into the professional world. It is clear from occasional trade advertisements that there were women practitioners out there – such as a Mrs Fletcher, who was active in Nova Scotia, Canada as early as 1841, describing herself in a trade advertisement in a Montreal newspaper as 'prepared to execute Daguerreotype miniatures in a style unsurpassed by any American or European Artist'.[14]

In England, Miss Jane Wigley had a licence from Richard Beard to run a daguerreotype studio in Newcastle in 1845, and was operating in London's Fleet Street by 1851; by 1854 a Madame Agnes Ruger was working as a 'daguerreotype artist' in Brighton. When photographer William Constable (who had made the first daguerreotype of Prince Albert in 1842), died in 1861, his two nieces – Eliza and Caroline, who had helped with customers in his highly fashionable studio in Brighton – took over the running of his business.[15] Other women certainly

worked as assistants to male photographers in their studios, notably Jessie Mann[16] in the Hill and Adamson photographic studio at Rock House in Edinburgh, who definitely operated machinery for them and is thought to have made several calotypes, including – in the absence of Hill and Adamson – one of the King of Saxony when he unexpectedly visited the studio in August 1844. But such women were probably rare exceptions; in the main women, certainly in the 1840s, were predominantly employed as assistants to deal with clients, and as colourists, although little record of them survives prior to the mid-1860s. By the time of the 1861 census in Britain, 204 women were working professionally in the photographic business.

In the USA, it was a different story entirely. Women daguerreotypists had seized the business challenge from the outset, with no inhibitions about entering a male-dominated world in major cities such as Boston, New York and St Louis. Mary Parker and Ethel Kinne were running their own photographic studios in Connecticut by the mid-1850s, as too was a Julia Ann Rudolp[17] in New York. On the West Coast during the California Gold Rush an enterprising English immigrant, Julia Shannon, imaginatively combined her valuable but disparate skills of midwifery and photography, and proudly advertised in the *San Francisco City Directory* of 1850:

> DAGUERREOTYPES TAKEN BY A LADY –
> Those wishing to have a good likeness are informed that they can have them taken in a very superior manner, and by a *real live lady* too, in Clay St., opposite the St. Francis Hotel, at a very moderate charge. Give her a call, gents.[18]

In the Talbot family, Henry's wife Constance is known to have tried her hand at photography in Henry's absence during the

summer of 1839, when she complained to him by letter that although some of her pictures were 'pretty good' she had 'spoilt them afterwards with the Iodine'.[19] 'I ought to have begun my study of the art while *you* were at hand to assist me in my difficulties,' she concluded. Some of Talbot's female cousins had also taken up photogenic drawing as a party game for their own amusement, getting their fingers stained with nitrate of silver in the process, as had his half-sister Caroline Countess of Mount Edgcumbe. She had been sufficiently pleased with her work to show the results to Queen Victoria, who had been 'very much interested with it'.[20] Of all the Talbot women it was his cousin Emma Talbot, who later married the photographer Nevil Story-Maskelyne, who most excelled in it. She produced photographs using the photogenic drawing process, the calotype and wet-plate collodion as well. Her images are highly prized today and she is regarded as the earliest woman photographer in Wales.

But the members of Talbot's own family were not the only early female practitioners. One of the earliest women acclaimed for her photographs in England was Anna Atkins, an amateur botanist who in the early 1840s experimented with Herschel's cyanotype, or blueprint process, making exquisite images of algae, which she published in 1843. But it was not until the 1850s that women photographers began to operate on a par with men. In 1853 Mary, Countess of Rosse, the wife of Lord Rosse, one of the founders of the Photographic Society, took up photography just before giving birth to her eleventh child. The following year Lord Rosse sent examples of Mary's work to Talbot; she became one of the first women amateurs actively to compete with male photographers, winning an award for her work from the Dublin Photographic Society in 1859. Position and privilege allowed other titled ladies to follow suit: Lady Frances Jocelyn, stepdaughter of Lord Palmerston, is

thought to have been encouraged by Prince Albert's librarian, Dr Ernst Becker, to take up the art in the late 1850s; in 1859 she was elected a member of the Photographic Society and exhibited four landscapes at International Exhibitions in London in 1862 and Dublin in 1864.[21] But like Lady Rosse, Lady Jocelyn took photographs primarily for private pleasure and she never practised professionally or sold her work in the commercial market. Nor did Clementina, Viscountess Hawarden, who took up her camera in 1857. In recent times Lady Hawarden has been recognized as one of the most accomplished female photographers of this early period, for the hauntingly beautiful, romantic images she took of her daughters in floating white gowns. Although she exhibited at the Photographic Society, Lady Hawarden – as all other early amateur female photographers – languished well into the twentieth century, in the shadows of the much-better-known and admired Julia Margaret Cameron, although Cameron did not take up photography till 1863 when she was given a camera as a Christmas present by her daughters.

*

At the beginning of the 1860s the photographic profession entered another dramatic period of change, with the emphasis shifting from small, independent studios to much larger industrial enterprises producing photographs in their thousands every day in order to cater to growing public demand. Edward Anthony, one of the largest suppliers of photographic equipment in the USA, launched a new business in 1859 selling stereographic images in vast quantities. Some were produced by his own photographers but most were images made by others; Anthony would buy in photographers' negatives for a one-off payment, reproduce them at his factory-sized printing establishment and market the finished stereo cards under his

own name with no credit given to the photographer who had originally made the image. The London Stereographic and Photographic Company did much the same; the rush to cash in on the most marketable photographs – such as those of members of the royal family or popular entertainers and celebrities – inevitably brought with it malpractice. If a particular image was in demand and the big photographic businesses were unable to purchase the original negative, they often simply bought a print of it, copied it in their studios and then ran off enormous quantities. Plagiarism was rife at this time and, unlike in the patent wars, went pretty much unchallenged and unpunished.

Mass production meant that standardized formats for photographs now became the norm. The first of these were widely known as *cartes de visite* or visiting cards, originally created and patented by the French photographer Eugène Disdéri in the mid-1850s. The patent quickly became irrelevant, with photographers all over France, England and America quickly copying the look of this novelty form. The cards were $2\frac{1}{2}$ inches wide by 4 inches in height with an albumen print mounted on them that was slightly smaller in size but which made the final product much more durable. In 1859 the *carte de visite* was given the royal seal of approval after Disdéri's work was patronized by the French emperor, Napoleon III. A year later, the queen, a close friend of his, ordered a set of *cartes de visite* of her own family to be made by the highly successful John Mayall, who now had premises in Brighton, as well as London's Regent Street and the Strand. These were published in 1860 as a royal album – the first authorized collection of its kind. By now, everybody wanted to own photographs of the celebrities of the day. In December 1860 the *London Review* noted how 'royalty, statesmen, philosophers, and actresses are to be seen *à la carte de visite* in every shop window'. Dickens, Trollope and Thackeray

were much in demand, as too politicians such as Lord Derby, religious figures such as the Reverend Charles Kingsley, and the celebrated opera singer Adelina Patti. Some purists complained that the genre was already being irretrievably debased by the 'cheap and obtrusive photographer', who catered to mass demand as a purely commercial venture. 'Having one's boots cleaned, eating a penny ice, and being photographed' were, according to the *London Review*'s rather sanctimonious critic, the three things 'most amorously required of a man in the streets of London'.[22] But it was the man in the street who was now providing jobbing photographers with the bulk of their income.

In no time at all the introduction of *cartes de visite* transformed the photographic experience for the average sitter. When someone went to have their image made the photographer would use a newly designed camera with four or eight lenses on the front instead of the original single lens. These cameras took as many pictures on one plate as there were lenses. Multiple images on one plate allowed for them to be printed quickly and most customers bought a dozen copies at a time. Many people opted for tintypes, a cheap off-shoot of the ambrotype, made on a piece of sheet iron that had been 'Japanned', a common term at the time for anything coated with black lacquer. Like the daguerreotype and ambrotype, tintypes were made directly in the camera without the use of a negative so that they could be ready in minutes and were extremely popular in America as a cheaper alternative.

The advent of the cheap tintype brought a new air of humour into the photographic studio. They were so cheap that sitters often didn't feel the need to arrive neat and tidy, or sober; nor did they sit quietly during the process for that matter. Some clients would have a portrait made of themselves face on and then would turn round and have a second picture

taken from behind. They would then mount these photographs on either side of the page in family albums as a visual joke, so that first you would see them from the front and then when you turned the page you would see them from the back. The heyday of the tintype came at a time when photographers were setting up sea-front studios for holiday-makers, sometimes providing caricature boards that people could stick their heads through. This popular spin-off persisted into the twentieth century at English resorts such as Blackpool and Brighton and at Coney Island in the USA. Tintypes were a huge success, especially in the United States, where the mobility of the country's rapidly growing immigrant population – at a time when the Midwest was rapidly being settled, the railroads built and the goldfields of California mined – meant that a cheaply produced photograph small and sturdy enough to travel through the post allowed families to keep up with their relatives far away.

Chapter Twenty-seven

THE EYE OF HISTORY

In the history of this first, rapidly changing period of photography – from the late 1830s to the beginning of the 1860s – two key events, marked by iconic photographs, would prove to be the harbingers of the coming power of the camera. One launched a presidency and the other brought a nation together through the dissemination of photographs on a till then unprecedented scale.

Although the genre was now more than twenty years old it was not until Abraham Lincoln's election campaign of 1860 that the photograph was first used as an effective political tool, by means of the tintype campaign button. These lapel buttons bearing Lincoln's photograph on one side and that of his running mate, Hannibal Hamlin, on the other were mass-produced and given away in their tens of thousands. It was the first time that Americans at large were able to see the faces of the candidates they were being asked to vote for. Soon after their release Lincoln's opponent Stephen Douglas was forced to do likewise – to no avail. Abraham Lincoln scored a historic, landslide victory, taking 40 per cent of the vote against three other candidates. Once Lincoln was inaugurated as president in 1861, his patronage of photography did not stop there: grasping its value in reaching his electorate, he embraced the new art and was photographed more than any other US

president of the nineteenth century and even many of his successors in the twentieth.

At the end of that same year, 1861, a very different run on photographs in Britain was created by the tragically premature death of Prince Albert, after years of self-punishing overwork. He died shortly before 11 p.m. on Saturday 14 December 1861, and when on the Monday morning the stationers' shops – albeit many of them sombrely draped in black and half-shuttered – opened, they were greeted by crowds of people clamouring to buy photographs of the late prince. The stampede on *cartes de visite* of Albert, particularly the most recent ones taken that year by Camille Silvy and John Mayall, went on for days. In London the diarist Arthur Munby went to Regent's Street on 21 December in search of a photograph of the late prince, only to find very few left in any of the shop windows. At one store, Meclin's, he found they had no copies left at all and was told they 'would put my name down, but could not promise even then. Afterwards I succeeded in getting one – the last the seller had – of the Queen and Prince: giving four shillings for what would have cost but eighteen pence a week ago.'[1] With such unprecedented demand continuing unabated for weeks and leading to outrageously inflated prices being charged, the London Stereographic and Photographic Company rushed out *cartes de visite* of Prince Albert in ever-increasing quantities to stationers all over the country. As the journal *Once a Week* observed, 'No greater tribute to the memory of his late Royal Highness the Prince Consort could have been paid than the fact that within one week from his decease no less than 70,000 of his *cartes de visite* were ordered from Marion & Co.' – Marion's being the largest wholesale dealer in photographs in Britain at that time.

During her deep and protracted mourning for her husband, Queen Victoria took advantage of the availability of

microphotographs, to have his image incorporated, much like the Lincoln lapel pins, into brooches, pendants and rings for herself and other members of the family and royal household. She abandoned her lifelong enjoyment of painting and sketching and turned increasingly to collecting photographs, surrounding herself with an iconography of her dear departed. She also relied on photographs to keep track of her rapidly growing family of forty-two grandchildren as well as those great-grandchildren born in her lifetime – all of them scattered across the royal houses of Europe. Such was her compulsion for collecting family photographs that they eventually took up every inch of space in her cluttered private rooms at Windsor, Osborne and Balmoral. The queen's collecting was emblematic of how the photograph was now central to everyday life. The rapid proliferation of *cartes de visite* of the British royal family proved to be one of the most successful marketing tools of the nineteenth century, for through their dissemination these till then remote personalities became familiar to ordinary people – as a family – something that the British people could understand and relate to and which would have a lasting effect on how we view our royal family today.

There was, however, one final and truly dramatic change in the role of photography – and one that had little to do with popular, commercial use and a great deal more to do with the unpalatable realities of the world around us – that did more than anything to change for ever the public perception of it as merely an idle amusement. And this was war photography. In the 1840s the processes and equipment then available had been incapable of capturing fast-moving and dangerous battle scenes, although an unknown photographer took a few poorly made daguerreotypes of the American occupation of Saltillo during the Mexican–American war of 1847–8, including one which purports to show a soldier undergoing an amputation.

It was clear that the daguerreotype process would never be suitable for the rapidly changing scenarios of war, but a few calotypes were taken during the Second Burma War of 1852–3 by military surgeon John McCosh. It was not until the Crimean War of 1854–6, however, that photographers ventured effectively into this new and highly dangerous field. A Hungarian-Romanian named Carol Popp de Szathmari was the first on the scene and is thought to have made more than 200 images in the Crimea, which he mounted in presentation albums for various heads of state, including one given to Queen Victoria. Although the images – mostly portraits and some staged battle scenes – were written about and created considerable interest at the time, most of them have disappeared over the years and only nine survive today.

The best-known photographer to work in the Crimea was Roger Fenton, fresh from his successes at the Great Exhibition, and thanks to the encouragement of Queen Victoria and Prince Albert. It is not clear who exactly sent him – Queen Victoria or the Manchester-based publisher Thomas Agnew – but Fenton travelled with letters of introduction from Prince Albert that facilitated his meetings with the Allied military commanders in the Crimea. He left England on 20 February 1855, travelling with a driver and assistant, a former corporal named Marcus Sparling, who had as much experience in photography as Fenton himself. Their ship arrived in Balaclava harbour on 8 March and from there Fenton slowly travelled to the army lines besieging Sevastopol five miles inland. His mobile laboratory had begun life as a wine delivery van but he had converted it to a portable darkroom and quasi-mobile home. In an attempt to prevent being shot at, he painted the words 'Photographic Van' on the sides. Used to working in England, neither Fenton nor Sparling was prepared for the difficult conditions in the Crimea. From April it was so hot

that they could hardly bear working in the closed van, but a light-tight darkroom was essential in the wet-collodion process and they persevered. By mid-June Fenton wrote home that he could only work in the early hours of the morning because by 10 a.m. the glare of the sun was so great that his subjects could hardly keep their eyes more than half open. To capture as much detail as possible he had brought a large camera and captured his images on glass plates that were 12 x 16 inches and 14 x 18 inches. But the air was so hot and dry that he ruined many plates simply because the collodion dried out before an exposure could be taken.

Despite all the difficulties he encountered, Fenton was able to capture many shots of officers (the rank and file were, in general, ignored except in group scenes), tented army encampments and views of Russian fortifications in Sevastopol. Perhaps his most iconic image is that of the desolate and rocky Vorontsov Road – dubbed 'The Valley of the Shadow of Death' – littered with cannon balls, though this was achieved with a little artistic arrangement from Fenton himself beforehand. What with the heat, the dust and the flies, and the occasional cannon ball from the Russian artillery whizzing overhead, it's surprising that Fenton came through it all unscathed, but by the time he left the Crimea on 26 June he had made over 350 large glass plate negatives, by which time he admitted that he 'felt quite unequal to further exertion, and gladly embraced the first opportunity of going home'. He sold his horse and van before departing, but his trip home was miserable rather than recuperative, as he had contracted cholera just before leaving Balaclava. Nevertheless his work was considered to be so important that immediately upon his arrival in England, he was commanded to Osborne to report on his experience to the queen and the Prince Consort. He was still so weak that

during his audience Fenton was allowed the unusual privilege of lying on a couch in the royal presence.

During his three and a half months in the Crimea Fenton had never attempted to photograph the true, grim reality of the battlefield dead, but some of the more severely wounded of the Crimean conflict were photographed on their return to England, at the specific request of Queen Victoria, who took a personal interest in the men's recovery and rehabilitation. By now the royal couple were commissioning and buying photographs on a regular basis as they built up one of the earliest and finest photographic collections in the country and they were the first to acquire a set of Fenton's remarkable Crimean War photographs. Before the year was out, these were published by Agnew & Sons of Manchester in five portfolios entitled *Photographs taken under the patronage of Her Majesty the Queen in the Crimea by Roger Fenton, Esq.*

Although Fenton's war photographs appear anodyne to us now, lacking as they do any depiction of fighting or suffering on the battlefield, Felice Beato – a Venetian photographer who had worked in the Crimea after Fenton left – produced a number of harrowing photographs during the Indian Rebellion of 1857–8. One of these, 'The Interior of the Secundra Bagh after the Slaughter of 2,000 Rebels by the 93rd Highlanders and 4th Punjab Regiment', showed the decaying body parts of a number of the rebels lying unburied on the open ground, four months after the battle, although accusations were later made that some of these had deliberately been placed in position by Beato to add to the dramatic effect. By the time the American Civil War broke out in 1861, it had become the norm for photographers to be sent, or to go of their own volition, into war zones. Thousands of photographs were made during the Civil War between 1861 and 1865, under the

supervision of the photographer, Matthew Brady, and they had an enormous impact on the American public.

In an interview shortly before his death in 1894 Brady revealed that he had taken up photography 'shortly after Daguerre made an artist of the sun'.[2] He had learned the process in New York from Samuel Morse and in 1844 opened a studio at a prime site on Broadway where he catered to numerous fashionable and celebrity clients. He quickly rose to the top of his profession as a portrait artist, setting up a subsidiary in Washington, DC in 1849. Basing himself in Washington, Brady was in an ideal location to document the war. He requested permission to travel to the battle sites, first from his friend General Winfield Scott and then directly from President Lincoln himself. Lincoln approved the project, as long as it was paid for privately and did not require government funding. Brady's friends tried to dissuade him by pointing out not just the danger of going into a battle zone but the financial risk to his business as well. But Brady had a sense of destiny about it and was determined: 'A spirit in my feet said, "Go", and I went.'[3]

His first experience of fighting (and one so close that he was nearly caught by the Confederates) came at the first Battle of Bull Run, near Washington, in July, the largest battle yet to take place on American soil. Most people thought that the war would be a short-run thing and when they heard of the impending battle, like Brady, they headed out to watch. As men and women settled down on a rise nearby with their picnic baskets they were horrified to see the Confederates unexpectedly drive the Union forces back towards Washington. Four more long, hard years of war followed; the project of recording it photographically was clearly beyond Brady on his own. In any event, he was suffering from failing eyesight and hired a team of more than twenty photographers with their

own travelling darkrooms to cover the various locations of the fighting under his auspices. It was the Scottish-born Alexander Gardner who took the first really graphic photographs of war dead, at the Battle of Antietam the following September. When these were exhibited by Brady in New York in 1862, their impact was powerful and unforgettable, as the *New York Times* recorded:

> The dead of the battle-field come up to us very rarely, even in dreams. We see the list in the morning paper at breakfast, but dismiss its recollection with the coffee . . . We recognize the battle-field as a reality, but it stands as a remote one. It is like a funeral next door: it attracts your attention, but it does not enlist your sympathy. But it is very different when the hearse stops at your own door and the corpse is carried over your own threshold . . . Mr Brady has done something to bring to us the terrible reality and earnestness of the war. If he had not brought bodies and laid them in our door-yards and along [our] streets, he has done something very like it.[4]

Perhaps the most haunting photographs of the war were taken at the bloodiest battle of them all – Gettysburg, in July 1863 – by another in the Brady team, Timothy H. O'Sullivan. The collective work of these pioneering photographers marked a seismic shift in the role of photography in the rapidly modernizing second half of the nineteenth century, for it signalled the birth of a new and important genre – photo-journalism. The camera had already proved that it was by no means an idle amusement, the mere 'philosophic toy' of its first descriptions.[5] It was a powerful tool that could totally transform our view of things; as Matthew Brady had so rightly said, it was 'the eye of history'.[6] The responsibility of photo-graphers from now on would be to record that history as

honestly and accurately as possible. For, as the *London Review* had acknowledged in 1860 when assessing the burgeoning new role of photography and the 'unimpeachable evidence of the photograph', what had for so long been a mere 'fanciful dream' had now become 'one of the most wonderful conquests which the human intellect has made.'[7]

There was now no aspect of life that went by – no meeting, no ceremony, no war or public disturbance, no human rite of passage – 'without photography being called in to perpetuate, as it were, a tangible, transferable memory of the occurrence'.

*

By the end of the nineteenth century, the camera had, as the *Morning Post* observed, 'become as indispensable as the bicycle' and at least as ubiquitous among hobbyists and enthusiasts.[8] Yet in the history of the genre, it has generally been the method rather than the men who made photography that has captured public attention. With the exception of anniversaries relating to the 1839 announcement, or the occasional article in a photographic publication, the two original inventors were rarely mentioned. Indeed, by the beginning of the 1860s Louis-Jacques Mandé Daguerre and William Henry Fox Talbot had already begun to fade into obscurity, leaving to posterity only the names they had given to their two different processes. Talbot, perhaps through a sense of humility as well as erudition, continued to call his process the calotype, in acknowledgement of the Greek origins of the word, but in Britain his supporters and the public at large generally referred to these images as Talbotypes. He was disappointed that the French, who had taken his process to their hearts as the primary vehicle for art photography in the later part of the century, stubbornly ignored his name as inventor, and often referred to his process as *le papier ciré sec* (alluding to Le Gray's waxed paper process).

In the end, William Henry Fox Talbot outlived his more celebrated competitor by twenty-six years. Throughout the 1850s and 1860s he and Constance spent their winters in Edinburgh where they could be near their daughter Matilda – the only one of their four children to marry and have children of her own. But with age catching up on him Talbot was finally forced to curtail his love of foreign travel – one of the great joys of his life – making his final trip to the Continent in 1869. His capacity for scientific study did not, however, diminish and he continued to publish papers for the rest of his life. Medals and awards continued to come his way in the scientific and academic worlds; the Société Française de Photographie, in a very generous act, acknowledged him as one of the inventors of photography in 1867 and the Photographic Society in Britain finally changed its rules to make him an honorary member in 1873. But his ground-breaking work on photography was never honoured with a knighthood.

Although he had sat for five daguerreotype portraits before 1845, it was not until the 1860s that Talbot finally agreed to sit for his own photograph on paper and he appears as dyspeptic in this as the earlier photographs taken of him. By the age of seventy-seven, he was largely confined to a wheelchair. On the morning of 17 September 1877, he finally collapsed and succumbed to the heart disease that he had suffered from for some time – appropriately enough, in his study at Lacock. The obituaries, unlike those for Daguerre, were few and modest. It was not until the hundredth anniversary of Talbot's birth in 1900 that it was noted that while Louis Daguerre had numerous public memorials in France and America, 'Fox Talbot . . . has never been so honoured'. With this in mind a committee was set up at Lacock under Talbot's son Charles, 'to raise a memorial fund for the restoration of the chancel of Lacock village Church in Talbot's memory'.[9] It was hoped

that the money for this memorial would come from the photographic world, but in the event, Talbot's posthumous legacy attracted as little attention as had Frederick Scott Archer's and most of the £1,300 was raised by family and friends. The location of the memorial was a rather strange choice, and one that suited the tastes and interests of the son – an antiquary and student of church architecture – rather more than the father. Hidden away in a country church, the Talbot memorial would be seen by few of his peers, or the public for that matter, and was out of character with a man who appeared to take little interest in religion or mention it in his many thousands of letters.

The far more enduring legacy of Talbot the man, his life and work is of course Lacock Abbey itself. The building, together with its paintings, the land around it and the village adjoining, was bequeathed to the National Trust by Talbot's granddaughter Matilda in a series of gifts to the nation from 1944 to 1946. Talbot's work continues to be celebrated in the museum named after him that was established by the National Trust at the gates of Lacock Abbey in 1975. Not far away in the village cemetery, Talbot lies in a modest family grave with his wife Constance, son Charles and granddaughter Matilda.

Over in France the grave of Louis Daguerre had of course been honoured soon after his death with a monument paid for by the great and good of the Paris art and photography worlds and a statue was also erected in his home town of Bry-sur-Marne. A Paris street was named after him and Daguerre's is one of only seventy-two names representing the great men of France that were engraved on the Eiffel Tower in 1889. In 1890, shortly after the fiftieth anniversary of the announcement of the daguerreotype, the Professional Photographers of America erected a monument to Daguerre in Washington, DC; a Daguerreian Society has been active in the USA since 1989

and has more than a thousand members who celebrate the photographer's accomplishments in their journal and at conferences. In 2011 the town of Bry-sur-Marne bought Daguerre's house and it is currently being converted into the Maison Daguerre to commemorate, in like manner to Talbot, its most famous resident.

*

Although Daguerre's brief meteor of personal celebrity was extinguished with his early death, he died while his eponymous process was still at its peak, with his crown as the king of photography firmly in place. Talbot, however, while never enjoying public acclaim, lived to see negative–positive photography as he conceived it rise to overtake the daguerreotype, albeit through the wet-collodion process that superseded both his and Daguerre's inventions. He also lived to see photography rapidly progress from an experimental art-cum-science to a recognized profession. But debate remains as intense today as it was in the 1840s as to which of these two great pioneers was the true inventor of photography. One might say it was Talbot for having achieved a negative–positive method in 1835 that could be continuously modified into the photographic techniques that dominated the art until the end of the twentieth century, whereas the more spectacular method of Daguerre, whilst being seen as more fashionably desirable in its time, was like a flare that burnt twice as bright but soon guttered and was gone. (In more recent years, a campaign for Niépce to be acknowledged as the true father of photography has been gathering momentum.)

The difficulty in determining the ascendancy of one inventor over the other lies not just in the differences between the two processes but also in the backgrounds and personalities of the men themselves. Talbot took a spark of an idea and by

dint of an orderly mind, good scientific practice and persever-
ance invented a process that was functional and versatile and
would lead to greater things in years to come. Daguerre, the
Parisian magician of visual wonders, conjured up a phantas-
magorical, shimmering mirror that fixed for ever the faces of
all those who sat for their portrait in a unique way that
continues to beguile viewers to this day. In truth, the camera
is the closest we have yet come to creating a time machine
that will transport us back into somebody else's now forgotten
world. When we look into the mirrored surface of a daguerre-
otype portrait we see not our own reflection, but another's
looking back at us, a face that was looking into the camera
almost two centuries ago. Who were these people, what were
their lives like? It's an uncanny feeling but the photograph has
the unique, talismanic ability to pick us up and deposit us, with
a jolt, in a very particular moment in time.

From the turn of the nineteenth century the invention of
photography had been inevitable. In the end it sprang to life
in England and France almost by accident, born of the imagin-
ation and determination of two very different men. But the
greatest changes were yet to come.

Epilogue

EVERYMAN'S ART

Writing in 1859, the English essayist Jane Welsh Carlyle remarked with pleasure on the advent of the exciting new medium: 'Blessed be the inventor of photography! I set him above even the inventor of chloroform!' Photography was a new and potent social leveller, 'It has given more positive pleasure to poor suffering humanity than anything else that has "cast up" in my time or is like to – this art by which even the "poor" can possess themselves of tolerable likenesses of their absent dear ones.' And, she added,

> mustn't it be acting favourably on the morality of the country? I assure you I have often gone into my own room, in the devil's own humour – ready to swear at 'things in general,' and some things in particular – and, my eyes resting by chance on one of my photographs of long-ago places or people, a crowd of sad, gentle thoughts has rushed into my heart, and driven the devil out, as clear as ever so much holy water and priestly exorcisms could have done![1]

Within twenty years of its invention, photography was playing a major part in people's lives. Thirty years later, its fiftieth anniversary in 1889 coincided with the founding of Eastman Kodak, which in short order finally opened the floodgates for photography to become 'everyman's art'. By the end of the

century it had become a much-practised and much-loved universal hobby, made possible by the introduction of Kodak's cheap and easy-to-use cameras and celluloid roll film. The introduction of roll film led directly to another of the great wonders of the modern age – cinema – when the first public screening of a film was given by two other French masters of illusion, the Lumière brothers, in December 1895. The 150th anniversary of photography in 1989 was marked by major exhibitions in photographic galleries and societies around the world and received more press attention than all of the earlier anniversaries put together.

The age-old argument of whether or not photography is an art form has, after many decades of debate, long since been put to rest by all but a few. Not only do most major art museums collect photography as a regular part of their remit, but entire museums and galleries dedicated to the art of photography have been established, such as George Eastman House in Rochester, New York, which became the first museum dedicated to photography when it opened its doors in 1949. The medium saw its largest and most dramatic shift yet in 1991, when photography based on the light-sensitivity of silver salts faced its first real challenge in 150 years – from the digital field. Kodak had come up with an experimental digital camera as early as 1975 and in 1991 introduced the first digital camera for the consumer market. The company's long-standing success had been built not just on the cameras it made but also on the sale of camera film and photographic processing. Digital cameras did away with the old roll film entirely and professional photographers were quick to take them up, with photo-journalists in particular switching to the new technology in order to increase their productivity and speed up the distribution of their images around the world. Today even the portraitist and the travel photographer – the pioneers of

professional photography in the early years – have largely accepted that digital is the way forward.

By the year 2000, digital camera sales had already exceeded those of analogue cameras and the demise of traditional, silver photography was confidently predicted. In the popular market this has certainly been the case: very few amateur photographers are still using film for their snapshots, having opted for the cost-effectiveness and convenience of digital cameras and even the inbuilt cameras in mobile phones. Photography today is truly everyman's art: any amateur can download and process their own images onto a computer at home and edit and enhance them, before either printing them out or sending them via the internet to anyone, almost anywhere in the world.

The rapid proliferation of digital photography has, however, recently given rise to an extraordinary artistic turnaround, by sparking a re-examination of not just the art but also the original chemical processes employed in early photography. There is today a small but growing backlash against digital photography that is attracting not just the traditionalists and Luddites who abhor technical change, but a number of professionals – mostly those working in the fine-art branch of photography – who have retained their preference for roll film or are converting back to it from digital; in some areas demand for roll film is even increasing.

In a serious attempt to rediscover the origins of the photographic process, a whole new generation of practitioners has turned back the clock even further and is dedicated to producing handmade images, using original techniques to produce modern daguerreotypes and calotypes of stunning beauty. This renaissance began with a few artists in America in the 1970s, grew in the 1980s – mostly at universities and art schools – and has about it now something of the ardour and energy of a new artistic movement. In an uncanny echo of the 1840s, history

has repeated itself, with the daguerreotype having first been the preferred medium over the calotype by many contemporary photographic artists, only for it and the calotype now – once again – to be eclipsed by the revival of wet-plate collodion photography. This is, if anything, final acknowledgement, if it were needed, that photography as first envisioned by the two great men Daguerre and Talbot had in fact achieved a level of artistic perfection by the 1850s that has never been surpassed and remains the benchmark for truly great work. Although the many changes that followed during the nineteenth century made photography easier, faster, cheaper and more widely accessible to the general public, nothing can take away from the allure of those first faltering images that bring us people, places and events from as far back as 175 years ago.

Photographers today can of course still examine some of those original photographs made in the 1830s, but extant images by Daguerre are rare. Some were almost certainly destroyed in the fire that consumed the Diorama but others have simply disappeared. At best around thirty Daguerre originals survive today. Three surfaced in the Research Library of the Russian Academy of Arts in St Petersburg in 2002, a gift from Daguerre to Tsar Nicholas I in 1839, but those given by him to Emperor Ferdinand I of Austria at the same time are still missing.

Talbot, on the other hand, is far more richly represented in collections around the world. Many of his negatives were lodged at his business premises, the Reading Establishment for Printing. When it closed down abruptly in 1847 all of the negatives and prints were carefully bundled up, wrapped in newspaper and sent back to Lacock, where they lay undisturbed until the twentieth century. Some were brought out of storage by Matilda Talbot as part of a concerted campaign to raise her grandfather's profile as the inventor of photography. In 1935 she staged an exhibition of Talbot's work at Lacock

Abbey to celebrate the hundredth anniversary of the first negative of the oriel window. Thanks to her generosity, about 6,000 negatives and prints were donated to the Science Museum in London. Several hundred more, as well as most of Talbot's cameras, went to the Royal Photographic Society. Thousands more prints and negatives remained at Lacock, many of them having been made in large quantities in anticipation of successful sales for *The Pencil of Nature*, as well as a demand for individual prints through stationers across Britain, but neither of these ambitious plans came to fruition. After the founding of the Fox Talbot Museum in 1975, Lacock remained home to over 2,000 prints, 10,000 family letters and a considerable archive of Talbot's personal and estate papers, until the Talbot family donated them all to the British Library in 2005.

*

Over the past twenty years, photography has seen massive changes not just in how we make images but in how we talk about it as well. Film speeds are no longer mentioned nor are the words 'roll' or 'spool'. ASA and ISO have been traded for PPI and resolution. Silver, the basis of photography from the beginning, has been replaced by the now familiar pixel, and the chemistry that had seemed so complex has been set aside in preference for manipulating binary codes through the use of even more complex software packages. Photography has moved from the darkroom to the desktop and what was, for more than 150 years, wet work has now become dry. The equipment and accessories that once dominated the talk of the techno-geeks of photography has changed as well. Cameras which began life as large wooden boxes with brass lenses have morphed into almost any shape, material, colour and size imaginable and have attached themselves to other everyday devices like computers and mobile phones. Interchangeable

lenses have, once again, become the province of the pro-
fessional and many of them are choosing systems that are
greatly simplified, compared to the mass of heavy equipment
that they used to have to carry around with them.

In the twenty-first century, photography has infiltrated every
aspect of our daily lives, to the point where George Orwell's
dystopian vision of a world where we are all monitored by Big
Brother has become chillingly real. Wherever we go today in
towns and cities around the world we are captured on CCTV
cameras. Travel from one country to another is accomplished
only after passing through an X-ray scanner to be checked for
weapons and contraband; when we arrive at our destination
cameras with facial recognition software attached identify us,
or the iris of our eye is scanned and compared with a stored
image to verify our identity. The scientific use of photography
allows doctors to examine us internally in real time and in 3D
through CAT scans and MRI machines. At an even higher
level of science, photography brings us images of phenomena
and galaxies in the universe that are millions of light years
away. It is able now to record the movement of sub-atomic
particles that a century ago we didn't even know existed.

Today the number of people who make photographs must
number in the hundreds of millions. That figure will probably
soon exceed one billion. In his novel *2001*, published in 1968,
Arthur C. Clarke estimated that there were 100 billion galaxies
in the known universe, one for each human being who had
walked the earth since the beginning of time. Kodak estimated
that we were making 20 billion photographs a year by the
mid-1990s. The ease with which we create digital photographs
means that we now produce more than twice that many each
year – maybe more – ensuring that every two or three years
we create at least one photograph for each of those 100 billion
humans who so far have inhabited the earth.

This exponential rise in the use of the camera and with it the dissemination of the photograph could never have been foreseen by either inventor. Back in 1839 Talbot had protested, with characteristic modesty, that all he had in fact done was to make the powers of Nature work for him, for after all, 'what *is* Nature, but one great field of wonders past our comprehension'.[2] Whether one admires the art or the science, the magic or the method, one thing is clear: with the invention of photography the human memory got immeasurably longer, our worldview got bigger and places and people that had once seemed mythical suddenly have become compellingly real. The invention of photography in 1839 ensured that time and distance became something we could miraculously overcome. It was now possible to see the world from the comfort of one's own home and in so doing become a witness to the triumphs – and tragedies – of world history.

The men of the 1830s and 1840s who finessed those first technical stages in the art of photography were, however, but one small group during a period of intense innovation and scientific and technical advancement. Their heyday saw the inauguration of steam power and the railways, and the advent of a communications revolution marked by the invention of Morse code, Braille, the electric telegraph, Pitman's Stenographic Sound Hand and the prototype for Babbage's calculating machine. Inroads were made not just in the field of invention: scientific enquiry in all its many aspects proceeded by leaps and bounds during those same years, exemplified by Charles Darwin's five-year voyage on the *Beagle*, which would be the foundation of his theory of evolution in *The Origin of Species*.

By the beginning of the nineteenth century, the elemental forces of scientific enquiry had already inexorably combined with centuries of accumulating human knowledge to create the perfect storm of ideas and innovation that would, in the end,

have created photography even if Louis Daguerre and Henry Fox Talbot had never lived. For, as it was once said, 'when the time is ripe for certain things, these things appear in different places in the manner of violets coming to light in early spring'.[3]

At Lacock Abbey that hot summer day in 1835, Henry Talbot, without realizing it, had set in motion a process of capturing light on paper permanently with the use of optics and chemistry from which all later photographic processes were descended. Four years later, it was his unknown rival, the charismatic Louis Daguerre, who reaped the initial rewards and attracted the lion's share of public interest. The fact that Daguerre announced first, to the immediate acclaim of the French nation – and, soon after, an astonished world – would be the stick with which many of Talbot's contemporaries, and even photographic historians today, would beat him.

Nevertheless, it was the quiet, dogged Talbot, and not the flashy Daguerre, who had perfected a method that ultimately was far more versatile, commercially viable and lucrative than the daguerreotype – for he had found a way of making copies of photographs reproducible in unlimited numbers from a single negative. Henry Fox Talbot's elusive, fuzzy outline of that oriel window – by no means a beautiful image – was the first small spark of genius along the way to modern photography. He remained, to his dying day, quietly humble about his achievement, at all times acknowledging the natural world that had made it possible. 'I know few things in the range of science more surprising than the gradual appearance of the picture on the blank sheet, especially the first time the experiment is witnessed,' he once wrote.[4] Ultimately the magic of photography lies in precisely that simplicity, in that one, simple yet miraculous moment of revelation. Its invention was a long time coming, but the birth of the photograph was destined to change the way we see the world in which we live for ever.

Acknowledgements

Our collaboration on this project, bringing together our knowledge as photographic historian and social historian, came about at the suggestion of our agent, Charlie Viney, who first had the idea for a book on the birth of photography. We are deeply grateful to him for his encouragement and enthusiastic support in the writing of the book. It has been a fascinating, rewarding and happy collaboration, during which we have gratefully drawn on the support and expertise of others.

We would like to thank the British Library, the National Media Museum, Bradford and the Royal Society for permission to quote from letters written by Henry Fox Talbot held in their archives. We are also extremely grateful to Dr Larry Schaaf, project director for the Talbot Transcription Project that allowed access to Talbot family correspondence online at www.foxtalbot.dmu.ac.uk. This wonderful site is a rich and valuable resource for anyone interested in the history of nineteenth-century photography.

We are indebted to various other institutions that have allowed us access to their collections and granted us permission to publish their images. The George Eastman House, Library of Congress, Conservatoire National des Arts et Métiers, British Museum, Fox Talbot Museum, Metropolitan Museum of Art, Victoria and Albert Museum, Science and Society Picture Library, Musée Bry-sur-Marne, Musée Niépce, and the Harry Ransom Center have all opened their doors and their collections to us; Paul Frecker offered the use of a post-mortem photograph from his collection, the Library of Nineteenth-Century Photography and Dr Brian May gave us permission to use a stereo daguerreotype from his collection.

Numerous friends and colleagues have offered their expertise on the characters and processes involved in this story. Mike Robinson was particularly helpful in sharing his in-depth understanding of the daguerreotype process and his speculations on the trail that led Daguerre to his discovery. Mark Osterman and France Scully Osterman have, for many years, generously shared their knowledge built on their own practice and experimentation with early processes. Trudy Wallace and Sheila Metcalfe spent years transcribing and translating the diaries of Amélina Petit de Billier, whose insight into the Talbot family and its dynamics added much-needed colour to the residents of Lacock Abbey. Margaret Calvarin and Camille Elisabeth of the Musée de Bry-sur-Marne, who are working to restore Daguerre's final home as the Maison Daguerre, a museum and education centre, gave Roger a tour of the house and a view of Daguerre's last remaining diorama during its restoration to help further bring to life Daguerre's work.

We wish to thank the authors of articles, books, websites and blogs, which have been read with interest. Incvitably, in the course of our research, we have accepted some ideas, and rejected others, but these authors have all offered their considered views on the birth of photography and suggestions of further original source material to review and digest. Gary Ewer's collection of nineteenth-century texts on the carly ycars of the daguerreotype have been generously placed on the Daguerreian Society's website and were a key source. The authors of other useful articles and books include: Manuel Bonnet, Jean-Louis Marignier, André Gunthert, Paul-Louis Roubert, Pierre Harmant, R. Derek Wood, Helmut and Alison Gernsheim, Beaumont Newhall and, most recently, Stephen Pinson, whose *Speculating Daguerre* is the first new book on the artist in more than half a century.

Roger also thanks Rachel Nordstrom, his long-time assistant, and his wife, Laura Brown, whose support and encouragement

was essential to this project and special thanks to Grant Romer, a photo-historian of encyclopaedic knowledge, an extraordinary teacher and a great friend of many years. Helen's brother, photo-historian Mike Ware, was generous in his sage advice and encouragement and for sharing his wonderful library of books on photography with her.

During the production of this book we have received stalwart support and creative input from our UK commissioning editor, Jon Butler at Pan Macmillan, and our US commissioning editor, Charlie Spicer at St Martin's Press. Kate Hewson also made a valuable contribution to the production process in the UK, and a special thank you goes to photographer Jeff Cottenden and designer Stuart Wilson for their wonderful cover, which was shot at Lacock Abbey.

Roger Watson and Helen Rappaport,
Lacock and Oxford, December 2012

Notes

NOTE: All quotations from letters to and from Henry Fox Talbot (HFT), his wife Constance, Lady Elisabeth (Lady E) and Admiral Charles Feilding are taken from the online collection 'The Correspondence of Henry Fox Talbot', to be found at: www.foxtalbot.dmu.ac.uk/letters/letters.html

Other cited sources are abbreviated as follows:

BL British Library
NMeM National Media Museum, Bradford
RS Royal Society

Epigraph

1 Charles Chevalier, *Guide du photographe*, Paris, 1854, in Helmut Gernsheim & Alison Gernsheim, *L. M. J. Daguerre: The History of the Diorama and the Daguerreotype* [hereafter LJMD], New York: Dover, 1968 [1956], p. 49.
2 Henry Fox Talbott, in a letter to the editor of *The Literary Gazette and Journal of the Belles Lettres*, 30 January 1839, p. 74.

Prologue

1 Extract from 'My First Daguerreotype', anonymously published in the *American Journal of Photography*, vol. 1, no. 16 (15 January 1859), pp. 233–7.

Chapter One

1 Quoted in Jennifer Ouellette, *Black Bodies and Quantum Cats*, London: Penguin, 2005, p. 52.

2 R. B. Burke, *The Opus Majus of Roger Bacon*, vol. 2, Philadelphia, PA: University of Pennsylvania Press, 1928, p. 420.

3 Mike Ware, *Gold in Photography: The History and Art of Chrysotype*, Brighton: ffotoffilm publishing, 2006, p. 22.

4 Elizabeth Johnson and Donald Moggridge, eds, *The Collected Writings of John Maynard Keynes*, vol. X, New York: St Martin's Press, p. 363.

Chapter Two

1 Gaby Wood, review of Uglow's *The Lunar Men*, in *Guardian*, 1 September 2002.

2 Schaaf, *Out of the Shadows*, p. 25.

3 Ibid.

4 *Photographic News*, vol. 29, no. 1415, 16 October 1885, p. 669.

5 See Batchen, 'Photographic experiments of Tom Wedgwood'.

6 Holmes, *Age of Wonder*, p. 254.

7 Litchfield, *Tom Wedgwood*, p. 194.

8 *Journal of the Royal Institution*, vol. 1, 1802, pp. 170–3.

9 See Tremayne, *The Value of a Maimed Life*.

10 Schaaf, *Out of the Shadows*, p. 25.

Chapter Three

1 Jones and Ware, *What's Who*, p. 189.

2 Edward Planta, *A New Picture of Paris, or the Stranger's Guide to the French Metropolis*, London: Samuel Leigh, 1816, p. 128.

3 R. Bruce Elder, *Harmony and Dissent: Film and Avant-Garde Art Movements in the Early Twentieth Century*, Ontario: Wilfred Laurier University Press, 2008, p. 104.

Chapter Four

1 Arnold, *William Henry Fox Talbot* [hereafter *WHFT*], p. 21.
2 Martin, *Wives and Daughters*, p. 63.
3 Lady E to her sister Harriet, February 1798, Arnold, *WHFT*, p. 23.
4 Martin, *Wives and Daughters*, p. 191.
5 Arnold, *WHFT*, p. 29.

Chapter Five

1 See e.g. advertisements in the *Morning Post* from 29 October 1801.
2 Etienne de Jouy, *The Paris Spectator, or L'hermite de la Chaussée-d'Antin*, vol. 1, Philadelphia, PA: M. Carey, 1816, p. 94.
3 Batchen, *Burning with Desire*, p. 71.
4 Gernsheim & Gernsheim, *LJMD*, p. 9.

Chapter Six

1 HFT to Lady E, 24 May 1808.
2 Arnold, *WHFT*, p. 32.
3 HFT letter to Charles Feilding, 27 May 1808.
4 Revd Hooker to HFT, 12 April 1812.
5 Lady E to her sister Mary, Arnold, *WHFT*, p. 34.
6 Lady E to Dr Butler, 24 May 1812.
7 Lady E to her sister Mary, Arnold, *WHFT*, p. 34.
8 Arnold, *WHFT*, p. 36.
9 Ibid., p. 37.
10 Lady E to HFT, 19 May 1817.
11 Arnold, *WHFT*, p. 43.

Chapter Seven

1 Gernsheim & Gernsheim, *LJMD*, p. 17.
2 Pinson, *Speculating Daguerre*, p. 85.
3 Ibid., p. 31.
4 *Morning Chronicle*, 1 October 1823.
5 *Morning Chronicle*, 29 September 1823.
6 *Morning Post*, 15 October 1823.
7 *Morning Chronicle*, 7 November 1823.
8 Frederick Collier Bakewell, *Great Facts – A Popular History of Inventions During the Present Century*, London: Houlston & Wright, 1859, p. 106.
9 Gernsheim & Gernsheim, *LJMD*, p. 53.
10 Ibid., p. 54.
11 Ibid., p. 1.

Chapter Eight

1 Lady E to HFT, 11 February 1821.
2 Ibid.
3 HFT to Charles Feilding, 7 November 1832.
4 Horatia to HFT, 10 November 1832.
5 Lady E to HFT, 17 November 1832.

Chapter Nine

1 Gernsheim & Gernsheim, *LJMD*, p. 54.
2 Ibid.
3 Ibid., p. 55.
4 Ibid., p. 57.
5 Fouque, *Niépce*, p. 71.
6 Gernsheim & Gernsheim, *LJMD*, p. 57.

Chapter Ten

1 Gernsheim & Gernsheim, *LJMD*, pp. 62–3.
2 Ibid., p. 64.
3 Ibid.
4 See: www.niepce.com/pagus/dagustus.html
5 Pinson, *Speculating Daguerre*, p. 113.
6 Kravets, *Dokumenty*, p. 373.
7 Pinson, *Speculating Daguerre*, p. 113.
8 Kravets, *Dokumenty*, p. 417.

Chapter Eleven

1 HFT to William Jerdan, 30 January 1839.
2 Talbot, *The Pencil of Nature*, p. 76.
3 Ibid.
4 Talbot, Notebook L, p. 73 (privately owned; currently on loan to the British Library).

Chapter Twelve

1 Lady E to HFT, 25 February 1830.
2 Ware, *Gold in Photography*, p. 38.

Chapter Thirteen

1 Schaaf, *Records of the Dawn*, p. xix.
2 HFT to Lady E, 7 October 1835.
3 Constance to HFT 2 September 1835.
4 HFT to Lady Mary Cole, 9 August 1839, letter now lost.
5 Arnold, *WHFT*, p. 108.
6 Schaaf, *Records of the Dawn*, p. xix.
7 Litchfield, *Tom Wedgwood*, pp. 196–7.
8 Constance to Lady E, Monday 22 (?) 1836, BL Collection.
9 HFT to his sister Horatia, 5 July 1838, BL Collection.

Chapter Fourteen

1 *Journal des Artistes*, 27 September 1835, pp. 203–4.
2 *Journal des Artistes*, 11 September 1836, p. 166.
3 Hubert's statement, published in Paris in 1840, can be found in full in ibid., pp. 167–8. There is a solitary copy of Hubert's pamphlet, the first handbook to be specifically written for the amateur, in the UK, in the British Library.

Chapter Fifteen

1 *Literary Gazette*, vol. 23, 13 April 1839, p. 236.
2 Weaver, *Diogenes with a Camera*, p. 83.
3 HFT to Herschel, 25 January 1839.
4 HFT to Biot and Arago, 29 January 1839.
5 Batchen, *Burning with Desire*, p. 29.
6 HFT, Notebook L, p. 103.
7 'Some Account of the Art of Photogenic Drawing' in *Philosophical Magazine*, vol. XIV, 1839, p. 201.
8 Ibid., p. 208.
9 *Liverpool Mercury*, 1 February 1839; see also *Morning Post* and the *Globe* for 25 January 1839.
10 Lady E to HFT, 3 February 1839.

Chapter Sixteen

1 Gaston Tissandier, *Les merveilles de la photgraphie*, Paris: Hachette, 1874, p. 64.
2 Newhall, *Photography: Essays and Images*, p. 18.
3 *Literary Gazette*, 12 January 1839, p. 28.
4 Gernsheim & Gernsheim, *Concise History*, p. 11.
5 'Photogenic Drawing, or The Sun the Most Correct Artist', *Liverpool Mercury*, 8 February 1839.
6 Lady E to HFT, 3 February 1839, BL Collection.
7 HFT to Lady E, 5 February 1839.

8 HFT to William Jerdan, 30 January 1839.

9 Ibid.

10 David Brewster to HFT, 4 February 1839.

11 Lady E to HFT, 27 February 1839, BL Collection.

12 Lady E to HFT, 7 April 1839.

13 Lady E to HFT, 30 April 1839.

14 Lady E to HFT, October 1839.

15 Lady E to HFT, 1 February 1840.

16 Lady E to HFT, 27 September 1839.

17 Lady E to HFT, 27 February 1839, BL Collection.

Chapter Seventeen

1 *New York American*, vol. 21, no. 7300, 22 May 1839.

2 *New York Observer*, 20 April 1839. It is possible that Morse's letter was the first published mention of the daguerreotype in America.

3 *Literary Gazette*, 30 March 1839.

4 Ibid.

5 *Bristol Mercury*, 27 April 1839.

6 *The Times*, 2 April 1839.

7 *Magazine of Domestic Economy*, vol. 4, May 1839, p. 339.

8 See article in the *Athenaeum*, 6 April 1839.

9 *The Chartist*, 28 April 1839.

10 As advertised in *The Times*, 16 July 1839.

11 Letter from George Butler to HFT, 31 May 1839, BL Collection.

12 Herschel to HFT, 9 May 1839, no. 1937–4847, NMeM Collection.

13 HFT to Lady Elisabeth, 5 October 1839, T/2 1276 NMeM.

14 *Freeman's Journal*, 26 February 1839.

15 Arago's address to the Chamber of Deputies, 3 July 1839. Gernsheim & Gernsheim *LJMD*, p. 95.

16 Duchâtel's address to the Chamber of Deputies, 15 June 1839; in ibid., p. 6.

17 Gernsheim & Gernsheim, *LJMD*, p. 96.

18 Ibid., p. 97.

Chapter Eighteen

1 Gernsheim & Gernsheim, *LJMD*, p. 70.
2 *Comptes rendus*, 19 August 1839, p. 250.
3 Gernsheim & Gernsheim, *LJMD*, p. 71.
4 Ibid.
5 Arago to the Chamber of Deputies, 3 July 1839, quoted in *Edinburgh Review*, January 1843, p. 322. John Pye's questions to Daguerre can be found in the *London Journal of Arts and Sciences and Repertory of Patent Inventions*, vol. XV, 1840, pp. 182–4.
6 *The Times*, 3 June 1845.

Chapter Nineteen

1 *Morning Post*, 26 September 1839.
2 *Morning Post*, 7 December 1839.
3 See Taylor & Dimond, *Crown and Camera*, pp. 26–9.
4 *Morning Post*, 31 October 1839.
5 *L'Artiste*, 25 August, 1839.
6 *Révue Française*, 10 June to 10 July 1859.

Chapter Twenty

1 HFT to Thomas Moore, 14 March 1839, in Wilfred S. Dowden, ed., *The Journal of Thomas Moore*, vol. 5 (1836–42), Delaware: University of Delaware Press, 1988, p. 2045.
2 *Camera Notes*, vol. 2, no. 1, July 1898, pp. 17–18.
3 Werge, *Evolution of Photography*, p. 31.
4 Alex Strasser, *Victorian Photography: Being an Album of Yesterday's Camerawork*, London: Focal Press, 1943, p. 28.
5 Maria Edgeworth, *Letters from England, 1813–1844*, Oxford: Clarendon Press, 1971, p. 594.
6 *Art-Union: A Monthly Journal of the Fine Arts*, vol. 3, 1841, p. 65.

7 Frederick Lokes Slous, *Leaves from the Scrap Book of an Awkward Man*, London: Stewart & Murray, 1844, pp. 110–11.
8 *Art Union*, vol. 3, 1841, p. 65.
9 Linkman, *The Victorians*, p. 27.

Chapter Twenty-one

1 Herschel to HFT, 19 June 1840, NMeM Collection.
2 Samuel Morse to Daguerre, 20 May 1839, in *Samuel F. B. Morse in His Letters and His Journals*, vol. II, New York: Houghton Mifflin, 1914, p. 95.
3 This story was first told in William F. Robinson, *A Certain Slant of Light: The First Hundred Years of New England Photography*, New York: New York Graphic Society, 1980, p. 3.
4 Letter from HFT to Herschel, 27 April 1839, RS Collection.
5 *Literary Gazette*, 27 February 1841, pp. 139–40.
6 'Some Account of the Art of Photogenic Drawing', *Philosophical Magazine*, vol. XVI, 1839, p. 201.
7 HFT to Herschel, 17 March 1841.
8 Herschel to HFT, 22 March 1841, NMeM Collection.
9 Weaver, *Henry Fox Talbot*, p. 7.
10 *The Times*, 6 September 1844.

Chapter Twenty-two

1 *Dundee Courier*, 13 March 1850.
2 *Dundee Courier*, 29 May 1850.
3 Arnold, *WHFT* p. 117.
4 *The Economist*, 28 December 1850, p. 1434.
5 *Art-Journal*, vol. 6, 1854, pp. 236.

Chapter Twenty-three

1 Lady E to HFT, 5 August 1840.
2 Lady E to HFT, 16 January 1843.

3 Lady E to HFT, June 1845.

4 See Gernsheim & Gernsheim, *Queen Victoria*, pp. 15, 257.

5 http://en.wikipedia.org/wiki/the_Great_Exhibition.

6 See e.g. *Punch*, vol. XX, 1851, p. iii.

7 HFT to Horatia Feilding, 1 May 1851, BL Collection.

8 HFT to Constance Talbot, 2 May 1851, BL Collection.

9 Christopher Benson and Viscount Esher, *Letters of Queen Victoria*, vol. 3, London: John Murray, 1911, p. 317.

10 *Morning Chronicle*, 12 September 1851.

11 *Morning Chronicle*, 17 September 1851.

12 Ibid.

13 *Illustrated London News*, 17 May 1851, p. 435.

14 Newhall, *History of Photography*, p. 34.

15 HFT to Lord Rosse, 30 July 1852, NMeM Collection.

16 'Account of a Total Eclipse of the Sun, 28 July 1851, Observed at Marienburg in Prussia', *Astronomical Society Memoirs*, vol. XXI, 1852, pp. 107–15.

17 HFT to Constance, 16 August 1851.

Chapter Twenty-four

1 Lenman, *Oxford Companion to Photography*, p. 587.

2 HFT to Wheatstone, 29 May 1852, NMeM Collection.

3 Letter from Rosse and Eastlake to HFT, dated July 1852, NMeM Collection.

4 HFT to Lord Rosse, 30 July 1852.

5 Charles Stanley Herve, 'A Half Century in Photography', *The Practical Photographer*, January 1893, p. 1.

6 See *Notes & Queries*, vol. 6, no. 165, 25 December 1852, p. 612.

7 Hannavy, ed. *Encyclopedia of Nineteenth-Century Photography*, vol. 1. p. 56.

8 *Journal of the Photographic Society*, vol. 3, no. 54, 21 May 1857, p. 269.

9 *Morning Post*, 25 May 1857.

10 Letter of Fanny Archer to Jabez Hogg, 9 December 1857, in Werge, *Evolution of Photography*, pp. 67–8.
11 Undated letter, as above.
12 Gernsheim & Gernsheim, *LJMD*, p. 126.

Chapter Twenty-five

1 HFT to Nevil Story-Maskelyne, 14 June 1854, BL Collection.
2 R. S. N. Gateshead, letter to the Editor, dated 12 June 1854, *Journal of the Photographic Society*, vol. 1, no. 18, 21 June 1854, p. 222.
3 *New York Tribune*, 29–30 April 1853.
4 *Quarterly Review*, vol. 101, April 1857, pp. 442–68.
5 *Journal of the Photographic Society*, vol. 1, no. 1, 3 March 1853, p. 1.
6 Talbot, *Pencil of Nature*, addenda insert between cover and title page.
7 The deathbed confession of 1865 comes from Robert Hirsch, *Exploring Colour Photography: A Complete Guide*, 5th Edition, New York: Focal Press, 2001, p. 27.
8 *Photographic Notes: Journal of the Birmingham Photographic Society*, vol. III, 1858, p. 39.

Chapter Twenty-six

1 Mike Weaver, *Henry Fox Talbot: Selected Texts and Bibliography*, Oxford: Clio Press, 1992, p. 87.
2 *Report from the Select Committee on Transporation*, House of Commons, 1856, p. 4.
3 The story of the daguerreotype being copied was published in several papers, including the *Morning Post*, 25 October 1855.
4 For the story of the Mayall *carte de visite* see 'Cartes de Visite', *Once a Week*, 25 January 1862, p. 137.
5 *Photographic News*, vol. VII, 8 May 1863, p. 226.
6 Guillaume-Benjamin Duchenne, *The Mechanism of Human Facial Expression*, trans. R. Andrew Cuthbertson, Cambridge: Cambridge University Press, 1990, p. 105.

7 Betty Miller, ed., *Elizabeth Barrett Browning to Miss Mitford*, London: John Murray, 1954, pp. 208–9.
8 *Standard*, 23 February 1850.
9 *Notes and Queries*, no. 185, 14 May 1853, p. 490.
10 *Punch*, vol. XXV, July–December 1853, p. 48.
11 HFT to Lady Mary Cole, 9 August 1839.
12 See Bill Jay, 'The Black Art', in 'Essays and Articles', see: www.billjayonphotography.com
13 *Quarterly Journal of Practical Medicine and Surgery*, vol. 26, October 1860, p. 382.
14 Palmquist, *Pioneer Photographers*, p. 11.
15 See: www.photohistory-sussex.co.uk/Sussexearly.htm
16 See: www.dating-au.com/mann-miss-jessie-1805–1867/
17 *Bulletin of the Connecticut Historical Society*, vol. 47, 1982, p. 99, and Palmquist, *Pioneer Photographers*, p. 463.
18 Palmquist, *Pioneer Photographers*, p. 486.
19 Constance to HFT, 21 May 1839.
20 Theresa Digby to HFT, 8 April 1839.
21 See: www.photohistory-sussex.co.uk/HastingsJocelyn.htm
22 *London Review*, 15 December 1860, p. 570.

Chapter Twenty-seven

1 Derek Hudson, *Munby: Man of Two Worlds*, London: Abacus, 1974, p. 111.
2 *Photographic Times*, vol. 25, 1894, p. 226.
3 *The World* (New York), 12 April 1891, p. 26.
4 Quoted in Ward, *Civil War*, p. 161.
5 *Morning Post*, 25 March 1854.
6 Gernsheim & Gernsheim, *History of Photography*, p. 271.
7 *London Review*, vol. 1, 15 December 1860, p. 570.
8 *Morning Post*, 20 February 1900.
9 *Ipswich Journal*, 10 February 1900.

Epilogue

1 Jane Welsh Carlyle, letter to Mrs Stirling, 21 October 1859, in James Anthony Froude, ed., *Letters and Memorials of Jane Welsh Carlyle*, Cambridge: Cambridge University Press, 2011, p. 15.

2 *Literary Gazette*, 2 February 1839, p. 74.

3 Attributed to Farkas Bolyai, father of the Hungarian mathematician János Bolyai, in 1825, when his son announced his intention to publish his work on non-Euclidian geometry. See Jason Bardi, *The Fifth Postulate*, New York: Wiley, 2009, p. 140.

4 Arnold, *WHFT*, p. 132.

Bibliography

DIGITAL SOURCES

Nineteenth-century British Library Newspapers
The *Illustrated London News* online
The Times online
Newspaperarchive.com

BOOKS AND ARTICLES

'All at Once a Moment Can be Caught for Ever', *Life Magazine*,
 23 December 1966.
Altick, Richard, *The Shows of London*, Cambridge, MA: Belknap
 Press, 1978.
Arnold, H. J. P., *William Henry Fox Talbot; Pioneer of Photography and
 Man of Science*, London: Hutchinson Benham, 1977.
Baldwin, Gordon, et al., *All the Mighty World: The Photographs of Roger
 Fenton, 1852–1860*, London: Yale University Press, 2004.
Batchen, Geoffrey, 'The Photographic Experiments of Tom
 Wedgwood and Humphry Davy: "An Account of a Method"',
 History of Photography, vol. 17, no. 2 (Summer 1993), pp. 172–83.
———*Burning with Desire: The Conception of Photography*, Cambridge,
 MA: MIT Press, 1999.
Bede, Cuthbert, *Photographic Pleasures, Popularly Portrayed with Pen and
 Pencil*, London: T. McLean, 1855.
Brusius, Mirjam, 'Beyond Photography: An Introduction to William
 Henry Fox Talbot's Notebooks in the Talbot Collection at the
 British Library', *Electronic British Library Journal*, 2010, article 14.
Fouque, Victor, *The Truth Concerning the Invention of Photography:*

Nicéphore Niépce, His Life, Letters and Work, New York: Tennant & Ward, 1935.

Gernsheim, Helmut, and Alison Gernsheim, *L. J. M. Daguerre, the World's First Photographer*, Cleveland, Ohio: World Publishing Co., 1952.

———— *Queen Victoria: A Biography in Word and Picture*, London: Longman's, 1959.

———— *The History of the Diorama and the Daguerrotype*, New York: Dover Publications, 1968.

———— *Concise History of Photography*, New York: Dover Publications, 1986.

———— *The History of Photography*, London: Thames & Hudson, 1969.

Gray, Michael, 'Tom Wedgwood (1771–1805): A Lunar Son and His Influences', conference pamphlet, London: Royal Institution, 2005.

Hannavy, John, *The Camera Goes to War: Photographs from the Crimean War, 1854–56*, Edinburgh: Scottish Arts Council, 1974.

———— *The Victorian Professional Photographer*, Aylesbury, Bucks: Shire Publications, 1980.

———— *Fox Talbot: An Illustrated Life*, Princes Risborough, Bucks: Shire Publications, 1997.

————, ed., *Encyclopedia of Nineteenth-Century Photography*, 2 vols, London: Routledge, Taylor & Francis, 2008.

Haworth-Booth, Mark, *The Golden Age of British Photography 1839–1900*, London: V & A Museum, 1984.

Hirsch, Robert, *Seizing the Light: A Social History of Photography*, Boston, MA: McGraw-Hill, 2008.

Hobsbawm, Eric, *The Age of Revolution: Europe 1789–1848*, London: Weidenfeld & Nicolson, 1995.

Holmes, Richard, *The Age of Wonder: How the Romantic Generation Discovered the Beauty and the Terror of Science*, London: Harper Press, 2008.

Jones, Roger, and Mike Ware, *What's Who? A Dictionary of Things Named after People and the People They Are Named after*, Leicester: Troubador Publishing, 2010.

Kravets, T. P., *Dokumenty po istorii izobreteniya fotografii: Perepsika Zh. N. Niepsa I Zh. M. Dagerra*, Moscow: Akademiya Nauk, 1949.

Lassam, Robert, *Fox Talbot: Photographer*, Tilsbury, Wilts: Compton Press, 1979.

Lenman, Robin, *The Oxford Companion to the Photograph*, Oxford: Oxford University Press, 2005.

Linkman, Audrey, *The Victorians: Photographic Portraits*, London: Tauris Parke Books, 1993.

——— *Photography and Death*, London: Reaktion Books, 2011.

Litchfield, Richard Buckley, *Tom Wedgwood, The First Photographer*, London: Duckworth, 1903.

Martin, Joanna, *Wives and Daughters: Women and Children in the Georgian Country House*, London: Hambledon Continuum, 2004.

Meteyard, Aliza, *A Group of Englishmen (1795 to 1815); Being Records of the Younger Wedgwoods and Their Friends*, London: Longman, Green & Co., 1871.

'M. Daguerre', *Illustrated London News*, 26 July 1851, vol. 19, no. 504, pp. 117–18.

Newhall, Beaumont, *Photography: Essays and Images. Illustrated Readings in the History of Photography*, New York: Museum of Modern Art, 1980.

——— *The History of Photography*, New York: New York Museum of Modern Art, 1999.

Palmquist, Peter E., *Pioneer Photographers of the Far West: A Biographical Dictionary 1840–1865*, Stanford, CA: Stanford University Press, 2002.

'Photography from a Commercial Point of View', *London Review*, 15 December 1860, pp. 570–1.

Pinson, Stephen, *Speculating Daguerre: Art and Enterprise in the Work of L. J. M. Daguerre*, Chicago: Chicago University Press, 2012.

Quennell, Peter, *Victorian Panorama*, London: Batsford, 1937.

Richter, Stefan, *The Art of the Daguerrotype*, London: Viking, 1989.

Schaaf, Larry, *Out of the Shadows: Herschel, Talbot and the Invention of Photography*, New Haven, CT: Yale University Press, 1992.

——— ed., *Selected Correspondence of William Henry Fox Talbot*,

1823–1874, London: Science Museum and National Museum of Photography, Film and Television, 1994.

———*Records of the Dawn of Photography: Talbot's Notebooks*, Cambridge: Cambridge University Press, 1996.

Smith, Christopher Upham Murray, and Robert Arnott, eds, *The Genius of Erasmus Darwin*, London: Ashgate, 2005.

Strasser, Alexander, *Victorian Photography, Being an Album of Yesterday's Camera-work*, New York: Focal Press, 1942.

Talbot, Henry Fox, 'Some Account of the Art of Photogenic Drawing, or the Process by Which Natural Objects May Be Made to Delineate Themselves without the Aid of the Artist's Pencil', *Philosophical Magazine*, vol. XIV, 1839, pp. 196–208.

——— 'Photogenic Drawing', *Morning Chronicle*, 25 February 1839.

———*The Pencil of Nature*, London: Longman, Brown, Green & Longmans, 1844–6.

Taylor, Roger, and Frances Dimond, *Crown and Camera: The Royal Family and Photography*, Harmondsworth: Penguin, 1987.

Tremayne, Margaret, ed., *The Value of a Maimed Life: Extracts from the Manuscript Notes of Thomas Wedgwood*, London: C. W. Daniel, 1912.

Uglow, Jenny, *The Lunar Men: The Friends Who Made the Future, 1730–1810*, London: Faber & Faber, 2002.

Ward, Geoffrey, *The Civil War: An Illustrated History of the War between the States*, London: Pimlico, 1992.

Ware, Mike, 'Luminescence and the Invention of Photography: "A vibration in the phosphorus"', *History of Photography*, vol. 26, no. 1, Spring 2002, pp. 4–15.

——— 'Photography', in *The Oxford Companion to the History of Modern Science*, ed. J. L. Heilbron, Oxford: Oxford University Press, 2003.

———*Gold in Photography: The History and Art of Chrysotype*, Brighton: ffotoffilm publishing, 2006.

Warner, Marina, *Phantasmagoria: Spirit Vision, Metaphors and Media in the Twenty-First Century*, New York: Oxford University Press, 2006.

Weaver, Mike, *Diogenes with a Camera: Henry Fox Talbot, Selected Texts and Bibliography*, Oxford: Clio Press, 1992.

Werge, John, *The Evolution of Photography*, London: Pier & Carter, 1890.

Wynter, A., 'Cartes de Visite', *Once a Week*, 25 January 1862, pp. 134–7.

Index